Witchcraft

in

ILLINOIS

Witchcraft

in

ILLINOIS

• A CULTURAL HISTORY •

Michael Kleen

FOREWORD BY OWEN DAVIES

THE
History
PRESS

Published by The History Press
Charleston, SC
www.historypress.net

Copyright © 2017 by Michael A. Kleen
All rights reserved

First published 2017

Manufactured in the United States

ISBN 9781625858764

Library of Congress Control Number: 2017940922

Contents

Foreword

The preoccupation with Salem as a national event has overshadowed the much longer history of witch persecution and counter magic in America. Witchcraft in colonial New England has been seen as a serious matter of study for historians, with witchcraft in the nineteenth and twentieth centuries left to folklorists. Furthermore, major scholarly folkloric or anthropological studies of European American witchcraft accusations and persecutions are few and far between. The obvious focus on witchcraft in colonial New England and the predominance of studies on the Pennsylvania Dutch have also tended to obscure the histories of witchcraft and magic in more recent American states, far from the Eastern Seaboard.

For all these reasons, Michael Kleen's book is a welcome contribution to our understanding of the history of American witchcraft.

Kleen's focus on Illinois highlights a number of important aspects of both the history of witchcraft and how to study it. As we move into the second half of the eighteenth century, for example, the history of American witchcraft becomes one that is integral to the stories of both African Americans as well as European Americans, and the two are deeply entwined.

This becomes apparent, furthermore, due to Kleen's *longue durée* approach. We can understand fully the continuities and changes in ideas and practices only through looking at the influence of broader social, ethnic, political, religious and cultural shifts over time. Two of the most profound developments were industrialization and urbanization. The nineteenth-century cases researched by Kleen illustrate how witchcraft accusations

were equally a part of life in rapidly expanding urban communities as in the scattered rural settlements of Illinois.

The cases and stories in this book are fascinating in their own right. Kleen draws on folklore archives, newspapers and censuses to dig deeper into the lives of the people concerned. Newspapers and censuses can provide details about individuals that folklore sources do not reveal, while the folklorists were able to capture the richness and diversity of beliefs and practices. The more such statewide studies we have, the better people will appreciate the long and complex story of witchcraft in America.

—OWEN DAVIES
Professor of social history, University of Hertfordshire, author of
America Bewitched: The Story of Witchcraft after Salem (2013)

Introduction

From the fifteenth to eighteenth centuries, a moral panic over witches and witchcraft gripped Christian Europe. Witches, in league with the devil, were believed to cause maladies, ailments and disasters of every variety. They represented a threat to the moral order, and practicing witchcraft was considered a crime warranting the harshest punishments. Witch trials peaked between 1580 and 1630. In colonial America, the Salem witch trials of 1692 and 1693 marked a dramatic end to organized witch persecutions, and witchcraft ceased to be a concern of the educated elite. There was no room in the growing field of natural science for magic and the occult. Many commoners, however, continued to believe in witches, and pioneers took their beliefs with them when they moved west over the Appalachian Mountains. Since the first Illinois pioneers hollowed out bullets and filled them with silver to ward off witches, witchcraft has remained a part of Illinois history, culture and lore.

A witch, from the Old English word *wicce* or *wicca*, is a person who professes or is supposed to practice magic or sorcery, and witchcraft is his or her art. Around AD 900, wicce evolved into the Middle English word *wicche*, which is also the root word for *wikke*, "bad," or *wikked*, "wicked." *Hex* comes to us through the German language. A hex is a spell or charm, but it also means to bewitch or to practice witchcraft. *Hexe*, in German, means witch.

In English culture, a witch was usually portrayed as an elderly woman accompanied by a familiar animal spirit or companion. Commoners believed there were two kinds of witches: malevolent and benevolent, or good and

bad. Bad witches caused harm, while good witches used magic to help their neighbors or break another witch's spell. On the Illinois frontier, pioneers called practitioners of benevolent witchcraft "witch doctors" or "witch masters." Both Anglo-American pioneers and later immigrants brought with them a large body of folk magic, but practitioners of folk magic did not consider themselves to be witches or witch doctors, though their charms and techniques were often identical.

For several centuries, Europeans believed witchcraft was a serious crime, and their laws reflected that belief. History shows that many Illinoisans took witchcraft seriously, but is practicing witchcraft illegal in the state of Illinois? In short, yes—though there is no state law explicitly prohibiting the practice. In 1874, the Illinois General Assembly passed the Illinois Revised Statutes, which remained in effect until 1993. While the Illinois Revised Statutes do not contain references to witchcraft, chapter 28, "Common Law—An Act to Revise the Law in Relation to the Common Law," approved on March 5, 1874, states the following:

> Be it enacted by the People of the State of Illinois, represented in the General Assembly, That the common law of England, so far as the same is applicable and of a general nature and all statutes or acts of the British parliament made in aid of, and to supply the defects of the common law, prior to the fourth year of James the First, excepting the second section of the sixth chapter of 43rd Elizabeth, the eighth chapter of 13th Elizabeth, and ninth chapter of 37th Henry Eighth, and which are of a general nature and not local to that kingdom, shall be the rule of decision, and shall be considered as of full force until repealed by legislative authority.[1]

The Illinois General Assembly originally passed this law on February 4, 1819, and it appeared as Section 1 of *Laws of the State of Illinois* (1819).[2] Apart from replacing Roman numerals with Arabic numerals, the 1874 law was identical to the one passed in 1819. It ensured Illinois's legal system remained anchored in English common law, on which its previous territorial laws and laws of the original thirteen American colonies were based.

The Witchcraft Act of 1604, *An Act Against Conjuration, Witchcraft and Dealing with Evil and Wicked Spirits,* passed by British Parliament in the first year of King James I, declared it a felony to conjure evil spirits; employ or feed evil spirits; disinter bodies or skeletons for the purpose of witchcraft, sorcery, charm or enchantment; or use witchcraft, sorcery, charm or enchantment

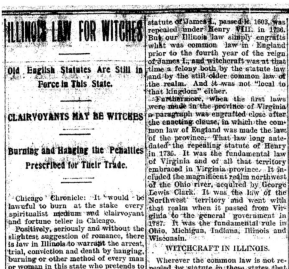

An 1897 newspaper article discussing English common law in effect in Illinois. *From the* Daily Review *(Decatur, Illinois).*

to kill, destroy, waste, consume, pin or lame a person or any part of his or her body. The penalty for these offenses was death. It also provided that anyone practicing or exercising witchcraft, charms, enchantment or sorcery to locate hidden treasure or lost or stolen goods, provoke love, destroy cattle or goods or hurt or injure a person would be pilloried for the first offense. A second offense warranted the death penalty.[3]

Under 5 ILCS 50, "Common Law Act," the current Illinois Compiled Statutes contains the same provision as chapter 28 of the Illinois Revised Statutes. The Witchcraft Act of 1604 was enacted prior to the fourth year of James I, and it has never been repealed by legislative authority in Illinois. Consequently, practicing witchcraft in Illinois is a felony. However, no one has ever been charged or convicted under this legal curiosity, and Illinois's legal history is silent on witchcraft. Witch accusations swirled around other, related charges, like murder (poisoning), attempted murder, slander, assault and battery, disorderly conduct and even running a confidence game. Accusations of witchcraft do not appear in court records, only in newspaper articles featuring interviews with eyewitnesses and participants. We will never know how many cases peripherally involving witchcraft failed to make it into the press.

Because Illinois held no witch trials, it is tempting to dismiss the history of witchcraft in Illinois. Lack of readily available sources, as well as the subject's social and academic stigma, has discouraged historians from exploring the extent of witch beliefs on the Illinois prairie. Witchcraft has long been seen as an embarrassing relic of a more ignorant time. Nevertheless, the existence of magic and witchcraft was a fact of life for many Illinois residents in the eighteenth, nineteenth and early twentieth centuries. Witch doctors skilled in the art of reversing misfortune with charms and talismans coexisted alongside modern medicine in some parts of the state into the early 1900s. Understanding this overlooked aspect of Illinois culture helps fill in a missing piece of our historical puzzle.

It is difficult to conceive a time when people believed fence posts should be erected during certain moon phases or boiling pins broke a witch's spell, but despite dismissal of these beliefs by educated elites, they continued to hold sway over the populace for over a century. Early historians used folk beliefs as a measure of progress and thought magic and witchcraft would evaporate in the face of education and scientific advancement. They did not.

THE OLD WORLD AND THE NEW

Successive waves of European immigration refreshed and renewed witch beliefs on the Illinois prairie, from the French and their Afro-Caribbean slaves in the 1700s to the Scotch-Irish and Anglo-American southerners in the early 1800s, Germans in the 1840s and '50s and the great urban flood of southern and eastern Europeans in the 1880s and '90s.

Hugging the Mississippi and Illinois Rivers, French settlers dominated the Illinois Country until 1763, when France ceded it to Great Britain after the Seven Years' War. Anglo-American settlement came after George Rogers Clark claimed the Illinois Country for Virginia during the Revolutionary War. The earliest American settlers were southerners who came up from Virginia, Tennessee, Kentucky and the Carolinas. Yankees and German immigrants followed close behind. These Germans were known as "Forty-Eighters," having fled central Europe after the failed liberal revolutions of 1848. In 1850, 81.1 percent of Illinois's foreign-born males came from Germany, Ireland and England. Immigrants also continued to arrive from the East Coast. In 1850, 67,180 New Yorkers and 24,756 Virginians moved into Illinois. Yankees from New England

THE SIXTH AND SEVENTH

BOOKS OF MOSES

THE MYSTERY OF ALL MYSTERIES

The Citation on All Spirits, The Spirit in the Burning
Bush, "Helmet of Moses and Aaron,"
Healing by Amulets

THE WONDERFUL MAGICAL AND SPIRIT ARTS

of Moses and Aaron, and the Old Wise Hebrews, taken from
the Mosaic Books of the Cabala and the Talmud,
for the Good of Mankind

PREPARED FOR PUBLICATION UNDER THE EDITORSHIP OF

DR. L. W. de LAURENCE

*Author of "The Great Book of Magical Art, Hindu Magic and East Indian
Occultism," "The Famous Book of Death and Hindu Spiritism," "The Mystic
Test Book of The Hindu Occult Chambers, Magic Mirror, Hindu and Egyptian
Crystal Gazing." Author and Publisher of the five famous "Text Books"
for "The Congress of Ancient, Divine, Mental and Christian Masters," etc., etc.*

RARE OLD MOSAIC BOOKS OF THE TALMUD AND CABALA

This rare and wonderful book, translated under personal supervision into
the English language, and published for the first time. With exact copies of
over One Hundred and Twenty-Five Seals, Signs, Emblems, etc., used by
Moses, Aaron, Israelites, Egyptians, etc., in their astounding Magical and
other Arts, including the period of time covered by the Old and New Testa-
ments. This wonderful translation is of great importance to the student of
Occultism. The extracts from the old and rare Mosaic Books of the Talmud
and Cabala are invaluable. The book contains 125 illustrations which are exact
copies of the stone tablets used by the Israelites and Egyptians to accomplish
their designs for good or evil, and are separately explained.

This book has become very rare, enormously popular, and formerly sold for $5.00.

*Translated from the German Original, Word for Word, according to the Old
Ancient Writings and Famous Manuscripts of the Hebrews.*

de LAURENCE, SCOTT & CO., Chicago, Ill., U.S.A.
1910

The 1910 cover of *Sixth and Seventh Books of Moses*, published by de Laurence, Scott &
Company. *Courtesy of Archive.org.*

spread out across the Midwest, settling Michigan, Indiana and Illinois. These immigrants tended to settle land passed over by earlier pioneers, particularly western and northeastern Illinois.[4]

As these nineteenth-century migrations occurred, occult beliefs and literature from the Old World continued to influence the United States. In Stuttgart, Germany, in 1849, Johann Scheible published a multivolume set of magical and occult texts from around the world called *Geheimniß und Offenbarungs Bücher und der Wunder-Hausschatz-Literatur Aller Nationen in Allen Ihren Raritäten und Kuriositäten* (1849), or *Secret and Revelatory Books and the Wonder-House Treasure Literature of All Nations in Its Rarities and Curiosities*. Volume Six was titled *Das Sechste und Siebente Buch Mosis, das Ist: Mosis Magische Geisterkunst, das Geheimniß Aller Geheimnisse*, or *Sixth and Seventh Books of Moses, That Is: Moses Magical Spirits Art, the Secret of all Secrets*.

Sixth and Seventh Books of Moses purported to be biblical apocrypha containing spells, incantations and seals used by Moses and ancient Israelite and Egyptian magicians to control spirits and perform miracles found in the Old Testament. In 1865, a New York publisher reprinted the original German text, and it spread to German American communities across the United States, including Illinois. An 1880 English translation made the book available to the general public.

Sixth and Seventh Books of Moses was influential on witch beliefs in Illinois, and those who possessed it were thought to have access to its occult power. One anonymous German American interviewed by folklorist Harry Middleton Hyatt in Adams County, Illinois, in the early 1930s warned of its powers. "A boy read the *Seventh Book of Moses*, and he bewitched the next door neighbor and she got real sick," he or she explained. "This boy went over to see if he could help her, and they would not let him do anything. This woman died that night because they would not let him take the spell off after he had put it on her."[5]

In a story titled "The Dried Foot-Print," told by a woman from Belleville, Illinois, and recorded by Charles Neely, a man who owned the *Sixth and Seventh Books of Moses* discovered a thief by drying the man's footprint, causing him to become sick. He let the man go after he promised never to steal again.[6] The appearance of this text in folklore accounts from western and southwestern Illinois demonstrates how it helped strengthen and perpetuate magical beliefs in that region.

Occult author and publisher Lauron William de Laurence (1868–1936) published a paperback English translation of *Sixth and Seventh Books of Moses* in 1910. De Laurence, Scott & Company, De Laurence's publishing company

Introduction

L.W. de Laurence. *From* The Mystic Textbook of the Hindu Occult Chambers.

and spiritual supply mail-order house, was located in Chicago, Illinois, and was influential in providing reprinted and original magical and occult texts to customers across the United States. De Laurence reprinted another influential German text, *The Long-Lost Friend* (1856), by John George (Johann Georg) Hohman. Hohman immigrated to the United States from Germany in 1802 and settled in Pennsylvania Dutch country, where he sold chapbooks on the practice of folk magic and herbal remedies. He originally published *Der Lange Verborgene Freund* in his native language in 1820, but translations were soon made available.

From his publishing house in Chicago, L.W. de Laurence popularized *The Long-Lost Friend* in African American communities, which had a lasting influence on hoodoo practices. Typical advice from *The Long-Lost Friend* included prescriptions such as this: "Let the sick person, without having conversed with any one, make water in a bottle before sun-rise, close it up tight, and put it immediately in some box or chest, lock it and stop up the key-hole; the key must be carried in one of the pockets for three days, as nobody dare have it excepting the person who puts the bottle with urine in the chest or box."[7]

These concoctions found their way into Illinois folk beliefs, and spells and charms involving hair, pins, coins, mirrors and bodily fluids spread to rural and urban areas in equal measure. In Chicago in 1919, for instance, an account of a woman burning salt, incense and a lamb's heart stuck with pins in order to coax a witch out of hiding appeared in the *Daily Tribune*. Like recipes in cookbooks passed down from immigrant parents to their children, *Sixth and Seventh Books of Moses* and *The Long-Lost Friend* purported to pass on esoteric old-world knowledge to new generations.

THE

LONG LOST FRIEND.

OR'

Faithful & Christian Instructions

CONTAINING

WONDEROUS AND WELL-TRIED

ARTS & REMEDIES,

FOR

MAN AS WELL AS ANIMALS.

WITH MANY PROOFS

Of their virtue and efficacy in healing diseases, &c. the greater part of which was never published until they appeared in print for the first time in the U. S. in the year 1820.

LITERALLY TRANSLATED FROM THE GERMAN WORK OF

JOHN GEORGE HOHMAN,

Near Reading, Alsace Township, Berks County, Penn.

HARRISBURG, PA.——1850.

The 1850 cover of *The Long-Lost Friend*, published by John George Hohman. *Courtesy of Archive.org.*

A Miserable Superstition

Nineteenth- and early twentieth-century journalists and historians considered the persistence of witch beliefs in Illinois an embarrassing footnote in history—when they acknowledged it at all. Convinced of American progress, historians dismissed witchcraft as a "miserable superstition" and an "imaginary crime" long vanished from educated minds.[8] "In early times the inhabitants of Illinois were in a small degree tinctured with the absurdity and nonsense of witchcraft and fortune-telling; but in after-days this ignorant superstition has entirely disappeared," former governor and congressman John Reynolds asserted (without much evidence) in *Pioneer History of Illinois* (1852). "All this ignorance and nonsense have disappeared from the minds of the people by a proper education," he concluded.[9] Two years earlier, in McDonough County, Illinois, however, a man named James Spiva accused a neighbor's wife of witchcraft and would have hanged for her murder—if shooting her image with a silver bullet had been a crime. In 1855, his wife accused him of attempted murder when he applied an old English remedy for witchcraft and scratched her cheek with a knife while she slept.

Writing several decades later, attorney Milo Erwin echoed Reynolds's sentiments. In his 1876 history of Williamson County, he asserted, "Happily for the honor of human nature, the belief in those foolish and absurd pretentions has been discontinued, for forty years by an enlightened public."[10] Likewise, in his *History of Effingham County, Illinois* (1883), William Henry Perrin noted with great satisfaction, "Yet as widespread as were these beliefs in goblins and spells, there are to-day men and

John Reynolds, fourth governor of Illinois, after a steel engraving in the governor's office, Springfield, Illinois. *From* McClure's Magazine, *January 1896.*

women in our county who grew up among such pernicious influences that will tell you of the terrifying beliefs of their childhood and laugh at them....By their own strength of mind they have grown away from the faith of their fathers."[11]

Even as they wrote, however, sensational stories involving witchcraft appeared in the press. In Franklin County, Illinois, just five years before Milo Erwin also claimed belief in witchcraft had been discontinued for four decades by an enlightened public, dozens of spectators flocked to a farmhouse to witness the strange spectacle of the Williams sisters, who claimed to have been bewitched. Three years later, in 1879, a Chicago man named Toby Allen complained of being tormented by a witch while he was incarcerated at the Joliet State Penitentiary.

While reporting on accusations of witchcraft, nineteenth- and early twentieth-century newspaper editors used belief in magic and witchcraft to ridicule immigrants, African Americans and poor rural whites. They attributed witch beliefs to mental illness and backward, uneducated and undeveloped people and regions. In 1871, *Chicago Tribune* editors described the bewitched Williams sisters as performing nightly to "large audiences of gaping country folk."[12] According to the editors at the *Chicago Inter Ocean*, "As a rule, these beliefs are only to be found in the rural districts...[and] isolated farming districts."[13] In 1911, the *New York Times* reported on a case of witchcraft in McDonough County, Illinois, under the title "People Who Still Believe in Witchcraft." The *Inter Ocean* reprinted the same article under the headline "Popular Belief in Witchcraft Is Not Yet Altogether Dead." Although the case actually occurred in the 1850s, both the *Times* and the *Inter Ocean* made it seem as though it had recently taken place and held it up as an archetypical absurd story from "the rural districts."[14]

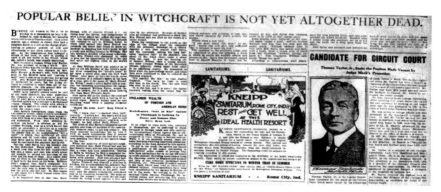

"Popular Belief in Witchcraft Is Not Yet Altogether Dead." *From the* Chicago Inter Ocean, *October 29, 1911.*

Reporting on the Toby Allen case, the *Chicago Daily Tribune* editorialized, "That the old Voodoo belief should yet linger in the hearts of the more ignorant of the colored race is not surprising, but Allen is of intelligent appearance, and uses good though rather high-flown [extravagant or overblown] English. There is little doubt, however, that the unfortunate man is absolutely insane."[15] In October 1885, a witch scare involving recent Polish immigrants in Decatur, Illinois, elicited the headline "Witchcraft Charged: The Polacks Crazy on the Idea—Their Silly Charges, Ec." The *Decatur Herald* concluded, "Their lamentable ignorance and superstition can have no cure."[16] Editors at Decatur's *Morning Review* were more generous, suggesting, "The Polanders may know better than to believe in witchcraft after they have lived longer in this country."[17] In 1904, when a young woman in Quincy, Illinois, named Bessie Bement committed suicide after visiting a witch doctor to obtain a cure for what she believed to be an evil spell, the *Daily Whig* was incredulous that such a man had been allowed to set up shop in the "enlightened" city of Quincy.[18]

When historians wrote about witchcraft in Illinois in the years prior to statehood, they often used it to distinguish modern, "enlightened" Anglo-Americans from the "superstitious" French and their Afro-Caribbean slaves, who clung to their old religion. The image they conveyed was not just of a new Salem but of a medieval fiefdom along the Mississippi River. Theodore Roosevelt, in his multivolume history *The Winning of the West* (1889), typified this view when he wrote, "It must be remembered that the creoles were very ignorant and superstitious, and that they one and all, including, apparently, even their priests, firmly believed in witchcraft and sorcery."[19] In 1885, historian John H. Gunn characterized the French inhabitants of early Illinois as backward and still clinging to the old laws and customs of the *Ancien Régime*.[20] According to these historians, the French were terrified of their Afro-Caribbean slaves, whom they had imported from the West Indies in the 1720s. Some of those slaves practiced an embryonic form of West African animism mixed with Roman Catholicism that came to be known as vodou, voodoo or hoodoo.

While witchcraft began to disappear from Illinois newspapers and history books in the early twentieth century, witch stories did appear in collections of Illinois folklore. In the early 1930s, Harry Middleton Hyatt and Charles Neely collected the beliefs, stories, songs and superstitions of rural residents of southern and western Illinois. Grace Partridge Smith and John W. Allen added to their body of work in the 1940s and '50s. All told, these accounts reveal the continued existence of a supernatural worldview fundamentally

different from the scientific materialism of our contemporary age. However, the appearance of modern conveniences like automobiles and telephones in some of the stories Hyatt collected reveal that his informants were not backwoods pioneers but men and women living in not only the modern world but also one of the most technologically advanced countries in the Western Hemisphere. The juxtaposition of this mystical belief system with modern American society is striking.

Over a century passed between the time when the first Anglo-American settlers arrived in the Illinois Country and Harry Middleton Hyatt and Charles Neely began collecting Illinois folklore, yet beliefs that were often dismissed as ignorance continued to find a receptive audience. When confronted by the endurance of this belief in magic, witches and folk remedies, William Henry Perrin blamed it for retarding the development of civilization in Illinois. "These ignorant superstitions, sucked by the babes with the milk from the mother's [breast], have done far more to beat back the cause of civilization among the common people than could all the swarms of greenhead flies, the murderous Indians, the poisonous snakes and wild beasts, the deadly malaria, disease and poverty," he argued. "Their tendency was to breed ignorance, to raise up a people that believed enormously, that never questioned, never doubted, but the more impossible the story the more implicitly they believed."[21] This unflattering portrayal of rural Illinoisans challenged the narrative that greater access to public and private education had liberated them from ignorance.

A Note on Sources

Given available sources, it is impossible to paint a complete picture of witch beliefs in Illinois. There is no accurate measure of how many people held these beliefs or for how long. Isolated incidents from newspapers and public records, inaccurate accounts in nineteenth-century history texts and stories and recollections recorded by folklorists do nothing more than show snapshots of particular times and places. Even Harry Middleton Hyatt's work, which did the most to illuminate beliefs regarding magic and witchcraft in Illinois, only applied to a small area of Adams County. Still, taken together, they open a window into this murky corner of Illinois history.

Most nineteenth-century works on Illinois history, if they mentioned witchcraft at all, focused on the execution of French Afro-Caribbean slaves

Moreau and Manuel in Cahokia and Kaskaskia in 1779. John Reynolds's *The Pioneer History of Illinois* (1852) first mentioned the incident. Reynolds reported that Moreau and Manuel had been executed for witchcraft, and subsequent works attempted to confirm this assertion. Alexander Davidson and Bernard Stuvé largely plagiarized Reynolds's account of the incident in their *Complete History of Illinois from 1673 to 1873* (1877).

In 1881, Edward G. Mason first published Colonel John Todd's *Record Book*, which contained a reference to the warrant of execution for Manuel. Acting on this new information, in 1885, historian John H. Gunn published a paper in the *Magazine of American History* titled "Witchcraft in Illinois." Gunn argued that Colonel John Todd's order confirmed Reynolds's account of events. Theodore Roosevelt, in *The Winning of the West*, vol. 2, *From the Alleghenies to the Mississippi* (1889), discussed the execution of Moreau and Manuel for witchcraft as though it was an undisputed fact. It was not until the Illinois State Historical Library published an English translation of the deposition from Moreau and Manuel's trial in 1907 that historians learned Moreau and Manuel were, in fact, tried for a series of lethal poisonings. That fact, however, never made it into subsequent works on Illinois history.

In the late nineteenth century, various authors, historical societies and commissions published histories of nearly every county in Illinois. These books contained geographic descriptions, town and city histories, anecdotes from the pioneer history of the county and biographies of influential citizens. Four in particular, *History of Effingham County, Illinois* (1883) by William Henry Perrin, *History of Williamson County, Illinois* (1876) by Milo Erwin, *History of Bureau County, Illinois* (1885) by H.C. Bradsby and *History of McDonough County, Illinois* (1878) by S.J. Clarke mention witchcraft.

Milo Erwin claimed that in the early days of Williamson County (1818 to 1835), belief in witchcraft was widespread and many witches were said to live there. At that time, Williamson County was part of Franklin County. The two counties split in 1839. He mentioned two individuals by name: a witch named Eva Locker and a witch-master/wizard from Hamilton County named Charley Lee. *History of McDonough County, Illinois* focused on the 1850 case of James Spiva, who was tried for the murder of a woman he believed to be a witch. It was a broad retelling of the incident, however, and did not contain any specific dates or names. Bradsby simply stated that it occurred "some forty years ago," which would have placed it in the 1830s. This conformed to a general narrative that consigned witch beliefs to the early pioneer history of Illinois.

An unshakable faith in American progress led these historians to assert that although early Illinois pioneers believed in witchcraft, those beliefs had long since vanished. They used witchcraft to illustrate the coarse, uneducated beliefs of the pioneers, which contrasted with the rapid development and modernization their books documented. This narrative of progress traced Illinois history from a primitive natural state to a bustling modern society. William Henry Perrin in particular explained how education had made significant progress in rooting out superstitions from the minds of his fellow citizens. While of limited historic value when it comes to the topic of witchcraft (in terms of verifiable facts), these sources helped reveal attitudes and beliefs regarding witchcraft in Illinois and served as a starting point for further research.

Newspapers provided a slightly more reliable source of information. Between 1871 and 1920, a variety of newspapers from as far away as New York reported on cases of witchcraft in Illinois. Though often embellished, these stories primarily focused on current events and demonstrated that belief in witchcraft did not simply consist of harmless folktales and pioneer history—it continued to affect the lives of believers. In 1904, the *Daily Whig* (Quincy) interviewed a witch doctor after the death of a young woman he treated for witchcraft. That series of articles offered invaluable confirmation of many of the anecdotes Harry Middleton Hyatt later collected in the 1930s. Most importantly, these newspaper articles provided a bridge between nineteenth-century history books and twentieth-century folklore collections.

Folklore texts represent a major source for information about witchcraft in Illinois. These books and articles consist of songs, ballads, superstitions, stories and anecdotes collected from Illinois residents. With some exceptions, these sources primarily focused on southern Illinois, or "Little Egypt." The first and largest folklore collection, *Folk-Lore from Adams County, Illinois* (1935) by Harry Middleton Hyatt, is a collection of more than eleven thousand items from in and around Quincy, Illinois. Harry Middleton Hyatt (1896–1978) was an Anglican minister and amateur folklorist who returned to his hometown of Quincy, located along the Mississippi River in western Illinois, after his early retirement. His other influential book, *Hoodoo, Conjuration, Witchcraft, Rootwork* (1970), is a five-volume 4,766-page collection of folklore containing material gathered from 1,600 informants across the United States between 1936 and 1940.

Stories of witchcraft and items of folk magic account for a substantial percentage of *Folk-Lore from Adams County, Illinois*. While the collection presents a rich picture of witch beliefs in the area, it is unclear how many

of those beliefs were shared in other regions of Illinois, especially in the early 1930s. *McDonough County Heritage* (1984) by John E. Hallwas was the only other collection of folklore from western Illinois to mention witchcraft. Hallwas presented a somewhat ahistorical account of the 1850 James Spiva case. He based his account on an article printed in the *Warsaw Record*, a newspaper in Warsaw, Illinois, in Hancock County, during the Civil War.

Three authors, Charles Neely (1902–1937), Grace Partridge Smith (1869–1959) and John W. Allen (1887–1969), collected folklore from the southern Illinois region. Charles Neely was an assistant professor of English at Southern Illinois Normal University in Carbondale. Published posthumously, *Tales and Songs of Southern Illinois* (1938) contains more than 150 folktales, ghost stories, ballads and songs collected between 1935 and Neely's untimely death. There are ten accounts of witchcraft in Neely's book, including several references to a witch named Mary Toombs and her husband. Neely's collection demonstrates that at least some of the beliefs that appear in *Folk-Lore from Adams County, Illinois* were shared in southern Illinois.

Grace Partridge Smith, one-time president of the Carbondale-based Illinois Folklore Society, wrote several articles on southern Illinois lore, including "Folklore from 'Egypt'" (1946), "Negro Lore in Southern Illinois" (1952) and "Flint Charms in Southern Illinois" (1956). "Folklore from 'Egypt'" in particular discussed witch beliefs. Smith noted, "At the present day, such ideas and practices have fairly generally died out except in out-of-the-way sections where one occasionally hears of a persecuted old soul whom everyone believes a witch."[22] This statement comes closest to admitting that some individuals still held onto witch beliefs even as late as the 1940s.

From 1953 to 1967, John W. Allen wrote over five hundred newspaper articles on southern Illinois history and lore. Many of these were collected in *Legends & Lore of Southern Illinois* (1963). *Legends & Lore of Southern Illinois* contains a small section on witchcraft, repeating much of what Milo Erwin wrote in 1876.

Two more recent works mention witchcraft in Illinois: *Black Magic: Religion and the African American Conjuring Tradition* (2006) by Yvonne Patricia Chireau and *America Bewitched: The Story of Witchcraft after Salem* (2013) by Owen Davies. Yvonne Patricia Chireau is a professor of religion at Swarthmore College in Swarthmore, Pennsylvania. In *Black Magic*, Chireau places the Moreau and Manuel case in context with similar incidents across the antebellum United States. Chireau's analysis of African American religious and spiritual beliefs makes the vital connection between the "art" of poisoning and witchcraft

(or hoodoo). This demonstrates how, although Moreau and Manuel were convicted of actual murders, their crimes could have been interpreted in a supernatural context.

Owen Davies is a professor of social history at the University of Hertfordshire in Hertfordshire, England. His book, *America Bewitched*, contains references to several early twentieth-century cases of witchcraft in Illinois. Davies demonstrates that witch beliefs in Illinois shared many elements with witch beliefs in other parts of the United States and that those beliefs continued to proliferate even in modern America.

Though limited in accuracy and scope, these sources represent the best available information on the history of witchcraft in Illinois. It is a shame that the written record of these beliefs is so thin. If nineteenth-century historians had not been so dismissive of witch beliefs, we might have a much better understanding of their popularity on the Illinois frontier. Unfortunately, the rich traditions Harry Middleton Hyatt documented in Adams County are absent from the historical record in nearly every other part of the state.

Academic scholars in Illinois did not develop the same kind of passion for folklore as their counterparts in Indiana, who diligently preserved folk beliefs across the Hoosier State. The folklore archives at Indiana State University in Terre Haute and Indiana University in Bloomington are treasure-troves of information about Indiana folkways painstakingly collected and catalogued over multiple decades. Without resources such as these, reconstructing the popular beliefs of Illinoisans, especially when it comes to the subject of witchcraft, is challenging at best. Still, we can be grateful that at least some sources exist and that a few men and women had the presence of mind to seek out and preserve these fragments of the past.

Part 1

History

Witchcraft in England and Colonial America

1640-1700

When Virginia Dare opened her eyes for the first time on an island off the coast of present-day North Carolina in 1587, she looked on the exhausted face of her mother, Eleanor Dare. Eleanor had just become the mother of the first English baby born in the Americas. Virginia's father was Ananias Dare, a tiler and bricklayer from London. Eleanor and Ananias had come along with 115 other Englishmen and women to reestablish Sir Walter Raleigh's colony on Roanoke Island. It was England's second attempt to colonize America, and it was an utter failure.

When John White, Eleanor Dare's father, arrived at Roanoke along with a supply ship in 1590—on his granddaughter's third birthday—he found the colony abandoned. All 118 English colonists had disappeared. Their fate remains a mystery, but they were likely absorbed by Croatoan Indians, massacred by Powhatans (led by the father of Pocahontas), enslaved by the Eno or any combination of the three. In 1567, the Spanish conquistadors who built Fort San Juan in the interior of what became North Carolina fared no better. They were killed by Joara Indians shortly after they arrived.

Between 1607 and 1763, the sons and daughters of ancient Albion spread out along America's East Coast, displacing native peoples, building villages, cities and plantations, felling forests and planting rich fields of wheat and tobacco. Over more than a century, and with the help of other western

European refugees, they slowly turned the American coast from a wilderness into a place reminiscent of their homeland. But these colonists brought more than physical changes to the New World; they also brought their faith, language and culture. "With the English language came a rich though intangible body of thought and feeling," historians T. Harry Williams, Richard Current and Frank Freidel wrote in their *A History of the United States (to 1877)*. "There came a mass of folklore, myths and superstitions, songs and ballads, unwritten stories, proverbs, sayings, and all the wisdom of unlearned people."

Those traditions included a strong popular belief in witchcraft, which accompanied the colonists from the Old World to the new. While captains Edward Wingfield and Christopher Newport founded Jamestown in 1607, printing presses back home churned out lurid details of witch trials, animal familiars and devils' marks. The magical world that fascinated and terrified the English people eventually found its way to the shores of the Illinois River, over four thousand miles away from the British Isles.

The great period of witch trials in Europe began on December 5, 1484, when Pope Innocent VIII issued the *Summis desiderantes affectibus*, a papal bull (or decree) that many historians point to as the origin of early modern witch persecutions. It said, in part:

> [M]*any persons of both sexes, unmindful of their own salvation and straying from the Catholic Faith, have abandoned themselves to devils, incubi and succubi, and by their incantations, spells, conjurations, and other accursed charms and crafts, enormities and horrid offences, have slain infants yet in the mother's womb, as also the offspring of cattle, have blasted the produce of the earth, the grapes of the vine....* [T]*hese wretches furthermore afflict and torment men and women, beasts of burthen, herd-beasts, as well as animals of other kinds, with terrible and piteous pains and sore diseases, both internal and external; they hinder men from performing the sexual act and women from conceiving, whence husbands cannot know their wives nor wives receive their husbands; over and above this, they blasphemously renounce that Faith which is theirs by the Sacrament of Baptism.*[23]

The papal decree was meant to apply only to certain regions in Germany but was interpreted by "witch finders" as a blanket license to roam Europe looking for witches, even in places where Catholicism did not hold sway. These persecutions lasted for over two centuries. In the 1680s, objections by educated elites resulted in the repeal of most laws against witchcraft.

In contrast to England and its colonies, the French monarchy was late to abandon laws against witchcraft, and witch trials continued in France into the eighteenth century. Bertrand Guilladot, a priest in Dijon who in 1742 confessed to making a pact with the devil, was one of the last to be executed for the crime. The gender of the accused was not a focus of witch trials in France as it was in England. According to historian Robin Briggs, "Of nearly 1,300 witches whose cases went to the *parlement* of Paris on appeal, just over half were men....In around 500 known cases which did not reach the *parlement*, although there is a small majority of women, men still make up 42 per cent of the accused."[24]

American society incubated during a time of great social and political upheaval in England. Protestants and Catholics, Parliamentarians and Royalists, and alchemists and natural philosophers all fought over the hearts and minds of their fellow Englishmen. It was dissenters seeking to purify the Church of England from Catholic influence (Puritans) who landed at Plymouth Rock in 1620. The social rifts that chased the Pilgrims to America led to a series of civil wars in England between 1641 and 1651 that climaxed in the beheading of King Charles I on January 30, 1649. At the beginning of those wars, most clergy and commoners embraced a fundamentally supernatural worldview. They believed invisible forces could and did influence their lives. Charms and conjurations, though against the law, were regularly used in rural England. Witches were people who, with the help of the devil, manipulated the natural world to wreak havoc on the social and natural order. They used *maleficium* (malevolent or harmful magic) to spread blight and disease, poison food and kill livestock, all with the aid of occult powers.

By 1640, English elites were increasingly skeptical of the existence of magic and witchcraft. The days of Heinrich Kramer and Jacob Sprenger's *Malleus Maleficarum* (1487) were long gone. Keith Thomas, in *Religion and the Decline of Magic*, argued that a growing number of mostly Protestant elites, during the seventeenth century in particular, rejected the idea that the devil could influence people, let alone grant them occult power.[25] Pamphleteers and so-called witch finders like shipping clerk turned amateur prosecutor Matthew Hopkins found themselves on the defensive, and they began producing accounts of witchcraft in order to convince their contemporaries of its reality. Sensationalism and profit also drove the printing presses to churn out lurid accounts of trials and alleged liaisons with the devil. Witchcraft in seventeenth-century England had become, essentially, a folk culture that both frustrated and fascinated the ruling elites, and those elites manipulated that culture for their own ends.

Hollywood and contemporary popular culture has distorted the nature of witchcraft in this period. According to historians Barry Reay and Alan Macfarlane, witchcraft accusations resulted from a breakdown in neighborly relations, not religious persecution or the deliberate suppression of an ancient nature religion. Violence and legal action usually occurred only after a long series of confrontations and only after several other recourses had failed. Reay suggested a lopsided power play was at work, in which the accused cultivated the witch persona to empower themselves against their neighbors, only running afoul of the law after several decades. Most witchcraft allegations "emerged from a context of household and neighborhood intervention, and from the inevitable frictions of community life."[26] Robin Briggs, in his book *Witches & Neighbors*, went so far as to argue that witch beliefs in England were largely tolerated among the common folk and that courts acted with caution and restraint in the face of the fantastic evidence presented to them.[27]

By the seventeenth century, men sold thousands of pages of ballads and stories from street corners, shops and taverns. In London workshops, a designated reader recited the latest news to her fellow spinners and weavers while they attended their craft. In taverns across England, men drank and sang the latest ballads off broadsides. Graphic woodcuts illustrated the text, and the lyrics—though telling a different tale each time—were usually sung to familiar tunes. Witchcraft was often the subject of this popular literature, and it reveals much about English attitudes toward maleficium and its practitioners.

The Divels Delusions was typical of these pamphlets. Printed in 1649, it related the story of two "notorious witches," John Palmer and Elizabeth Knott, in Hartford County, England. Its author began the account by writing, "It had been very difficult to convince me of that which I find true, concerning the wiles of that old serpent the Divel" and offered Palmer's and Knott's confessions as proof. In his confession, John Palmer claimed he had been a witch for sixty years. He not only confessed to being a witch, he confessed "to be the head of the whole colledge of Witches, that hee knows in the world." He had also given "suck to two familiars," which was a sure sign that he had made a compact with the devil.[28]

A familiar was a small animal (usually a cat) that helped the witch and served as a liaison between the witch and the devil. Witches supposedly fed their familiars through teats that appeared somewhere on their body, and female juries looked for these marks when someone stood accused of practicing maleficium. The presence of familiars set English witchcraft apart from witch beliefs in other parts of Europe.

Another unique (but not exclusive) feature of English witchcraft was the distinction by commoners between benevolent and malevolent witches. The author of *The Divels Delusions* informed his readers that the people of Hartford County were "long gratified [with John Palmer's] conjurations, that time and ignorance stiles him a good witch, or a white witch." Rejecting the distinction, he concluded by reminding his readers of the deceptive powers of Satan, whom he accused of "tempting and deluding those who are led captive by him, namely an inordinate desire to know more than his maker hath thought fit for him to know."[29]

In 1652, an incident regarding the so-called Witch of Wapping, a woman by the name of Joan Peterson, sparked controversy in London. The debate over the authenticity of the case—and the high social standing of the persons involved—illustrated the divide between popular and elite culture and showed how English elites manipulated common beliefs about witchcraft. The author of *The Witch of Wapping* (1652), one of the first pamphlets to describe the accusations against Joan Peterson, was all too ready to accept the testimony at face value. He began his relation by writing, "[M]any are of opinion, that there are no Witches" and then set out to educate his peers regarding what seemed to be common knowledge in the countryside. "There are two sorts of Witches," he explained, "which the Vulgar people distinguish by the names of the Good Witch, (I wonder how that can be,) and the Bad; by reason, when one bewitcheth a party, the other unwitcheth him again."[30] Joan Peterson appeared to be both.

At her trial, Joan was accused of committing several benevolent acts of witchcraft, such as curing a headache and revealing in a pot of boiling water the face of a woman who had bewitched cattle, as well as acts of maleficium, such as causing a man to go into fits after he withheld payment for having been cured of an ailment. One of Joan's neighbors also related that a black cat (which vanished from plain sight when confronted) tormented her and her baby. Most fantastically, a maid in Peterson's employment testified that one night, when they lay together in bed, a squirrel came and "her Mistress and it talkt together a great part of the night." The author of the pamphlet then explained, "[B]ut being demanded what they discoursed on, she replied that...she was so bewitched by it, that she could not remember one word." Joan's son also had allegedly told his school friends about the squirrel. "These and other strange things being proved against her," the author concluded, "she was condemn'd to be hanged at Tyborn of Munday the 12 of April, 1652."[31]

Not long after, another pamphlet circulated, "A Declaration in Answer to several lying pamphlets concerning the Witch of Wapping," (1652) that

accused the plaintiffs in the trial of outright fraud. Its author alleged that in an elaborate plot, three men—Abraham Vandenbemde, Thomas Crompton and Thomas Collet—had manufactured the charges against Joan Peterson after she refused to help them accuse a different woman of witchcraft, who had also refused to do the same against one Anne Levingston. Levingston had been given an estate by the deceased Lady Powel that some of the men thought should have been willed to them. The "confederates," as the three were called, were afraid of being prosecuted if Joan went to the authorities with the plot, so they traveled to Wapping, near to where Joan lived, and procured a warrant from a justice of the peace to "apprehend the said Petersons person, and to search her house for images of clay, hair, & nails…but upon strict search and diligent inquiry could find no such thing."[32]

This account suggests the three men were willing to exploit witch beliefs, even to the point of having a woman executed, to satisfy their greed. Not believing in witchcraft themselves, they conspired to pay someone who they thought would readily cooperate. Even after two women refused, they still persisted in their plot. Being of lower social standing, the judge thought nothing of believing the men and giving them access to Joan Peterson's home. Joan denied the charges that she used witchcraft to murder the Lady Powel, saying she had "never used sorcery or Witch-craft, neither had she ever heard of the Lady Powel."

Despite Joan's denial, a group of women searched her for marks, but "the searchers could find nothing on her body which might create the least suspition in them of her being a witch." After further questioning, she was "searched againe in a most unnatural & barbarous manner, by fower [four] women whom they [the confederates] themselves for that purpose had brought along with them, [one] of which women told the Justice that there was a Teat of flesh in her secret parts more then other women usually had."[33]

During Joan's trial, several doctors testified that the Lady Powel died of "Dropsie, the Scurvey, and the yellow Jaundies," not of witchcraft. Regardless, "many women persons of mean degree (and of ill fame and reputation) were produced against her." The pamphlet's author also related the testimony of a man who had sought out Joan Peterson's help for his illness and recovered but "afterwards relapsed, and…was urged to induce the Court and Jury to believe that he was Bewitched."[34]

"Many other witnesses were produced," the author continued, "but could only swear to generalities, hear-says, and most absurd and ridiculous impertinences."[35] Several of the witnesses, he alleged, were strangers from the courtyard whom Thomas Cromton had paid to testify against Joan Peterson.

At the end of the trial, the judge found Joan not guilty of bewitching the Lady Powel but convicted her of being a witch and ordered her execution.

Because a trio of strangers deliberately sought out evidence to win a conviction against Joan Peterson, the Witch of Wapping was an unusual case. In most circumstances, charges originated among community members who had exhausted several means of dealing with maleficium before they brought a suspected witch before the courts.

In early modern England, news was disseminated not only in pamphlets but also more widely on what were known as broadsides. These were large pieces of paper with woodcuts and sensational stories printed on the front. They were cheap to reproduce and sold at street corners. Broadsides like "Great News from the West of England" (1689) contained detailed descriptions of how witches were discovered and tested, often in front of a large crowd of witnesses. This particular broadside related the story of a young man from Beckenton, Somersetshire, who was allegedly bewitched by an old woman who threatened him with a warrant after he publicly accused her of witchcraft. According to the anonymous author, "[W]ithin a few days after this Young Man fell into the strangest fits that ever Mortal beheld with Eyes." The young man also claimed to see the old woman in his bedroom mocking him during the fits.[36]

A girl by the name of Mary Hill also had several altercations with the old woman, and afterward, "something arose in her Throat…and at the same time [she] fell into violent fits…and in the midst of them, she would tell how she saw this old woman against the wall, grinning at her." A few days later, the girl vomited dozens of foreign objects, including nails, handles of spoons, pieces of iron and "above Two Hundred crooked pins." The townspeople, numbering around one hundred, tested the old woman by escorting her near the house where Mary lived without the girl's knowledge. A member of the crowd brought Mary outside, where she reacted violently to the sight of the accused witch. A short time later, a justice of the peace ordered a jury of local women to search the accused, and the jury found "several purple spots, which they prickt with a sharp needle, but she felt no pain."

The old woman was then taken to a river near town. Her legs were tied, and she was thrown into the river three times. But each time, she "did endeavour to the uttermost…to get her self under, yet she could not, but…did swim like a piece of cork." Each time, a greater number of people showed up to witness the event. The crowd threw a "lusty young woman" in at the same time to serve as a comparison, and she sank (but was saved from drowning). That was, according to the account, enough to

convince everyone who was present of "the Truth of this thing." The town rector, churchwardens, overseers of the poor and constables all signed the broadside to attest to its accuracy.[37]

The restoration of the English monarchy in 1660 led to a sense of stability on the British Isles. That same year, a number of natural philosophers—among them Robert Boyle (a founder of modern chemistry), John Wilkins, Sir Robert Moray and Christopher Wren—laid the foundations of modern science by organizing the Royal Society of London for Improving Natural Knowledge. Predominantly Puritan in theology, these men searched for a scientific theory that would help restore social order. They rejected the notion that knowledge came from divine illumination and instead advocated a rigorous experimental investigation of nature. From the university lecterns they preached corpuscularism—the idea that the world was made up of small particles held together by natural laws established by God. From then on, science was to be the proper vehicle to reform the earth and improve the condition of its inhabitants.

In that reformative vision, they shared the millenarian worldview of proto-communist religious groups like the Quakers, Diggers and Seekers but rejected their methods and the notion that the material and the spiritual were one in the same. According to historians James and Margaret Jacob, experimental science in England worked hand in glove with the Anglican Church to suppress the radicalism espoused by nonconformist sects. "In the period after 1689 Newton's natural philosophy served as the underpinning for the social ideology preached by the church in response to the Revolution settlement," they argued in their 1980 article "The Anglican Origins of Modern Science."[38] Armed with Newtonian physics, the Royal Society stood as a bulwark against both atheism and radical spiritualism.

Witchcraft held a rapidly shrinking place in that worldview, although men like Newton and Joseph Glanvill continued to take alchemy seriously, even while promoting Francis Bacon and René Descartes's more logical approach to scientific inquiry. Glanvill, though not a scientist, was a fellow of the Royal Society and author of *Saducismus Triumphatus: or, Full and Plain Evidence Concerning Witches and Apparitions* (1681), which laid out an argument for the existence of witches and supernatural powers.[39] Along with Robert Boyle and Isaac Newton, Glanvill was concerned with the growing mechanist and materialist views championed by students of Descartes, Thomas Hobbes and Baruch Spinoza. With *Saducismus Triumphatus*, he hoped to present empirical evidence that the invisible world was real and its reality could be supported by tangible proof.

For their part, radical sects like the Quakers (or the Society of Friends) continued to believe God and Satan took a very active role in the everyday affairs of humanity. A shoemaker named George Fox founded the Society of Friends in the 1650s. Quakers embraced the doctrine of Inner Light, or the notion that God's divine illumination dwelled in everyone regardless of sex or social standing. Gerrard Winstanley, the founder of the Diggers, joined the Society of Friends in the early 1650s after his own movement failed. After the restoration of the monarchy, Quakers became reviled in England, and many fled to America. Early on, they were chased out of New England and settled in North Carolina, but in 1671, Quakers purchased and settled West Jersey. A decade later, fortune smiled on them, as King Charles II granted William Penn—himself formerly exiled by his family for joining the Society of Friends—a large tract of land to the west of Jersey and north of Maryland. Together with a group of German immigrants, the Quakers created what became known as Pennsylvania and built the "City of Brotherly Love." They believed they were continuing their divine work in the New World, but they found the devil there, too.

Puritans in New England had dealt with witchcraft for years, and no one was more concerned about the spiritual well-being of his fellow Englishmen than Reverend Cotton Mather. Cotton was the son of Increase Mather, whose mother and father had fled England in 1635 after King Charles I dissolved Parliament in an unsuccessful bid to rid himself of his Puritan enemies. Between 1630 and 1640, around twenty thousand Puritans left England to found their "City upon a Hill" in America. By the 1680s, Cotton Mather was a towering figure in New England. He graduated from Harvard when he was only fifteen years old and became the author of several hundred books and pamphlets. So, in 1689, when he stood behind a pulpit in Boston and preached a sermon titled "A Discourse on Witches," his contemporaries paid attention.

Cotton Mather's sermon was largely inspired by Joseph Glanvill's *Saducismus Triumphatus*. "A Discourse on Witches" perfectly illustrated the cultural divide between commoner and elite in both England and New England. In his sermon, Cotton Mather presented himself as a dispassionate observer merely responding to witchcraft, as opposed to someone who experienced it daily. "WHAT Witchcraft is; My Hearers will not expect from me an accurate Definition of the vile Thing; since the Grace of God has given me the Happiness to speak without Experience of it," he began. "But from Accounts both by Reading and Hearing I have learn'd to describe it so."[40] As an educated and respected pastor's son, Mather had never partaken

The Wonders of the Invisible World:

Being an Account of the

T R Y A L S

OF

Several Witches,

Lately Excuted in

NEW-ENGLAND:

And of several remarkable Curiosities therein Occurring.

Together with,

I. Observations upon the Nature, the Number, and the Operations of the Devils.

II. A short Narrative of a late outrage committed by a knot of Witches in Swede-Land, very much resembling, and so far explaining, that under which New-England has laboured.

III. Some Councels directing a due Improvement of the Terrible things lately done by the unusual and amazing Range of Evil-Spirits in New-England.

IV. A brief Discourse upon those Temptations which are the more ordinary Devices of Satan.

By COTTON MATHER.

Published by the Special Command of his EXCELLENCY the Govencur of the Province of the Massachusetts-Bay in New-England.

Printed first, at Boston in New-England; and Reprinted at London, for John Dunton, at the Raven in the Poultry. 1693.

The 1693 cover of *Wonders of the Invisible World* by Cotton Mather. *Library of Congress, Prints and Photographs Division, Washington, D.C.*

of the common people's folk culture. Their superstitions and behaviors struck him as alien.

Like pamphleteers before him, he rejected the distinction between good and bad witches. "There is Mention of Creatures that *they* call White Witches which do only Good-Turns for their Neighbors," he wrote (emphasis added by author). "I suspect that here are none of that sort; but rather think, There is none that doeth good, no, not one. If they do good, it is only that they may do hurt." The farmers and craftsmen of Massachusetts Bay Colony were familiar with this folk culture. It was the "vulgar people," not Harvard-educated Cotton Mather, who tolerated some types of benevolent sorcery. In fact, fortune telling and other forms of divination, charms and folk remedies were widespread in rural New England.

Mather then turned his polemic against his principle targets: the increasing number of learned men who were skeptical of witches and witchcraft. "Their chief Argument is, That they never saw any Witches, therefore there are none," he wrote. "Just as if you or I should say, We never met with any Robbers on the Road, therefore there never was any Padding [a highwayman] there." There were, he countered, two things that demonstrated the existence of witchcraft: the testimony of Scripture and the testimony of experience. Witchcraft appears in the Bible, and Exodus 22:18, in the King James version (the version with which Mather and his audience would have been intimately familiar), commands, "Thou shalt not suffer a witch to live." Why prescribe the death penalty for an imaginary crime? Mather then called on his opponents to explain why so many accused witches had confessed. "This Confession is often made by them that are owners of as much Reason as the people that laugh at all Conceit of Witchcraft," he added with a touch of ridicule.[41]

The witch scare centered on Salem Village broke out less than three years after Cotton Mather's sermon, which was reprinted and sold around the colony. The Salem witch trials were the last—and perhaps most famous—series of witch trials in the Western Hemisphere. In all, 156 people were imprisoned and 20 executed. Four others died while awaiting trial. To put this in perspective, the total number of New Englanders put to death for the crime of witchcraft between the years 1620 and 1700 was 34.[42] Less than a year after the trials, in 1693, the jurors who had, on the basis of incredible testimony, ordered the deaths of their friends and neighbors, formally recanted and apologized for their poor judgment. "We justly fear that we were sadly deluded and mistaken; for which we are much disquieted and distressed in our minds; and do therefore humbly beg forgiveness," they wrote.

The Salem witch trials were a sobering affair, and their aftermath fanned the flames of doubt. "By the end of the seventeenth century, such defenders of demonological and witchcraft belief as Glanvill and More were engaged in a desperate struggle to halt the spread of skepticism and disbelief among the educated classes in Europe," historians Alan Charles Kors and Edward Peters explained. "By the eighteenth century witchcraft had ceased to be an intellectual and legal concern of educated people."[43] Elsewhere, colonial elites actively discouraged popular belief in witchcraft. The colony of Virginia, widely settled by royalist gentry from southern England, saw no witch executions, and courts punished false accusations. Some colonists successfully brought defamation suits against their accusers. Likewise, the Quaker elite of Pennsylvania actively tried to stamp out belief in witchcraft.[44]

Of all Anglo-American culture groups, only the Scotch-Irish appeared to zealously cling to a belief in magic and witchcraft. The great period of Scotch-Irish immigration lasted from 1718 to 1785, when over 200,000 people fled Scotland and Northern Ireland for the American colonies. They predominantly settled in the Appalachian Mountains and the Carolinas. According to cultural historian David Hackett Fischer, Scotch-Irish pioneers were obsessed with magic and sorcery. "Witch masters" were a Scotch-Irish tradition. Witch masters worked commonly in backcountry communities and were expected to make house calls. In their absence, the afflicted applied their own home remedies.[45] As these pioneers began to move west beyond the Appalachian Mountains, they took their folk beliefs with them. The folklore and history of Illinois shows that belief in witches did not die out in the 1700s. Witchcraft was alive and well on the frontier.

Witcfcraft in tfie lllinois Country

1701–1800

french colonists and their Afro-Caribbean slaves first brought witchcraft to the Illinois Country. In 1673, two French explorers, Louis Joliet and a Catholic priest of the Jesuit order named Jacques Marquette, canoed down the Fox, Wisconsin and Mississippi Rivers from the future site of Green Bay, Wisconsin, to the mouth of the Arkansas River. They were followed in 1682 by René Robert Cavelier, Sieur de La Salle (or simply, Robert de La Salle), who claimed the land along the Mississippi River for France. Two years earlier, LaSalle built Fort Crèvecœur near Peoria Lake in modern-day Tazwell County. The French monarchy called this land the Upper Louisiana portion of "New France."

As Joliet and Marquette discovered, however, American Indians already lived in the area. Until 1690, the Illiniwek—a confederation of Algonquin tribes such as the Peoria, Cahokia, Tamaroa and Kaskaskia (among others)—dominated the Illinois Country, to which they gave their name. The civilization that constructed the sprawling earthen mounds near present-day Collinsville was already a distant memory by the time European missionaries stood in the shadow of Monk's Mound and pondered its origin. Nevertheless, French explorers established forts and small trading communities along the rivers that would come to define Illinois. These settlements were known as Cahokia, Kaskaskia, Fort de Chartres and Vincennes.

In 1684, La Salle formed the *Compagnie du Mississippi*, or Mississippi Company. A Scottish economist named John Law bought the Mississippi Company in

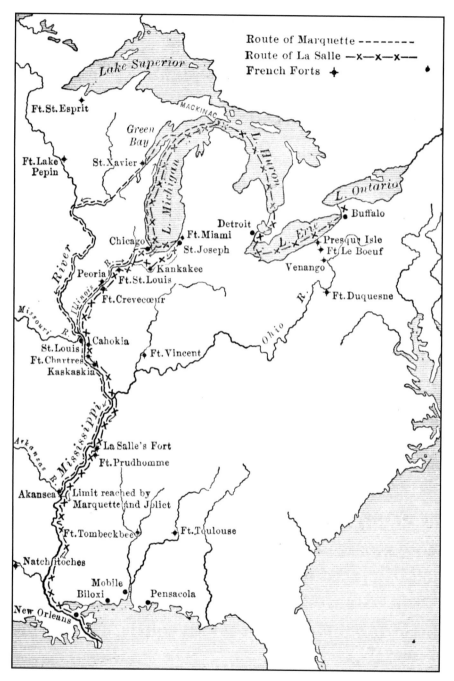

A map of North America showing the routes of early French exploration of the Mississippi Valley in the 1600s. *From* The Redway School History *by Jacques W. Redway, 1911.*

1717 and renamed it *Compagnie d'Occident*, or Company of the West. The French monarchy granted the company exclusive rights to trade in the West Indies and North America, and its agents founded New Orleans in 1718. In 1719, the Company of the West became known as *Compagnie Perpétuelle des Indes*, or Company of the Indies, after it combined with the French East India Company, which was near bankruptcy. Slaves were among the "goods" in which the French East India Company traded, since plantation agriculture formed the basis of the economy along the Mississippi.

Acting as an agent of this company, Philip François Renault purchased several hundred African slaves in Santo Domingo, a Spanish city on the island of Hispaniola in the Caribbean (and the modern-day capital of the Dominican Republic).[46] In 1720, he brought the slaves to Fort de Chartres in what is now Monroe County, Illinois, intending to use them in a silver mining operation. As it happened, John Law spread rumors of great riches in the territory in order to sell stock in his company, deceiving the whole of France. After the bubble burst and the French economy collapsed, he fled to other parts of Europe and died in poverty.[47] Renault's slaves, however, remained in Illinois. The French census of 1726 showed 129 black slaves (including men, women and children) in the Illinois Country. In 1732, they numbered 164.

The French almost certainly tried to convert these slaves to Catholicism. The *Louisiana Code Noir*, or Black Code of Louisiana, only permitted the practice of the Roman Catholic faith and made it imperative on masters to impart religious instruction to their slaves. Portions of the first Code Noir were instituted in 1685 for the French colony of Saint Domingue (present-day Haiti). The Black Code of Louisiana was based largely on this document, with several key differences, mainly involving the prohibition of marriages between blacks (both slave and free) and whites. It was introduced in 1724 and remained in force until the United States took full possession of Louisiana in 1803.

As happened in New Orleans, the forced conversion of Afro-Caribbean slaves likely resulted in an amalgamation of Christian and animistic beliefs. Animism is the notion that nonhuman beings—animals, plants and even inanimate objects—have souls. In West Africa, animism manifested itself in fetishes—man-made objects believed to possess supernatural powers. Over time, the mixture of Catholicism and the tribal religions of West Africa evolved into Haitian vodou (or voodoo, as it is known here in the United States) alongside the African American folk magic of hoodoo. It was often the case that French Catholics interpreted these vestigial remains of West African religion as witchcraft.[48]

According to historians Alexander Davidson and Bernard Stuvé, descendants of Europeans—particularly the French living along the Mississippi River—eyed their slaves with suspicion. In their *Complete History of Illinois*, they wrote, "It was a very common feeling among the French to dread to incur in any way the displeasure of certain old colored people, under the vague belief and fear that they possessed a clandestine power by which to invoke the aid of the evil one to work mischief or injury to person or property." One such person living near Cahokia, an elderly woman named Janette, was widely feared for that purported ability. Janette "inspired such terror by her appearance that adults as well as children would flee at her approach."[49] In *The Winning of the West*, Theodore Roosevelt also noted the French fear of witchcraft on the Illinois frontier. "It must be remembered that the creoles were very ignorant and superstitious, and that they one and all, including, apparently, even their priests, firmly believed in witchcraft and sorcery," he wrote. "Some of their negro slaves had been born in Africa, the others had come from the Lower Mississippi or the West Indies; they practised the strange rites of voudooism, and a few were adepts in the art of poisoning. Accordingly the French were always on the look-out lest their slaves should, by spell or poison, take their lives."[50]

France lost control over the Illinois region in 1763 in the Treaty of Paris, when King Louis XV formally ceded it to Great Britain. During the American Revolution, American general George Rogers Clark wrested the Illinois Country from British control. Virginia claimed the territory after the war, and it was under Virginian control until 1784. Although the British and Americans were accustomed to English common law, both sought to preserve French customs. Virginia law stated that civil officers must "conduct themselves agreeable as much as possible to the laws, which the present settlers are now accustomed to" but that they were allowed to pardon persons found guilty under these laws except in cases of murder or treason.[51] Article 27 of the Black Code of Louisiana prescribed the death penalty for "[t]he slave who strikes his master, his mistress, the mistress' husband or their children, and causes bruising or blood to flow, or strikes the face." Likewise, Article 28 provided, "[A]s to the excesses and acts of violence which slaves commit against free persons, we wish that they be severely punished, even by death if it is necessary."[52]

When in 1779 a court of French judges sentenced two slaves, Moreau and Manuel, to be burned at the stake on the shore of the Kaskaskia River, Lieutenant Commandant of the County of Illinois John Todd exercised his authority and commuted their sentences to hanging. For more than a

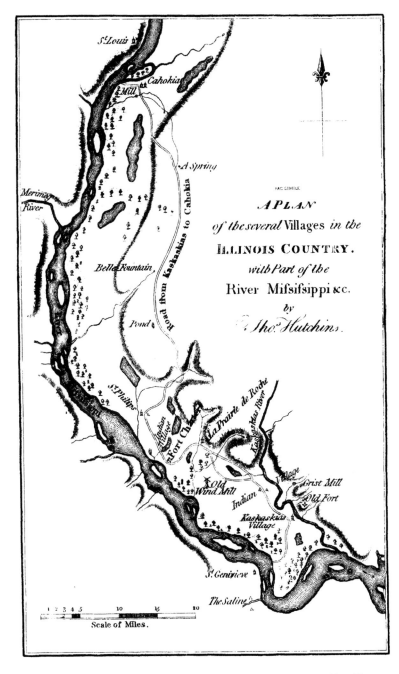

A map of several villages in the Illinois Country by Thomas Hutchins. *From The Conspiracy of Pontiac and the Indian War after the Conquest of Canada, Vol. 1, 1851 by Francis Parkman.*

century, the deaths of these two slaves were considered to be the first and only legal executions for witchcraft in the history of Illinois. The truth is more complicated.

The Execution of Moreau and Manuel

In June 1779, Captain Nicholas Janis and a small detail of the First Company, Kaskaskia Militia executed two slaves of Afro-Caribbean descent named Moreau and Manuel for the crimes of murder and conspiring to commit murder. When the court of Kaskaskia convicted Moreau and Manuel, it ordered they be disposed of in a "manner of execution which cannot be too cruel for criminals who have committed deeds so extraordinarily horrible and frightful." French magistrates who presided over their case ordered at least one slave, Manuel, be burned at the stake on the shore of the Kaskaskia River and his ashes scattered. The colonial military authorities, however, remitted that sentence to a more merciful death by hanging. Over the intervening century, the execution of these two slaves became more myth than reality, and a legend sprouted that the superstitious French executed Moreau and Manuel for witchcraft.

Not much is known about Moreau and Manuel. They once belonged to a Frenchman named Charles Marois, whose estate was settled on December 14, 1778. A man named LeComte purchased Moreau (Moreaux) for sixteen livres and five sols, and a man named Beaulieu purchased Manuel for seven livres.[53] The next time Moreau and Manuel appeared in records, they were on trial for a series of deadly poisonings.

The original record of their trial, written in French, went unpublished in English until 1907, leaving the events up to wild speculation. Repeating hearsay, in his *Pioneer History of Illinois* (1852), former governor and congressman John Reynolds asserted that Moreau and Manuel had been executed for witchcraft. He wrote:

> *In Cahokia, about 1790, this superstition got the upper hand of reason, and several poor African slaves were immolated at the shrine of ignorance for this imaginary offence. An African negro, called Moreau, was hung for this crime on a tree not far southeast of Cahokia. It is stated that he had said, "he poisoned his master, but his mistress was too strong for his necromancy." Another slave, Emanuel, was shot in Cahokia for this crime.*[54]

In 1800, when Reynolds was twelve years old, his family moved from Tennessee to Kaskaskia, Illinois. Later, he set up a legal practice in Cahokia, where he undoubtedly heard secondhand accounts of the executions. Alexander Davidson and Bernard Stuvé copied Reynolds's account of the incident in their *Complete History of Illinois* (1877).

Historian John H. Gunn, who was born "within a day's journey of Old Fort Chartres," also grew up hearing the story of "the burning of the witch at 'old Kaskia.'"[55] When Edward G. Mason first published Colonel John Todd's *Record Book* in 1881, which contained a reference to the warrant of execution for Manuel, Gunn believed he had finally found historical proof of the witch executions. In 1885, he published this assertion under the title "Witchcraft in Illinois" in the *Magazine of American History*. Theodore Roosevelt, in his multivolume history (published before he was elected president) *The Winning of the West* (1889), also accepted that interpretation of events at face value. "It seems a strange thing that, in the United States, three years after the declaration of independence, men should have been burnt and hung for witchcraft, in accordance with the laws, and with the decision of the proper court," he noted. "The fact that the victim, before being burned, was forced to make 'honorable fine' at the door of the Catholic church, shows that the priest at least acquiesced in the decision."[56] When the Illinois State Historical Library finally published an English translation of the deposition from Moreau and Manuel's trial in 1907, it went generally unnoticed.

The truth about Moreau and Manuel's trial and execution is stranger than fiction. Guilty of murdering several people in the community, Manuel provided the poisons that Moreau administered to their victims. While the historical record does not say they were executed for witchcraft, it is reasonable to assume that at least some of their contemporaries believed they were practicing maleficium. Elements appearing in the Moreau and Manuel trial depositions, such as a horn of boiling blood and the act of burying an object under the threshold of the door, were reminiscent of nascent voodoo or hoodoo practices, as was the power to poison. Folklorist Harry Middleton Hyatt collected dozens of accounts of the African American folk magic of hoodoo in Adams County, Illinois. On the power to poison, one man (simply identified as *Negro*) told Hyatt, "If a hoodoo person wants to show you something, let them put their own hand on it. You keep yours off, for they can poison you like that."[57]

Moreau referred to Manuel as his "chef de la medicine," or "medicine chief," a curious name for someone who concocted poisons. The term "medicine chief," however, could also refer to American Indian medicine

men, individuals who were believed to possess supernatural powers. In the context of North American Indians, the Oxford English Dictionary explains that "medicine" refers to "magical power, esp. for healing or protection; an object or practice thought to possess or convey this; a spell, charm, or fetish." Living in the Illinois Country in the late eighteenth century, both Moreau and Manuel, as well as their French contemporaries, would have been familiar with these terms. On several occasions in the depositions, the terms "poison" and "medicine" were used interchangeably. One man, upon being poisoned, begged Moreau to "take away the sickness," as though he believed Moreau had the power to poison and heal at will. When viewed in this context, later rumors that Moreau and Manuel were executed for witchcraft do not seem unreasonable or farfetched.

In *Black Magic: Religion and the African American Conjuring Tradition* (2006), Yvonne Patricia Chireau argued that enslaved blacks utilized a belief in supernatural harm, particularly poisoning, as an act of personal defiance against their oppressors. Many African Americans interpreted poisoning as a mysterious deadly force, wrapped in an aura of supernatural power. "Although technically distinguishable from harming practices that operated solely by supernatural agency, the secretive nature of poisoning, and its tendency to inflict sudden, inexplicable illness and death, led many persons to connect them," she argued. "Negro doctors" or "conjurers" were frequently identified as responsible for creating and administering poisons. In the eighteenth century, there were hundreds of prosecutions for poisoning among slaves throughout the South. According to Chireau, in Virginia between 1740 and 1785, poisoning was second only to theft among crimes for which slaves stood trial. South Carolina's 1751 Negro Act prescribed the death penalty for any slave who instructed another slave "in the knowledge of any poisonous root, plant, herb, or other poison." As the Moreau and Manuel case demonstrated, however, African American slaves were just as likely to poison their fellow bondsmen as they were their white masters.[58]

On the evening of Thursday, June 10, 1779, clerk of the Cahokia Court, Father Saucier, took depositions on the case of Moreau and Manuel at the home of Brevet Saucier. Also present that night were President of the Court Pierre Godin, François Trottier, Charles Gratiot, Brevet Saucier, Antoine Girardin and Michel Beaulieu. The following is a complete English transcript of that testimony:

> *Catherine, a negress belonging to Bte. Saucier, after having been summoned and examined, said that last year her husband had asked of his master permission*

to walk to Kaskaskia and when Manuel and Moreau, negroes belonging to MM. [Monsieurs] LeComte and Beaulieu, knew that he was going, they brought him a pint of tafia [a cheap rum] saying that it was for his journey; and that he had no sooner drunk of that liquor than he felt sick and that he is still sick up to the present; and that the day on which the said negroes were arrested on the accusation of having poisoned several persons, these same negroes confessed to her that they had poisoned her husband; she declares that the named Moreau told her that Manuel, when he gave him the medicine, wished to make her husband die suddenly, but that he had answered that it was better to make him die slowly; and she said that since that time her husband has been pining. The said negress declares also that Moreau had said to her that Manuel positively wished to poison M. [Monsieur] Martin and his wife and that the negress of the said gentleman was in this plot; and that another negro named Guanga belonging to the said M. Martin, having had news of this, had said to them that if they didn't take away the poison, which they had thrown into his master's house, he would denounce them, which caused them to dig up a poison which they had buried under the threshold of the door.

Paul, a negro belonging to Madame Lapance, after being summoned and examined, said that he had heard all the negroes, who have already given their testimony, say that the named Manuel and Moreau had poisoned all the persons mentioned in the declaration which has already been made by them. The named Sasa, a negro belonging to Mademoiselle Buyat, after being summoned and examined, said that he was in the cottage of M. Martin to ask for a pipefull of tobacco from his negress, named Janette, and that she had told him to go to the head of her bed and he would find some, and that when he looked he had found a horn in which there was boiling blood; and as he was surprised, he had asked the negress what it was; that the negress told him not to touch that, and that it was Manuel who had given it to her to put her master and mistress to death; and that Moreau, when he knew that, had said to her: "What! Can you keep a thing like that in your house? Do you not know that it was this horn that Manuel used to poison Monsieur and Madame Nicolle?" He declares furthermore that a negro, named Samba belonging to M. Quenel, took this horn and had shown it to Moreau and that he said that it was the same horn that Manuel had given him to put to death Monsieur and Madame Nicolle.[59]

According to Catherine and Paul's testimony, Moreau and Manuel poisoned her husband and conspired to poison Monsieur Martin and his

wife. Janette, Monsieur Martin's slave, was apparently in on the plot and had kept a "horn" of "boiling blood" in her bedroom. That same concoction had allegedly been used to poison Monsieur and Madame Nicolle at the behest of their unnamed slaves. According to a slave named François, whose cross-examination appears below, Moreau also poisoned a male slave belonging to Monsieur Laurant of St. Louis in a fit of jealousy, as both had been romantically involved with Janette. (The French text used the word *commerce*, which was translated into English as "intercourse.")

Fr. Saucier, Clerk. First cross-examination of the negro called François belonging to M. Jaquet. After having been summoned and examined, he said that the negro, named Moreau, had told him in conversation that he had made the negro of M. Laurant of St. Louis, sick on account of the negress of M. Martin, named Janette, since both had some intercourse with her, and that this was the reason he had given him poison. The said negro declares, also, that as soon as the negro of M. Laurant felt sick and he surely knew that he was poisoned, he came to find the said Moreau and said to him: "My countryman, take away the sickness which you have given me," to which the said Moreau answered that, it was too late "It is not in my power to take it from you"; and that the negro of M. Laurant said again that if he would cure him he would pay him well, to which the said Moreau answered that he could not do it; but, nevertheless, the negro of M. Laurant in going away left him a basin and a handkerchief and promised him that if he did not die he would satisfy him more fully.

At another cross-examination, the said negro of M. Jaquet declares that, shortly after the negro of M. Laurant had been sent across the river, he died; and that he had reproached the two negroes suspected of poisoning and said to them: "What! There is another negro dead, whom they say you have poisoned"; to which Moreau replied that if he had done it, he was not alone, for it was Manuel who was the medicine-chief and had furnished him poison whenever he had need of it.

The said negro declares also, that Moreau had asked some favor of M. Nicolle's negress and promised her that if she granted it to him, he would give her medicine to make her mistress gentle, as she complained to him that the latter was very bad, and he gave some likewise to the husband of the said negress for his master; and that after the death of the late M. Nicolle and his wife, Moreau demanded what had been promised to him, and the negress did not particularly wish to grant him what she had promised; and for this reason the said Moreau poisoned her and she died therefrom.

The said negro said also that when the said negress of the late M. Nicolle fell sick, several negroes of the country of the said negress went to find Moreau to beseech him to cure the said negress; to which the said Moreau answered that it was no longer in his power to take from her that which he had given her. Cupidon, a negro belonging to Bte. Saucier, after being summoned and cross-examined, declared that, when M. and Madame Nicolle were dead, the named Moreau said to their negress: "You ought to be content now. There are your master and mistress dead and you can take a walk and go where you wish"; to which the husband of the said negress of the said M. Nicolle, answered: "We did not ask you to make them die. We wished only that you make them a little gentler"; and that Moreau asked the negress to grant him what she had promised and the negress replied to him that he was too old and that she did not wish to; that the said Moreau said: "You find me too old, and well shall you repent of it"; and that shortly after he poisoned the negress according to the declaration of the said negro.

These depositions made by the negroes aforesaid were made in the presence of MM. Trottier, Touranjeau, Beaulieu, Martin, and Bte. Saucier, who have said that the depositions were made by the said negroes aforenamed, and that it was their opinion, after having heard it said by divers negroes, that this said Manuel and Moreau had done that of which they were accused, and that they should be found truly guilty. At Cahokia June 10, 1779, at eight p. m., in the house of Bte. Saucier.[60]

According to François and Cupidon, Monsieur and Madame Nicolle apparently treated their slaves poorly, so two of their slaves—a husband and wife—approached Moreau for a poison to "make their mistress gentle." In exchange, the wife allegedly agreed to sleep with Moreau. Moreau, however, gave Monsieur and Madame Nicolle a deadly dose of poison. When he came to collect, the unnamed female slave refused to sleep with him, so he poisoned her as well. While she was dying, neighbors went to Moreau and begged him to cure her, but as in the previous case of poisoning, he claimed it was no longer in his power to do so. Other than the poisoned rum Moreau and Manuel gave the slave traveling to Kaskaskia, the depositions do not make clear how Moreau was able to administer the poison to his other victims. Moreau must have been able to get in close contact with their food or drink or gave them poison disguised as a gift.

The arraignment by the state's attorney suggested Moreau and Manuel were accused of poisoning soldiers of the garrison in addition to Monsieur and Madame Nicolle and several fellow slaves. If the Black Code of Louisiana

prescribed the death penalty for "the slave who strikes his master, his mistress, the mistress' husband or their children, and causes bruising or blood to flow, or strikes the face," the French judges must have considered Moreau and Manuel's poisoning spree to be an atrocity worthy of the harshest punishment. Upon reviewing the evidence, Jean Girault, state's attorney of Virginia for the district of Kaskaskia, counseled the court to dispose of them in a "manner of execution which cannot be too cruel for criminals who have committed deeds so extraordinarily horrible and frightful." Girault's arraignment was as follows:

> *I, State's Attorney of Virginia, for the District of Kaskaskia, hereunder signed, have the honor to set forth to the honorable Court of Kaskaskia that from the testimony of different negroes of Cahokia it appears that the negroes, Moreau and Manuel, are really guilty of the horrible crime of which they are accused; and that from all the declarations and testimonies it appears that the negro Moreau is more guilty than the other, since he has administered the poison which the other had given him. From which poisons several of the good subjects of this Republic and soldiers of the garrison have died.*
>
> *This is the reason why in the name of the State I think, gentlemen, that if you find the said negoes guilty, you should pronounce their sentence of death, and name the day thereof and the manner of execution which cannot be too cruel for criminals who have committed deeds so extraordinarily horrible and frightful. At Kaskaskia, June 12, 1779. J. [Jean] Girault.*[61]

At first, recently appointed lieutenant commandant of the county of Illinois Colonel John Todd went along with the court's decision to inflict a particularly harsh punishment. He wrote to the sheriff of the district of Kaskaskia, Richard Winston:

> *Negro Manuel, a Slave, in your Custody, is condemned by the Court of Kaskaskia, after having made honorable Fine at the Door of the Church, to be chained to a post at the water side & there to be burnt alive, & his ashes scattered, as appears to me by Record. This Sentence you are hereby required to put in Execution on Tuesday next, at 9 o'clock in the morning; and this shall be your Warrant. Given under my hand & seal at Kaskaskia, the 13th day of June, in the third year of the Commonwealth.*[62]

The next day, Colonel John Todd drew heavy black lines through that order and issued a new warrant. It read:

You are hereby authorized & required between the Hours of nine & Eleven in the morning of the Sixteenth of this Instant to cause to be executed Manuel a Slave in your Custody by being hung by the neck untill he be dead. & this shall be your Warrant. Given under my hand & seal the 14th day of June 1779.[63]

On June 15, he wrote to Captain Nicholas Janis:

You are hereby required to call upon a partey of your Militia to guard Morace, a Slave condemned to execution, up to the Town of Kohos. Put them under an Officer they shall be intitled pay, Rashtions, & Refreshment dureing the Time they shall be upon Duty, to be certifyed hereafter by you....I recommend 4 or 5 from your Compy & as many from Capt. Placey's, and consult Mr. Lacroix about the Time necessary.[64]

Colonel John Todd's decision to efface the original death sentence and replace it with a less horrific method of execution has been controversial. Under the assumption that Moreau and Manuel were falsely accused of witchcraft (after all, an "imaginary crime"), historians E.G. Mason and John H. Gunn both believed Colonel Todd's second order proved that although he could not legally pardon either Moreau or Manuel, he commuted at least one of their sentences to a more merciful death by noose or bullet—as legend had long maintained—and dispatched the militia company to carry out the sentence and guard the prisoner from any extralegal actions.[65] We now know, however, Moreau and Manuel's crimes were real and resulted in the deaths of at least four victims. Why, then, did Colonel Todd commute Manuel's sentence? Was it because he provided—but did not administer—the poison, or was it because, as nineteenth-century historians argued, Colonel Todd was simply more enlightened than his French contemporaries?

If French judges did interpret Moreau and Manuel's crimes in a supernatural context, as nineteenth-century historians alleged, Colonel Todd may have been hesitant to validate their beliefs by consenting to execution by burning. He may have also sought to avoid a witch panic in the already volatile climate of slave poisonings and a military occupation. Furthermore, British (and by extension, its colonies) culture and government had become ambivalent toward witch burnings. The *Act Against Conjuration, Witchcraft and Dealing with Evil and Wicked Spirits* (1604) of King James I made witchcraft a civil crime and banned burning at the stake as a punishment except in cases of petty treason. The Witchcraft Act of 1735 superseded all other laws

concerning witchcraft in Great Britain and no longer treated witchcraft as a real crime. Instead, it punished the *pretense* of witchcraft, fortunetelling and other alleged supernatural powers with fines and jail time.[66] Furthermore, Article Nine of the Virginia Declaration of Rights, adopted unanimously in 1776, banned cruel and unusual punishments. As a child of the Anglo-American Enlightenment, Colonel Todd may have recoiled at the prospect of inflicting such a medieval punishment.

In the following decades, the execution of Moreau and Manuel, as John H. Gunn remarked, quickly became one of the "weird and wild stories of the French and Indians for winter-night entertainment."[67] But it was not the last time a fascination with witchcraft appeared on the prairie. As Anglo-Americans began migrating to Illinois from the southern states in the nineteenth century, they brought their own set of witch beliefs—beliefs that persisted for generations.

Witchcraft in Illinois

1818–1885

The end of the Revolutionary War opened the vast Northwest Territory to settlement, and Scotch-Irish pioneers began to cross the Appalachian Mountains and travel down the Ohio River looking for new land. Many settled in the bottomlands between the Ohio and Mississippi Rivers in what would become southern Illinois. Following close behind, Yankees from New England spread out across northern Illinois and down the Illinois River Valley.[68] Rapid growth transformed the state from a sparsely populated wilderness to a thriving agricultural region. Between 1800 and 1840, Illinois's population grew from 2,458 to 476,183 residents.

Southern Illinois was called "Egypt" or "Little Egypt" for its proximity to a vital river trade route (like the Nile delta in Egypt) and the presence of towns with names like Cairo, Thebes, Dongola and Karnak. New Englanders who immigrated to Illinois in the early half of the nineteenth century also called it "Dark Egypt." They viewed the Scotch-Irish pioneers who preceded them as uneducated, boorish and backward. For their part, the Scotch-Irish, who migrated from Virginia, Kentucky and the Carolinas, viewed these Yankees, in the colorful words of one historian, as "a skinning, tricky, penurious race of peddlers, filling the country with tinware, brass clocks, and wooden nutmegs."[69]

According to cultural historian David Hackett Fischer, Scotch-Irish pioneers were obsessed with magic and sorcery, and they brought those beliefs with them into Illinois. One early account of witchcraft in Little Egypt comes from

A map of the Northwest Territory in 1787, showing European forts and settlements and indigenous tribes. *From* A History of the United States *by Charles Kendall Adams.*

the *History of Williamson County Illinois* (1876). "From 1818 to 1835," its author claimed, "there were a great many witches in this county."[70] On a place called Davis' Prairie (also known as David's Prairie), there lived a woman named Eva Locker, who was widely reputed to be a witch. Her exploits were so well known they have been noted in nearly every early chronicle of the area's folklore. Eva was notorious for her ability to steal milk from cows by hanging a towel over a rack or door and then, magically, wringing out the milk from the towel. Many decades later, a Belleville resident named Henry Juenger Sr. explained the process to Esther Knefelkamp, who related it to folklorist Charles Neely in the 1930s. According to Knefelkamp, "This old lady had several towels hanging on her back porch. With a towel hanging before her, she would milk the neighbors' cows from the lower two corners; when she was finished she would have several large foaming buckets of wholesome milk."[71]

Local pioneers blamed this old spinster for maladies of all kinds. "She could do wonders, and inflict horrible spells on the young, such as fits,

An 1818 map of Illinois by John Melish. *Library of Congress, Prints and Photographs Division, Washington, D.C.*

twitches, jerks and such like; and many an old lady took the rickets at the mere sound of her name," Milo Erwin, author of the *History of Williamson County, Illinois*, wrote.[72] According to folklorist John W. Allen, Eva had the

Like many pioneers, Abraham Lincoln's family lived in a modest log cabin after migrating to Illinois in 1830. *Boston, Joseph Ward, 1865. Library of Congress, Prints and Photographs Division, Washington, D.C.*

ability to kill cattle by shooting them with balls of hair, which were found in the stomachs of the afflicted animals.[73]

When Eva Locker struck, the men of Williamson County sent for Charley (Charlie) Lee, a noted "witch master" from Hamilton County who broke Eva's spells by piercing an effigy of her with silver bullets. Erwin wrote, "It was a nice sight to see this old fool set up his board and then measure, point and cipher around like an artillery man planting his battery, while the whole family were standing around veiled and with the solemnity and anxiety of a funeral." Where supernatural misfortune was concerned, only a supernatural solution would do. There were no shortage of these "wizards" to unhex what had been hexed, but Eva Locker, it was said, proved to be more powerful than most could handle.[74]

When Illinois went through a succession of administrative changes between 1809 and 1859 (the last time a new county was established) witch beliefs continued to proliferate in the same places it had for a generation. The *History of Williamson County Illinois* tells us "witchcraft prevailed to a great extent in the east side of this county in an early day,"[75] so when Franklin County split from Williamson in 1839, these witch beliefs remained.

The curious case of the Williams sisters, which occurred there over thirty-five years after Eva Locker put away her cattle-killing hairballs, is further evidence that these beliefs did not simply vanish, as Milo Erwin maintained, but stubbornly persisted even after the Civil War.

THE WILLIAMS SISTERS

The year was 1871. Buds of corn and tobacco poked out of the fields in rural Franklin County near the small town of Frankfort while the Big Muddy River coiled its way through the ample timberland. First settled by migrants from Kentucky and Tennessee between 1804 and 1810, Franklin County lay at the heart of Little Egypt and retained much of its Southern character. Frankfort (now known as West Frankfort) derived its name from "Frank's Fort," built in 1811, during Tecumseh's War, to protect the white settlers from attack by the Shawnee.[76] In 1871, the entire county had a population of no more than 12,700 residents.

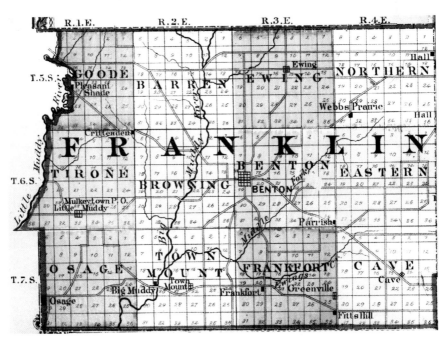

An 1870 map of Franklin County, Illinois. Note the locations of Frankfort (later renamed West Frankfort) and Fitts Hill. *From the* Atlas of Illinois *by Warner & Beers.*

On a farmstead around eight miles outside Frankfort, the Williams sisters, sixteen and eighteen years old, went about their chores. They were petite and pleasant, shy but willing to engage in polite conversation with passersby on the old Shawnee Trail. As the last rays of sunlight disappeared over the horizon, a small crowd began to gather outside the Williams home. After supper, the girls jumped to their feet and together raced north barefoot through the newly planted corn. After a short time, the two girls returned to their home and, with almost supernatural ability, climbed to the roof and began dancing along its precarious edge. Their father, James Williams, in front of around fifty spectators, pleaded with his daughters to come down. They replied with animal-like shrieks and groans. Then, in unison, the two sisters began to convulse before falling limp on the rooftop like marionettes cut from their strings. An electric enthusiasm shot through the crowd, and those in the back pushed forward to get a better view. After a few moments, the sisters rose and began their strange dance once again.

News of the spectacle quickly spread to neighboring counties as the Williams sisters repeated their strange behavior night after night. On June 30, the *New York Times* picked up the story and reprinted an article about the girls that appeared in a local Illinois newspaper. "WITCHCRAFT IN ILLINOIS," the headline read. "Strange Performances in Franklin County—A Couple of Frisky Young Females." Before long, the story spread to newspapers in Kansas, Indiana, Wisconsin, Tennessee and even San Francisco, California. The correspondent described the scene:

> *Some fifty or a hundred persons are there every night, and they say it is quite entertaining to witness* [the sisters'] *performances. They are perfectly sane during the day, but at the approach of night they become frenzied and uncontrollable, performing feats that the best acrobats could hardly perform. Scaling the house, they dance upon the comb of the building, apparently with perfect ease and impunity, uttering, at the same time, the most hideous and frenzied screams....You can imagine the excitement when I tell you that, since I began to write, nearly fifty people have passed through our little village on their way to see the girls.[77]*

An eyewitness quoted by the *Chicago Tribune* described the girls' acrobat act, but, he said, rather than uttering screams while dancing on the roof, the sisters sang "beautiful songs." Upon lying down on the comb of the roof, the sisters "glide down on its edge and swing off, holding by their teeth to the comb, then suspending themselves in the air, throw themselves back again

The Alton Telegraph

FRIDAY MORNING, JUNE 30, 1871.

ALTON WEEKLY TELEGRAPH

PUBLISHED EVERY FRIDAY,
AT THE
TELEGRAPH BUILDING
FOURTH ST., ALTON, ILL.

TERMS:

Single copy, one year, - - - $1 50
In clubs of ten or more, one year, each, 1 25

L. A. Parks & Co.,
ALTON, ILLS.

L. A. Parks, C. Holden, W. T. Norton.

Rebels on the Situation.

The New York Herald says: "Alexander H. Stephens, Linton Stephens, Toombs, Wade Hampton, and all the recognized leaders of the Democracy of the Cotton States, have repeatedly expressed, and very lately, too, the precise opinions of Davis on the situation. They do not accept it; they will not consent to the validity of these new amendments, and they have been counting upon the Northern Democracy to hold fast to their Tammany National Platform of 1868, in still declaring the whole reconstruction system of Congress unconstitutional, revolutionary, null and void.

Extra Session of the Legislature.

The Springfield correspondent of the Missouri Republican, in a recent letter remarks, that "the first and extra sessions of the Legislature have consumed a period of five and a half months; the longest held in this State, and probably ever held in this country. It was really a very long

Witchcraft in Illinois.

A recent dispatch says, the town of Frankfort, Perry county, Illinois, is greatly excited over what the citizens regard as a clear case of witchcraft, recently developed in the vicinity of that town. Two young ladies, daughters of Jas. Williams, are the victims. It has been thought by neighbors for some time that something was wrong with the girls, and a few days since a physician was called to visit them. He failed to discover the difficulty. Since that time immense crowds have visited the girls, averaging from fifty to one hundred each night. They are perfectly sane during the day but at the approach of night, they become frenzied and uncontrollable, performing feats that would put first class acrobats to shame. Scaling the house, they will dance and "gyrate" on the comb of the roof with perfect ease and impunity, uttering at the same time the most hideous and frenzied screams. Very frequently while performing such feats they fall perfectly rigid with spasms, but never fall off however near the eaves they may be. During the day, at which time they are perfectly sane, they seem modest and reserved. The spell comes on both at nearly the same time, generally during the twilight, when they both break into a run. They always run north in the direction of the house of an old lady who they say has bewitched them. These spells are put upon them, they say, on account of their telling something that she forbade them, and that she and a cat are with them on their house-top dances. Their conversation, when laboring under these spells, is in an unknown tongue. They catch and eat all the flies they can get hold of, until nausea is produced, when they both vomit at the same time. What one does the other does at the same time, and they seem to be moved by one controlling power.

"Witchcraft in Illinois." *From the* Alton Telegraph, *June 30, 1871.*

on the roof, pass over the gable end, go through a small opening 10 by 12 inches into the garret, with as much ease and rapidity of a squirrel."[78] The Williams sisters must have been thin to fit through a window with an area less than a square foot, but while their feats were certainly incredible, they were not physically impossible.

Two months after their nighttime activities began, their understandably frustrated father sought the aid of a local doctor, who was at a loss for a treatment. Until that time, the *New York Times* correspondent informed his readers, neighbors attributed the girls' behavior to insanity, but after medical science failed to provide an answer, they began to suspect something supernatural was at work.

The strange behavior of the Williams sisters was not confined to rooftop dances. They conversed with each other in a language only they could understand, and they appeared to act in unison without conscious effort. The sisters were also said to catch and eat flies until they vomited. Their explanation for their activities proved to be just as bizarre. The sisters claimed to have been bewitched by an old woman who lived nearby in retribution for having refused to become witches themselves.

On a pleasant afternoon not long before their nightly performances began, one sister met the old woman on the road and touched fingers with her. The sister was immediately lifted up onto the old woman's saddle, and the woman, according to the *Tribune*, "carried her to her house in the country, where many beautifully-dressed women were congregated, and invited her to 'give her (the Williams girl's) soul to the Devil,' after which she would become a witch in good standing, with the power to bewitch whomever she pleased." After the Williams girl declined her invitation, the old woman became enraged and magically transported her back to her father's farm. The crone then used magic to control both sisters, forced them to eat pins and flies and accompanied them (in spirit) on their rooftop dances.[79]

Children suffering fits, convulsions and vomiting objects like pins and needles was an old witch trope dating back to seventeenth-century England. Between 1645 and 1647, the children of a man named George Muschamp allegedly suffered at the hands of a trio of witches in Northumberland, a county that bordered Scotland. Their affliction was recounted in the pamphlet *Wonderfull News from the North: or, A True Relation of the Sad and Grievous Torments, Inflicted upon the Bodies of Three Children of Mr. George Muschamp, Late of the County of Northumberland, by WitchCcraft* (1650). The author, Mary Moore, took great pains to establish that "many people of great Ranke and Quality" attested to the truth of her story. It began in early August 1645,

when Margaret Muschamp fell into a trance and claimed to have a divinely inspired vision. After several months, Margaret's condition worsened. On February 1 (Candlemas Eve), "[S]he was suddainely striken with a great deale of torment, called for a little beere, but ere they could come with it, the use of her tongue was gone, with all her limbs, pressing to vomit, and such torments, that no eyes could looke on her without compassion."

The fits continued for sixteen weeks and subsided during the evening but always returned the next morning. Ministers came by her bedside to pray, and physicians examined her, but nothing seemed to alleviate her condition. Strangely, "as soone as these torments were over, the child would instantly smile, and make signes she felt no paine at all." As in the case of the Williams sisters, the family first sought help from a physician. When he could offer no relief, they began to suspect something supernatural was at work.

The following winter, two days after Christmas, the extraordinary affliction seized Margaret's eldest brother as he lay in bed. According to eyewitnesses, "The next morning he was a little eased of his extremity and pain, but both his stomack and the use of his legs taken from him, so that he was forced to have help to put on his cloathes, was lifted into a chaire where he sat all day long, but could neither eate nor drinke any thing, but a little milke or water, or sowre milke." A few weeks later, Margaret began to experience nightly battles with some unseen attacker. She used her hands and bedclothes to shield herself from its blows and later described the thing as various animals, some real and some imaginary. "Sometimes he would fight with her in the shape of a Dragon, of a Bear, a Horse, or Cow."

After a time, the Muschamps and several neighbors visited a man named John Hutton, who "was one it was suspected that could do more then God allowed." Hutton was a prototypical witch master, like those later found on the Illinois prairie. He told them that a woman named Dorothy Swinow was the origin of their children's torment and two drops of his blood would release their daughter from the spell. When the party returned home, Margaret declared that her life had been saved and that two angels had revealed that John Hutton (who later died in prison) and Dorothy Swinow were her tormentors. No sooner had the family breathed a sigh of relief than the girl "fell into a terrible fit; saying, Dorothy Swinow with two Witches more were come to torment her worse then ever Hutton did, and the one was a yong [sic] woman, and the other an old: So that till they had Justice of Dorothy Swinow, her mother and they should never be at peace." Margaret's mother sought out a justice of the peace to apprehend Hutton and Swinow, but since she couldn't find one who took her accusations seriously, she was

convinced that the witches had "hardened [the justice's] hearts" against her. Soon, both Margaret and her sister were seized by fits, this time vomiting stones and pins.

At long last, a woman named Margaret White confessed that Dorothy Swinow and her sister Jane Martin "were in the Divels company" and that they "came purposely to the house of Mr. Edward Moore of Spittle, to take away the life of Margaret Muschamp and Mary, and they were the cause of the Childrens tormenting." Furthermore, she confessed, "she hath beene the Divels servant these five years past, and that the Divell came to her in the likeness of a man in blew cloaths, in her owne house, and griped her fast by the hand, and told her she should never want, and gave her a nip on the shoulder, and another on her back; And…her Familiar came to her in the likenesse of a black Grey-hound, and that the Divell had carnall knowledge of her in her owne house two several times."

Her confession was heard by Justice John Sleigh and recorded by Robert Scot, clerk of Barwick. On April 24, 1650, a jury indicted Dorothy Swinow for "*Witchcrafts, Enchantments, Charmes,* and *Sorceries,* and especially for using and practicing the sayd Diabolicall Arts upon *Sibilla Moore* an Infant and Child of Mrs. *Mary Moore.*" The pamphlet contained a thorough account of the suffering of the children, a statement made by Margaret Muschamp when she was in her last extreme fit (which seemed incredibly coherent and detailed), the confession of Margaret White and a warrant for the arrest of Dorothy Swinow, all signed and attested to by several witnesses. In the case of the Williams sisters, however, the old woman they accused of tormenting them remained anonymous, and no one came forward to accept the blame.

The facts behind the Williams sisters' case are difficult to confirm. Williams was a common surname in southern Illinois, but there are no records of a James Williams living in Franklin County in 1871 with daughters of comparable age. According to the 1870 census, however, there was a woman named Elva Williams living in Benton Township (north of Frankfort) who had six children. Two of her daughters, Mary J. and Susan M., were eighteen and sixteen years old at the time of the census, the same age as the two girls in the newspaper articles. Mary and Susan, as well as their mother, were born in Tennessee. Elva's other four children were born in Illinois (the youngest was three months old), but the census does not list a husband.[80] The *Chicago Tribune* mistakenly claimed that James Williams and his family lived in Perry County, which borders Franklin to the west, near a place called Fitts' Hill. In actuality, Fitts' Hill, a former post office and site of a general store, was located in Franklin County in Frankfort Township.[81]

Regardless, there are several James Williams in the 1860 Perry County census, but the oldest would have been twenty-eight in 1871—too young to have an eighteen-year-old daughter.[82]

Were the fantastical activities of the Williams sisters real, or were they born in the mind of some creative newspaper editor? Without any record of a "James Williams," who is explicitly mentioned in the article as the father of the bewitched girls, it is nearly impossible to determine, but that the events were widely reported in several newspapers with such detail does lend some credibility to the story. According to editors at the *Nashville Union and American*, most Franklin County residents had "come to the conclusion that it is an imposture of the young ladies themselves, or that their freaks are the result of drugs administered to them by some evil-disposed person or person[s]."[83]

The Williams sisters case showed that some local residents were willing to entertain their old superstitions when they encountered something that seemed incredible. Their belief in witchcraft had not quite been discontinued, as the author of the *History of Williamson County* maintained, and the Williams sisters were able to reach back into a long tradition in order to construct their story about how they came to be "bewitched."

THE STRANGE CASE OF JAMES SPIVA

Not all migrants from the South settled in southern Illinois. Many came to what was known as the Illinois Military Tract of 1812. The Illinois tract was surveyed in 1815 and roughly constituted the area between the Mississippi and Illinois Rivers. The federal government, mimicking a practice of the ancient Roman Republic, set that land aside for veterans at 160 acres a man. Much of it was sold to speculators and not settled until the 1830s. From this region came the bizarre story of Elizabeth Friend and the Spiva brothers, James and William, who believed Elizabeth was a witch. Despite Elizabeth actually dying of natural causes, James confessed to her murder and was nearly hanged for the offense.

The origin of this unusual tale is rooted in the genealogy of James and William Spiva. As the *New York Times* explained, "[James] Spiva's forefathers came from the Carolinas at a time when belief in witchcraft was strong, and they brought their superstitions with them into what was then the Western wilderness."[84] The Carolinas were created as a consequence of the English Civil War (1641–51) when, after the monarchy was restored, King Charles

II sought to reward his supporters with land in the New World. In 1663, he carved the Province of Carolina from the Colony of Virginia and gave it to eight supporters, known as the Lords Proprietor, headed by Lord Anthony Ashley-Cooper. Not long after, the Lords Proprietor divided Carolina into north and south.

North Carolina, home of the Spiva family before they came to Illinois, was a harsh tangle of swamps and forests. The Scotch-Irish who settled in this new colony were looked on as "a lazy and immoral set of runaway servants, debtors, thieves, and pirates." According to historian T. Harry Williams, et al., "They had practically no towns, churches, or schools, few roads or large plantations, and more than their share of trouble from both rebellious whites and resentful Indians."[85] Virginians viewed their neighbors to the south much the same way as Yankees in Illinois did their neighbors in Little Egypt.

As men and women from both North and South moved west toward the Mississippi River and beyond, they took their folkways with them. In the 1830s, when the Friends and Spivas settled in Illinois in McDonough and Schuyler Counties, Americans on either side of the Mason-Dixon line had already developed their own distinct and competing interests, habits, values and even ways of speaking. Although Illinois's southern pioneers were by all accounts generous and hospitable, they mistrusted their northern brethren. In his *History of McDonough County* (1878), S.J. Clarke explained, "[T]here was one peculiar trait about these early settlers of the county—they had a strong prejudice against the Yankees, and hated them with a 'righteous hatred.' All persons born in the Eastern and New England States were Yankees in their estimation."[86]

After the first white settlers arrived in the area in 1826, McDonough County was carved out of Pike County and named after Commodore Thomas McDonough, who commanded a naval flotilla on Lake Champlain during the War of 1812. Up until the early 1830s, there were still a number of American Indians from the Sac and Fox tribes in western Illinois, and they frequently traded with the pioneers. Among those early pioneers were William Spiva (also spelled Spivey or Spivy), who married Phebe Van Winkle in Schuyler County in August 1830, and James H. Spiva, who married Rheumay (spelled Rhenansy in the marriage record) Friend on October 9, 1831.[87] In the summer of 1835, Charles Friend and his wife, Nelly, settled on a homestead in Section 28 in present-day Lamoine Township, McDonough County. In February 1836, James Spiva purchased 40 acres of land for $1.25 an acre in the southwest corner of that same section, near Hogwallow Creek. His brother, William, bought up 233 acres in Schuyler County.[88]

An 1833 map of Illinois by H.S. Tanner. *From* Tanner's Universal Atlas.

The Friends and Spivas lived as neighbors and acquaintances for the next thirteen years. In August 1841, James Spiva and his wife helped organize Concord Church at the home of Charles Friend's brother, Abel.[89] Abel and his wife, Elizabeth, had come from Sangamon County and settled in McDonough County sometime after their marriage in December 1829 but

before the 1830 census. According to a McDonough County cemetery record book, Abel and Elizabeth Friend lived in the southwest quarter of Section 20, approximately a mile and a half northwest of Charles and Nelly, near a narrow tributary of the La Moine River. They had six children together: Catherine Ann, Mary Jane, Elias Andrew, James, Maria and George. The Friends and Spivas were simple farmers, and none warranted any mention in the notable biographies of the county. If it had not been for their belief in witchcraft, no one would have ever heard their names again.

It was late in the winter of 1849–50, and the California gold rush was in full swing. Thousands of men packed tin pans and shovels into horse-drawn wagons and set off across the Great Plains to strike it rich in the mountains of the West Coast. In McDonough County, Illinois, farmers huddled in their cabins. Husbands and wives shared one room with a half dozen children on average—sometimes more—lit by candles and oil lamps. Even at this late date, their homes hugged the timber. Very few souls ventured far into the prairie, where there was no wood for fires or fences and packs of wolves still roamed at night. Most travel stopped when the snow fell. Rivers froze, and roads disappeared. There was no railroad in McDonough County until 1856.

Log cabins like this one from Rock County, Wisconsin, were typical on the northwestern frontier. *Library of Congress, Prints and Photographs Division, Washington, D.C.*

On a farm near the meandering banks of Hogwallow Branch, James Spiva lay awake, tossing and turning. He was not physically ill, but nevertheless, he had been irritable and lethargic for weeks. His wife, Rheumay, complained that he was neglecting his chores and the supervision of their seven children, and a string of bad luck afflicted their farm: his cows gave bad milk, his favorite dog died and his oxen went missing. James consulted his brother William, who lived a few miles south in Schuyler County. According to the *New York Times*, William was a rural physician as well as a witch master in the vein of Hamilton County's Charlie Lee. Together, James and William decided James must be bewitched. His depression and exhaustion—symptomatic of seasonal affective disorder—was not the result of a natural causes but the result of his nightly rides to a witch's Sabbath. Perhaps, they reasoned, the witch even transformed James into a horse for that purpose. To cure him and end his family's misfortune, they had only to catch the witch and break her spell. Their thoughts wandered to a nearby farm where Elizabeth Friend lay in bed, stricken by typhoid fever.[90]

James and William knew the Friends. James's wife was related to both Abel and their neighbor Charles, and the families were members of the same church. Their children probably attended the same one-room schoolhouse. The *New York Times* suggested that the Friends had rebuffed William's charms and talismans, and therefore he was open to the idea that Elizabeth was the witch tormenting his brother. He advised James to draw an image of her, nail it to a tree and shoot it with a silver bullet. James took his brother's advice, and it just so happened that around that same time Elizabeth Friend succumbed to her illness. She died on February 28, 1850, at forty-three years of age. Abel buried her body on their farm, where it rests to this day (although her grave marker has been moved to Harmony Cemetery outside of Bentley in Hancock County).

Not long after, James was out chopping wood when a neighbor passed by and informed him of Elizabeth's death. "I know it," he reportedly replied. "I killed her." This confession no doubt startled the neighbor, and word quickly spread. On April 4, 1850, Abel Friend swore an oath in front of Justice Tridwell accusing James of murdering his wife "by willfully felonious and malicious administering poison to her person."[91] James was arraigned in court that summer, and there are two different versions of what happened next. According to the *History of McDonough County* (1878), he pleaded guilty and the judge sentenced him to hang, "but in consideration of the fact that he was an unconverted man, remanded him to the jail at Macomb for spiritual consolation and to make due preparation for eternity."[92] According

to the *New York Times*, Justice Tridwell sentenced James to be shot in the same manner as he had shot the effigy of Elizabeth Friend, but "because of Spiva's plea no evidence was produced to show that Mrs. Friend had not died as the result of a bullet wound."

A lawyer named Samuel Wilson rode up as the execution was about to be carried out and inquired as to what was going on. On hearing the circumstance, he began arguing with Justice Tridwell. At first he argued Tridwell had no legal authority to execute James and asked that the prisoner be given time "to prepare to meet his God." The judge agreed and handed James over to the county sheriff, who never carried out the execution. Eventually, James was released.[93] The *New York Times* account may have been based on the recollection of eyewitnesses, since while the newspaper confused the names of most participants, Samuel Wilson and John Tridwell were accurately represented. The court dockets bear Justice Tridwell's signature, and the *New York Times* mentioned that Wilson was "later Col. Wilson of the Sixteenth Illinois Infantry." Illinois muster rolls show Samuel Wilson of Colchester, McDonough County, joined the Sixteenth Illinois regiment as a lieutenant colonel on May 24, 1861.[94]

The story of James Spiva's battle with the supernatural did not end there. "Some months later," the *New York Times* reported, James "felt himself again 'under a spell,' and his brother William told him that his wife was the guilty witch." Recalling the old English remedy of scratching a witch on the face to break her spell, William allegedly told James to draw blood from his wife's forehead with a knife while she was asleep. "Startled from a sound sleep, she suddenly sat up in bed and the knife cut a deep gash down her cheek."

Nearly two hundred years earlier, the English pamphlet "A Relation of the Most Remarkable Proceedings at the late Assizes at Northampton" (1674) described a similar practice. The pamphlet related the trial of a woman named Mary Forster, who allegedly used witchcraft to kill thirty sheep and burn down their owner's house and two barns. Mary Forster was the wife of a poor cobbler, and the victim, Joseph Weedon, was "a farmer of good ability or repute, being generally respected and beloved," who began selling some of his sheep for butchering at a cost of fourteen pence per quarter animal.

Opposite, top: Elizabeth Friend's broken headstone in Harmony Cemetery outside of Bentley, Illinois, in Hancock County. *Author's collection.*

Opposite, bottom: Close-up of Elizabeth Friend's headstone in Harmony Cemetery outside of Bentley, Illinois, in Hancock County. *Author's collection.*

Mary offered to pay twelve pence, but Joseph refused. She responded with these words: "You had better let me have it, for you shall have more Mutton shortly lye upon your hands then you know what to do with."

Throughout the following week, Joseph discovered each morning that several sheep "strangely" had their legs broken in several places. He suspected witchcraft, so "according to their tradition," he took one of the maimed sheep and burned it alive so that the witch would come out of hiding. While the sheep was burning, Mary came over and asked what the farmer was doing. "According to another old observation," the pamphlet's author related, Joseph scratched her on the face with a knife when he found his fingernails were not sharp enough. Mary threatened to sue, so Joseph agreed to pay her twenty shillings, not a small sum at the time.[95]

James Spiva's use of that old English remedy occurred five years after he was charged with the murder of Elizabeth Friend. On October 8, 1855, his wife went before the justice of the peace and accused him of attempted murder. The court record reads, "Ruema [Rheumay] Spiva comes, and on her complains against one James H. Spiva her husband, and says that he, the said James H. Spiva did, at the County of McDonough in the State of Illinois, on the seventh day of October 1855 then and there unlawfully assault her by cutting her with a knife with the intention of murdering her and threting [sic] her life." The judge then ordered his constable to arrest James "to be dealt with according to law." He issued a $1,000 bond, but James was either unable or unwilling to pay.[96]

The judge ordered him sent to the county jail. He evidently was found not guilty and fled the state, because in December 1858 his wife filed for divorce on grounds of abandonment. Her complaint mentioned that James left her around September 1855 and had not returned to provide support to her or their children.[97] On December 11, she placed a notice in the *Macomb Eagle* for James to appear in court the following April to answer charges against him. The notice stated that he was currently "a non-resident of the State of Illinois."[98] The divorce was finalized in 1859, but as the *New York Times* concluded, "[T]o her dying day his wife carried the scar as a ghastly emblem of [James] Spiva's belief in witchcraft."

Decatur's Witch Scare

Founded in 1823, Decatur is an industrial city straddling the Sangamon River in central Illinois. It was an important juncture of the Wabash, Illinois Central, and Baltimore & Ohio Railroads. In 1885, its population had grown to roughly twelve to thirteen thousand. Recent eastern European immigrants, particularly from Poland, crowded into Decatur's Fifth Ward, located on the city's far northeast side along the Illinois Central Railroad. That year, a controversy erupted over a fifty-year-old woman whose neighbors suspected of being a witch.

In October 1885, the woman, who lived at the east end of Condit Street, appeared at an attorney's office downtown and inquired about bringing a lawsuit against her neighbors, who were harassing her and accusing her of witchcraft. Soon after moving to Decatur, she alleged, a neighborhood boy named Starbati died, followed by the son of a man named Nalefski (or Nowleski). Another child became sick, and neighbors accused her of giving the child a bewitched drink. Rumors quickly spread through the tightknit Polish settlement. According to the *Decatur Herald*, neighbors ostracized the woman and, when she passed by, pointed their fingers at her and said, "*Da geht die alte Hexe*," a German phrase meaning "There goes the old witch."

When a reporter visited the neighborhood, its residents were eager to share their stories of encounters with "the witch," whose identity remained anonymous. "I went to a neighbor's well and got water," one woman said. "The old witch was there and talked to me. She bewitched me and I went into the house and fell down in a faint." According to another, "She shuffles cards and decides who of us are to die, who are to be sick, and who are to be afflicted with sores. She decides also by coffee grounds."[99]

On Sunday, October 11, the neighbors gathered in small groups after church to gossip about the witch. They accused her of causing "felons and runarounds," boils and rheumatism to appear. "She gave one child brain fever, and it died," they said. "Another is sick. We must stop her." According to the *Decatur Herald*, the Polish residents of that neighborhood attended a Lutheran church led by Reverend Landgraf, "whom they reverence and believe without question." Reverend George Landgraf led St. Paul's Lutheran Church in 1880, when the congregation erected a small brick church with a single steeple at West Wood and Edward streets. That was the church the "superstitious Poles" attended.[100]

This was the first publicized case of recent European immigrants bringing witch beliefs to Illinois, but it would not be the last. Chicago furnished

many more examples. Like Chicago, Decatur grew up around industry, manufacturing and railroads. It was not the rural backcountry where belief in witchcraft allegedly held sway. At the dawn of the twentieth century, like the French, Anglo-Americans and German Americans before them, immigrants from southern and eastern Europe, clinging to their folkways, refreshed and renewed witchcraft in Illinois.

4
Windy City Witches

Founded in 1833, Chicago grew from a town of two hundred to over half a million residents by 1880. It became a major transportation hub, connecting resources in the western United States with markets in the East. By 1879, when a man named Toby Allen appealed to his alderman to relieve his torment at the hands of a witch, Chicago had recovered from the Great Chicago Fire of 1871 and was coming into its own on the national stage. Allen, an African American man about thirty years of age, lived with his mother on South Clark Street. In 1871, just a few months after the Chicago Fire, he was found guilty of grand larceny and sentenced to serve time at Joliet State Penitentiary. He was incarcerated from December 7, 1871, to June 9, 1875, when Governor John Lourie Beveridge pardoned him.

In a letter to Second Ward alderman Addison Ballard dated April 12, 1879, Allen alleged that in 1873 the State of Illinois hired a man named Johnson under the pretext of enforcing cleanliness standards at the prison. He moved into the prison with his family, but all was not as it seemed. According to Allen, Johnson's preferred method of enforcement was maleficium. "I, sir, know of their murdering several, and threatening my life after crippling me for life," he wrote. "They still have their witchcraft on me, and therefore I come to you to investigate and have me released from this infernal power of witchcraft."[101] The *Chicago Daily Tribune* printed the letter in full and sent a reporter to interview Toby Allen at home.

When the reporter confronted him, Allen admitted that he had never met "Johnson" in the flesh but Johnson and family materialized in his cell. "One

night as he lay in his cell voices came to him as if in the same apartment, the stone walls vanished like the airy fabric of a dream, and he beheld face to face his persecutors," the article said. Johnson allegedly compelled Allen to cut off one of his fingers, killed a convict named Grass and drove another insane so that he had to be sent to the Cook County Poor House upon release. The *Daily Tribune* ridiculed Allen and pronounced him insane. It even went so far as to suggest the county physician should examine him before he imagined his voices in the form of a prominent citizen, "and may emancipate himself from the thralldom in which he is held in a manner which might prove inconvenient to such citizen."[102]

In their third and final article on Allen's predicament, the *Tribune*'s editors used his case as a springboard to review events surrounding the Salem witch trials and other seventeenth-century witch persecutions. Whereas in the 1870s the court would simply pronounce Toby Allen insane, they concluded, "His statements are of precisely the kind upon which thousands of persons have in former times been convicted of witchcraft."[103]

Over the next two decades, Chicago's population more than tripled in size, with an influx of immigrants from southern, central and eastern Europe, including Italians, Jews, Poles, Bosnians and Czechs. Many of these immigrants retained long-held beliefs regarding maleficium, and a flurry of witchcraft cases appeared at the turn of the century. The year 1901 saw three such cases, and they were reported in newspapers as far away as Des Moines, Iowa; Newark, Ohio; Dubuque, Iowa; and Fort Worth, Texas. These accounts appeared to confirm prejudices held by many Anglo-Americans that this new wave of immigrants was backward and superstitious, just as witchcraft beliefs among African Americans and Scotch-Irish reinforced prejudices in the previous century.

In October 1901, the *Chicago Daily Herald* reported the arrest of Thomas Kelly for throwing stones through the window of an unnamed neighbor, whom he suspected of being a witch. According to Kelly, this woman tormented and then attempted to extort another neighbor, a Mrs. Cohen. After coming out on the losing end of an argument, the alleged witch put a curse on Cohen. Cohen's horse died, and then she became ill and paralyzed on one side. After she recovered, the alleged witch demanded thirty dollars to lift the curse completely. Outraged, Kelly confronted his neighbor in front of her home and threw stones through her window. He was arrested and taken before a judge, but the newspaper did not report the outcome.[104]

In November 1901, an Italian man named Peter Calebrese and his sister, who lived on Ewing Street on the Near West Side, felt themselves under a

spell. Calebrese suffered from delusions and odd behavior. During the day, he was too tired to work, but noises filled his ears and would not allow him to sleep. He walked backward down the street and obsessively swept the sidewalk in front of his residence. The witch, he claimed, made him eat too much and suffer from subjective vertigo, which made him feel like he was falling through the air. While his sister sought assistance in Italy, he approached a Captain Wheeler at the police station on Maxwell Street and asked him to arrest a woman named Mary DeVito, whom he suspected of being his tormentor. The authorities told Calebrese they would have to look up the law concerning witchcraft first (Illinois had no law explicitly prohibiting witchcraft), so Calebrese sought assistance from his local priest, Father Dunn(e).[105] Like the previous account, the resolution to this story has been lost to history.

In December 1901, shortly after Guglielmo Marconi received the first transatlantic radio signal in Newfoundland, Canada, nearly a dozen neighbors of a woman named Helen Roth took the witness stand in Chicago to support charges of assault and battery, threats and disorderly conduct against her. Mary Donovan, who lived near Roth on Cortez Street in Chicago's West Town neighborhood, brought the charges, though she explained the real problem was that Helen Roth was a witch who tormented her neighbors. Roth, a German immigrant who worked as a nurse in Holland before coming to America, admitted to being a hypnotist, clairvoyant and magnetic healer but vehemently denied being a witch. "It is the mysteries of this science which puzzle my neighbors and make them believe I am a witch," she explained.[106]

As her trial began, Helen Roth complained that she was a poor woman who could neither pay for a lawyer nor find anyone to speak in her defense. She sold flowers on the street to pay for her residence. When the judge asked if she had a lawyer, Roth explained that she had prayed to God to send someone to defend her. At that moment, a former city attorney named Miles J. Devine happened to walk into the courtroom. Roth exclaimed that her prayers had been answered, and the startled Devine agreed to represent her at no charge. Judge James Dooley postponed the trial for ten days and allowed Roth to go free without bond on the stipulation that she confine her hypnotism to her own family.[107] Afraid of her power, Roth's accusers refused when Devine requested they shake hands.

According to the *Fort Worth Morning Register*, a parade of witnesses told "[w]eird tales of witchcraft, hypnotism, and other mysterious things," but the printed testimony of two witnesses was unremarkable. One neighbor, Mrs. E. Cousinesu, accused Roth of attempting to hypnotize both her and a

child. Another woman, Mrs. M. Andersson, explained that Roth had failed to cure her sore throat through hypnosis. "She looked into my eyes and made peculiar signs, but she failed to put me to sleep," Andersson said. Helen Roth defended herself by arguing, "In their ignorance they misconstrued my efforts to benefit them and have brought disgrace upon myself and my family."[108] Again, the newspapers failed to follow up on the trial, leaving its outcome unknown.

Two years later, in 1903, a short article appeared in a Logansport, Indiana newspaper regarding a case of witchcraft in Chicago's Polish community. Late that summer, Mrs. Frank Calenski alleged a woman named Francesca Krejewski kissed her child, who soon fell ill. Krejewski already had a reputation as a witch among her neighbors at Center Avenue and James Street, so when a fortuneteller told Calenski that her child was bewitched, she had an idea of the culprit. "Your child is under a spell from a witch," the fortuneteller allegedly said. "To break it you must get a piece of the witch's shawl and some of her hair. Burn both so you and the child will smell of the smoke." Calenski then proceeded to cut off pieces of Krejewski's hair and shawl with scissors. She burned both as instructed, but her child did not recover. Instead, Krejewski, who denied being a witch, brought charges against Calenski and had her arrested.[109]

On October 15, 1906, Felix Rybiski and his wife, Julia, appeared before Justice John R. Caverly at the Harrison Street Police Station, located at the corner of LaSalle and Harrison Streets in the Second Precinct. Caverly, an English Catholic and longtime friend of infamous First Ward alderman Michael "Hinky Dink" Kenna, served as Chicago city attorney from 1906 to 1910.[110] Felix Rybiski was there to answer charges of abandoning his wife and their newborn baby. Felix, however, had an astonishing tale. His wife, he told the city attorney, had abused and bewitched him and by supernatural means held him in matrimony against his will. He begged Caverly to protect him from her influence. Originally printed in the *Chicago Inter Ocean*, newspapers as far away as the *Leavenworth Post, Indianapolis Star* and even the *Punxsutawney Spirit* reprinted Felix's tale.[111]

Before they met, both Felix and Julia lived near Union Stockyards and Chicago's Back of the Yards neighborhood. Felix, twenty-one, was a roofer and son of a Polish manufacturer. His wife was around twenty-four years his senior and described as a "short, sweet faced, motherly looking woman." She lived on Lyman Street in the Bridgeport neighborhood and was employed as a telegraph operator at Union Stockyards. Her maiden name was Murphey. According to Felix, he first met Julia and came under

In the heart of the Great Union Stock Yards, Chicago, circa 1909. *Library of Congress, Prints and Photographs Division, Washington, D.C.*

her spell while he was shingling her roof in the fall of 1905. "One day I was shingling the roof of her home when she waved her arms at me, and with a shriek that caused me to shake all over told me to go down," he testified fearfully. "I did not obey, and in a moment I felt myself sliding off the roof. I fractured my shoulder in the fall." As he told Justice Caverly his story, he allegedly glanced repeatedly at his wife "as if he expected to be again cast under a spell."

Felix continued, alleging that he became powerless to resist her commands and moved into her home, where she kept him "doped" on "high balls

and other intoxicants." She then informed him they were married, despite Felix's prior engagement to a woman his own age named Mary Runklowicz. Whenever he regained self control, his wife would put a spell on him with a glance. Failing that, she would ply him with intoxicants or "sling plates at his head until he would obey her through fear." Jane Runklowicz (unknown relation to Felix's former fiancée) and Felix's sister-in-law, Ella Hofft, backed up his testimony that his wife was a witch.

Julia Rybiski, however, testified that her husband was insane. She petitioned Justice Caverly to charge him with "inhuman cruelty" and abandonment. Her husband's mind began to slip, she alleged, while he spent long hours preparing a patent for a new type of shingle. Then, he fell off the roof and hit his head. Refusing medical attention, his behavior became erratic and alarming. "At one time he got the hatchet and ran almost half a mile in an attempt to escape from imaginary pursuers," she alleged. "On another occasion, while walking with me, he assaulted a man absolutely without cause." As for his allegations of abuse, Julia claimed that he, in fact, was the abuser. "Many times, when we were conversing on ordinary topics, he would pick up a book, a plate, anything that was handy, and sling it at me," she testified. She denied being a witch, saying that if she had unnatural powers, she would not have to work ten hours a day to support herself and her child.

Rather than dismiss Felix's incredible claims, Justice Caverly continued the case until October 22, in order to have time to further investigate.[112] Unfortunately, the *Inter Ocean* failed to follow up the story, and Felix and Julia Rybiski disappeared from public record.

Another case involving witchcraft from Chicago's Back of the Yards neighborhood appeared over a decade later, involving a bitter dispute over a sister's untimely illness and death. Victor Sleeth was an assistant superintendent for Armour & Company, the meatpacking company that defined the Yards. Armour & Company opened in Chicago in 1867 and by 1910 employed over 8,700 people at the Union Stockyards. Victor's twenty-two-year-old wife, Mary, had contracted consumption. She was in the advanced stages of the disease when her sister twenty-one-year-old Augusta Wilke, an assistant foreman at Armour & Company, called in a fifty-year-old nurse named Mary Vogel. Vogel attended to Mary Sleeth for a month, until Mary died on February 2, 1919. On Monday, February 24, William L. Sehlke, a masseur and husband to Mary Sleeth's other sister, Martha, went to the Stockyards police to ask for warrants for the arrest of Mary Vogel and Augusta Wilke.

William and Martha Sehlke told the *Chicago Daily Tribune* an incredible tale. According to the Sehlkes, Mary Vogel was a witch and Augusta Wilke

The Great Union Stock Yards of Chicago, 1878 illustration by Charles Rascher. *Library of Congress, Prints and Photographs Division, Washington, D.C.*

her understudy, and they sought protection from her slander and sorcery. Augusta allegedly told Martha that Mary Vogel believed Martha was a witch and had poisoned her sister for the benefit of two other witches, a Mrs. George Hellman and Marian Sleeth, a widow and Mary Sleeth's sister-in-law. In turn, Martha accused Vogel of being a witch. Father Phillips of the Franciscan Fathers of St. Augustine Church told reporters he went to Victor and Mary Sleeth's home, where he found Vogal burning salt in the oven and incense in the rooms. "She was making motions with her hands, and I told her to get out, and she did," said the priest.

According to Martha Sehlke, "Mrs. Vogel was burning salt and incense. She got a lamb's heart and put some new pins in it and burned it. This was to find out which of us 'witches' would be around that day and to cast a spell over the one that would come." After her sister's death, Martha alleged that Vogel sent for William Wilke, her brother-in-law, and a week later he died.[113] Public record does not reveal if this dispute was ever resolved, but it demonstrates a continued association between witchcraft, sickness, poison and a breakdown in social relations. The traditional tools of witchcraft—incense, salt, pins

Many Chicagoans Believe in Witches.

Police Have Lots of Trouble Because of the Black Art.

THAT more people believe in witches in Chicago than ever believed in them in Salem, or any of the other witch centers of old, sounds like a joke, but it is a solid fact.

There have been several cases lately which have come to the attention of the police and of Police Justices Sabath, Severson, and Dooley that prove that not only hundreds but thousands of Chicago's citizens believe firmly in the existence of witchcraft.

The cases which have come within the ken of the police became public simply because the black art worked the wrong way.

For instance, one woman was arrested upon the complaint of another woman, who charged that the first had bewitched a child. The evidence given in court was to the effect that the alleged witch had cut a lock of hair from the child's head and a bit of cloth from her jacket. With these ingredients the supposed witch was accused of going through a long incantation. The result, witnesses said, was that the feet of the bewitched child began to swell.

There is a strong belief in one colony near the West North avenue police station that cows die in that neighborhood because "spells have been put upon them." The manner in which these spells have been formed and put into working order is identical with the procedure used by women who were executed in New England in the early days under witchcraft indictments.

Wax is bought and fashioned into something that looks like a cow. Then pins, over which incantations have been recited, are thrust into the waxen mass and the wax is set before the fire. The belief is that as soon as the wax begins to melt pains will begin to afflict the cow in the lungs or the throat or whatever part of the body that corresponds to the part of the waxen image into which the pins have been stuck.

"Many Chicagoans Believe in Witches." Chicago Daily Tribune, *August 23, 1903.*

and organs—remained in use even in industrial-era Chicago following World War I.

Were the preceding cases isolated incidents, or do they reveal an undercurrent of belief in magic and witchcraft in early twentieth-century Chicago? In 1903, the *Chicago Daily Tribune* investigated this question and concluded, "That more people believe in witches in Chicago than ever believed in them in Salem, or any of the other witch centers of old, sounds like a joke, but it is a solid fact." Based on cases investigated by the Chicago Police, the *Tribune* concluded Chicago was home to not hundreds but thousands of believers. "Three or four times every week the police at some of the stations are asked to intervene between supposed witches and their frightened victims," it wrote. "Many of the applications come from women....Some men, however, get the idea that some witch is exercising a malign influence over their lives." In one example, police received complaints that witches were causing household unhappiness by leaning a fire poker against the front gate or door or spreading cinders on the sidewalk and muttering, "Be accursed." Distraught homeowners summoned the police to take away the cursed pokers. "Any one who believes in witches knows that it is a highly dangerous

act to touch a poker that the witches have used," quipped the *Tribune*. "The police are not so sensitive."[114]

At the very least, these cases reveal a colorful variety of unconventional beliefs in turn-of-the-century Chicago, including witchcraft, hypnotism, clairvoyance and fortunetelling. They demonstrate that a belief in witchcraft was not confined to rural areas but was alive and well in the largest city in Illinois. As the Victorian era ended, superstitions that persisted throughout the nineteenth century on the Illinois prairie continued to persist in the teaming immigrant communities of the Windy City. L.W. de Laurence's Chicago-based occult publishing company and mail-order house no doubt made some contribution to the proliferation of these beliefs. It was more likely, however, that just as their predecessors, a new generation of immigrants brought their folkways with them from the Old World to the new. We will never know how many accusations, confrontations and strained relationships between neighbors the belief in witchcraft caused, but these few cases offer a fascinating glimpse into its effect on average Illinoisans as they went about their daily lives.

5

Witchcraft in Contemporary Illinois

Today, belief in magic and witchcraft is alive and well in Illinois, having attracted a small but steady following. According to witchvox.com, an online gathering place for witches, Wiccans and neopagans, there are at least seventy-four groups and organizations dedicated to those beliefs throughout Illinois, catering to adults, teens, families, military members, college students and more. As many as fifteen stores serve the needs of these groups, with locations in a variety of towns and cities, such as Chicago, Springfield, Carbondale, Galesburg, Peoria and Urbana. Metaphysical stores are notoriously transient, vulnerable to both the ebb and flow of the economy as well as the subculture's local popularity. The oldest currently operating in Illinois, Alchemy Arts at 1203 West Bryn Mawr Avenue in Chicago, opened in 1990. Some, like Cleo's Aroma Pothecary in Rockford and Beads N Botanicals in Urbana, have changed locations several times over the past decade. Like L.W. de Laurence's spiritual supply mail-order house in the early twentieth century, these stores provide material support to individuals interested in magic, spiritualism and the occult. Many also host meetings, workshops and other social events designed to educate and bring members of that community together.

Most contemporary believers in witchcraft maintain witchcraft, or Wicca, is a neopagan religion or spiritual belief centered on nature worship. The origins of this revisionist view can be found in the books *Aradia; or The Gospel of the Witches* (1899) by American folklorist Charles Godfrey Leland (1824–1903) and *The Witch-Cult in Western Europe* (1921) and *God of the*

Charles Godfrey Leland, circa 1855–1865. *Library of Congress, Prints and Photographs Division, Washington, D.C.*

Witches (1931) by British archaeologist and anthropologist Margaret Murray (1863–1963). Both Leland and Murray espoused the theory that medieval and early modern witch trials were an attempt by the Roman Catholic Church to stamp out a pre-Christian nature cult. Leland's work focused on Tuscany, Italy, and relied on information provided by a woman named Maddalena. Maddalena claimed that Tuscan witches had survived Christian persecution and worshipped a pagan goddess called Aradia. According to Margaret Murray, the pre-Christian nature cult allegedly worshipped the ancient Roman goddess Diana and a horned fertility god, which Christians interpreted as Satan, at nighttime Sabbaths. Scholars of European witchcraft and the medieval period have since called into question the validity of both Leland's and Murray's works, and their general consensus is that there were no surviving pre-Christian religions in Europe at that time.[115]

Nevertheless, Leland's and Murray's works inspired claimants to the title of modern-day incarnations of this ancient cult. The most prominent of these was Gerald Gardner (1884–1964), a British civil servant and author. In the mid-1930s, Gardner joined an occult group in New Forest, England, called the Rosicrucian Order Crotona Fellowship. In 1939, he claimed to have been initiated into a coven of witches that survived the early modern persecutions. In 1951, British Parliament passed the Fraudulent Mediums Act, which repealed the Witchcraft Act of 1735. Gardner took this as a license to spread his newfound faith. He published *Witchcraft Today* (1954), with an introduction by Margaret Murray, and founded the Bricket Wood Coven. Gardner's beliefs soon made their way to the United States, where they gained popularity alongside the New Age movement in the late 1960s and '70s. Although he did not use the term *Wicca*, he referred to witches as "the Wica." The term gained popularity as adherents of the new faith tried to distance it from historically negative connotations.

Others, most notably Anton LaVey (1930–1997), embraced a darker image of witchcraft and occult practices. LaVey founded the Church of Satan in San Francisco, California, on Walpurgisnacht in 1966. According to German tradition, Walpurgisnacht (April 30) was the night witches met on the highest peak in the Harz Mountains to usher in spring. The popularity of his book *The Satanic Bible* (1969), as well as the sensational but discredited tale of satanic ritual abuse *Michelle Remembers* (1980), prompted a fundamentalist Christian backlash against modern Satanism and witchcraft that lasted into the early 1990s.

During the 1990s, interest in witchcraft in the United States increased, due in large part to the popularity of movies such as *Hocus Pocus* (1993), *The*

The 1899 cover of *Aradia; or The Gospel of the Witches* by Charles Godfrey Leland. *Courtesy of Archive.org.*

Crucible (1996), *The Craft* (1996), *The Blair Witch Project* (1999) and television programs such as *Sabrina, the Teenage Witch* (1996–2003) and *Charmed* (1998–2006). Books like *Teen Witch: Wicca for a New Generation* (1998) by Silver RavenWolf, *Wicked: The Life and Times of the Wicked Witch of the West* (1996) by Gregory Maguire and *Harry Potter and the Sorcerer's Stone* (1998) by J.K. Rowling helped popularize Wicca and witchcraft among young people. The first installment of the *Harry Potter* series reached the top of the *New York Times* list of bestselling fiction in August 1999. According to the American Religious Identification Survey, there were approximately 8,000 people in the United States who described themselves as Wiccans in 1990. In 2001, there were 134,000. In 2008, there were roughly 342,000.[116]

Ariela Keysar, coauthor of *Religion in a Free Market*, helped conduct the American Religious Identification Survey and attributed this growth to the Internet and "less than negative" portrayals of witchcraft in Hollywood movies.[117] Based at the Institute for the Study of Secularism in Society & Culture at Trinity College in Hartford, Connecticut, and with a sample of over fifty thousand respondents, the study is a nationally representative survey of U.S. adults in the forty-eight contiguous states.

Gerald Gardner and Margaret Murray's revisionist perspective of European witchcraft laid the groundwork for a more positive portrayal of witchcraft in American culture. While many Christians greeted this Wiccan revival with a mixture of skepticism and alarm, it gained traction among a notable percentage of the population. Witchcraft was no longer either an ignorant or dangerous belief—it was now also promoted as a positive good with the motto "Do what you will, so long as it harms none." (Doreen Valiente originally formulated this rede as 'An' it harm none do what ye will" in a speech in 1964.) Several modern organizations arose in Illinois to support the growing Wiccan and neopagan community.

Established by Reverend Kaye Berry in 1993, Temple of the Phoenix, primarily based in Peoria, is one of the largest Wiccan/neopagan organizations in Illinois. According to its bylaws, the group is "a collective group of all Natural Earth Religions: Wiccans, Native American, Pagans and another 200 traditions all under the Natural Earth Religion umbrella acting as a networking group in the Central Illinois Area." Like many similar groups, it appeals to a variety of nonconventional religious believers. It defines "Natural Earth Religions, Pagan/Wiccan" as "any positive, life affirming and earth-based religion, ethic or philosophy, whether practiced solitary or in a group, consistent with the ideals and behaviors generally accepted to be stated in the Principles of Natural Earth Belief."

Mirroring its New Age predecessors, Temple of the Phoenix promotes Wiccan and neopagan beliefs as a positive, earth-centered spiritual path. Prospective members are expected to complete a membership application and pay thirty dollars in annual dues. In return, they are offered voting rights at the Temple of the Phoenix General Membership meeting, as well as a membership card and discounts to events, classes and lectures. Membership is also offered to small groups or covens that commit to regular meetings and ceremonies.[118] The organization is based at Mystic Arts Ltd. at 817 Southwest Adams Street in Peoria, Illinois.

Student-run organizations like NIU Pagan Student Association and the Society of Metaphysical Advancement promote Wiccan and neopagan beliefs on college campuses. Paul Herrick, a graduate student in anthropology, created the NIU Pagan Student Association at Northern Illinois University in DeKalb in 2009. Its first meeting featured a talk by Anastasia Blechschmidt, a spiritual adviser from Circle Sanctuary Church in Barneveld, Wisconsin. According to the *Northern Star*, Blechschmidt discussed the three guidelines of Wicca and argued that the guidelines demonstrated the pacifistic nature of witchcraft. "The first of the guidelines was the Rede, which states, 'do as you will, cause harm to no living thing,' which contradicts a long-held belief since the nineteenth century that Pagans conducted bloody sacrifices and were associated with Satanism," it explained.[119] The NIU Pagan Student Association is still recognized by the NIU Student Association and holds regular meetings on campus.

Jason and Sarah Dothager and Anita and Steve Beaman founded the Society of Metaphysical Advancement, or SOMA, at Eastern Illinois University in Charleston in 1995. For many years, that recognized student organization provided a place for Wiccan and neopagan students to meet, as well as "a welcoming environment for those who have to deal with others' disapproval of and misconceptions about their spirituality." In an interview with the student newspaper *Daily Eastern News* in 2002, then-president Ashley Keifer said the most common misconception about the group was that they were Satanists. She explained, however, that witchcraft had acquired an undeserved reputation over the past millennia.[120] A 2003 article stressed the group's openness to other beliefs and highlighted the diversity of its membership, which included Buddhists and Muslims in addition to Wiccans and other neopagans.[121]

Correllianism and the Witch School

In 1990, a group of Wiccans created the Church of Gaia in Chicago, Illinois, which for many years was home to an Internet-based school called the Witch School. Over the next two decades, the Witch School would be influential in the Illinois Wiccan and neopagan community, even after it moved to rural Vermillion County. Donald Lewis, a co-founder, considers himself to be the inheritor and spiritual leader of the Correllian Nativist Tradition, a neopagan sect allegedly founded in the Danville, Illinois area in 1879 by his great-grandmother Caroline High Correll. "Caroline was a woman of mixed racial heritage who practiced various forms of magic, herbalism and spiritualism," he explained. "With her husband, John Correll, Caroline ran a circus during summer months and focused on exhibitions during the winter—described as 'art lectures,' these exhibitions actually showcased many of the new visual and audio technologies that were emerging at the time."[122] She was involved with both the Spiritualist and Universalist movements and was associated with Henry and Lydia Beckett of Galveston, Indiana.

Henry C. Beckett, who died in 1953 at the age of eighty-three, was pastor of the Galveston Universalist Church for fifteen years. His wife, Lydia, was a painter who, according to her obituary, "was also widely known for her antique collection." They were married on August 26, 1888, and moved to Galveston in 1905.[123] According to the *Logansport Pharos-Tribune*, Lydia Beckett, "along with being a leading expert in Druidie amulets, read the Tarot, and prepared herbal cures." In 1937, Henry and Lydia Beckett established a collection of items related to magic and witchcraft that they housed in a small log cabin. Lydia Beckett, whose exact relationship to Caroline High Correll is unclear, allegedly practiced a form of witchcraft based on the works of American folklorist Charles Godfrey Leland.

Henry and Lydia Beckett's daughter Atsie married Glen C. Lawrence, the Galveston town marshal. The two had a son named Reginald Lawrence. Reginald was a stage magician who in turn had a son named Lawrence E. Lawrence. Like Donald Lewis, Lawrence was greatly influenced by his grandparents' work. He gained stewardship over their collection, which became known as the Lawrence Museum of Magic & Witchcraft. Indiana governor Edgar D. Whitcomb, who was in office from 1968 to 1972, once issued Lawrence a certificate proclaiming him to be Indiana's "official witch."[124]

In Illinois, Donald Lewis was carrying on his family traditions as well. His mother, LaVeda, headed the Correllian Nativist Tradition from 1966 until

1979 and initiated Donald in 1976. In 1979, the group appointed Krystel High-Correll as the new head of the Correllian Tradition, with Donald as co-head. Donald considers this tradition distinct from the Wiccan tradition as conceived by Gerald Gardner. "Like many other American Wiccan groups, we are not related to Gardnerian Witchcraft except in as much as we are both part of a larger movement and we share a number of practices, some of which arise because of common ancestry or inspiration and others as a result of assimilation with the Eclectic Wiccan community," he explained.[125] Eclectic Wiccans create their own spiritual paths by adopting and reinventing the beliefs and rituals of a variety of religious traditions connected to Wicca and broader paganism. According to its website, the Correllian Nativist Tradition is "a highly political and deeply synchretic form of Pagan universalism, which stressed the need for the world's Native (Pagan) religions to unite in the face of colonial Christianity."[126] The Correll Mother Temple is currently located at 509 North Vermilion Street, Suite 532, in Danville, Illinois.

In 1990, Ed and Kris Hubbard of the New Castle Society joined with Donald Lewis in Chicago to create the Church of Gaia—a temple that would honor both traditions. Hubbard and Lewis felt that Chicago was "a holy city whose religious history and diversity give it a special and sacral character." Renamed the Correllian Temple of the Holy City to reflect that belief, it continued to operate in the Windy City until entering a hiatus in 2014. The Witch School began in 1997 as an e-zine called the *Daily Spell*, which was published by Ed Hubbard. It featured lessons in Wicca written by Donald Lewis, which proved to be so popular that Hubbard and Lewis decided to begin offering classes to the public.

In 2003, Donald Lewis and Ed Hubbard relocated their Chicago-based online Witch School to Hoopeston, Illinois, a small town of 5,351 residents in northern Vermillion County, due to its lower cost of living and more affordable labor pool. In the late 1800s, Hoopeston was home to a thriving vegetable-canning industry. To this day, the community celebrates its agricultural heritage with an annual Sweet Corn Festival and Miss National Sweetheart Pageant. Its high school nickname is the "Cornjerkers." Community activists circulated a petition and lobbied the city council to keep Lewis and Hubbard's Witch School from coming to town. "Before we ever moved to the city there were 'pray-ins' aimed at preventing our coming," Lewis explained. "A city council meeting that we attended was filled with aggressive protestors who hovered on the edge of violence so visibly that the local police feared for our safety as

we did ourselves. It was a terrifying scene, carefully orchestrated to scare us away."

Later, it was revealed that many of the protestors were not from Hoopeston but came from the surrounding area. "As we left the meeting that evening the local police chief, Mark Drollinger—a wonderful person and a fine officer—informed us that he had never seen many of these protestors before....Chief Drollinger and other local figures reached out to us, asking us to reconsider locating to Hoopeston. Chief Drollinger arranged for us to address a local group that actually was composed of Hoopeston citizens, who turned out to be polite and welcoming. By now the deal for the original building had fallen through, but an opportunity for another building arose—the old warehouse mentioned above. In the end we did in fact come to Hoopeston, and made many friends there."[127]

According to Lewis, local residents initially refused to rent to staff relocated from Chicago. "For two years, several of us lived in the headquarters, an old and uninsulated warehouse heated by space heaters," he explained. "Friends in the area helped us by letting us use their shower until we were able to have one put in at the headquarters." Despite this opposition, it set up shop in a former brick horse stable near the Hoopeston Civic Center. According to Hubbard, 30 to 50 new students signed up for online classes per day, and over 120,000 from around the world were actively enrolled.[128] It offered 120 classes featuring subjects like numerology, tarot card reading, cultural history, aromatherapy and candle magic. After operating for three years as an exclusively Internet-based school, in July 2006, it opened its doors to the public. Hubbard and Lewis invited local residents to view its ritual space, video studio and library. "The Hoopeston Post Office had to add eleven extra hours of work per week to accommodate us," said Lewis. "In time, our staff could grow to sixteen persons, not counting local artists whose work we sold through our store."[129]

The Witch School was a victim of its success and suffered multiple online intrusions and hacking attempts. One year later, in July 2007, it packed up and moved seven miles south, to the village of Rossville. It occupied space in a residential neighborhood at 314 South Chicago Street. Rossville, population 1,331, was a former destination for antique shopping, but a fire in 2004 destroyed many of its historic downtown shops. Today, a ConAgra plant employs most of its citizens. While Mayor Terry Prillaman took a laissez-faire approach toward the new business, others were not as tolerant. Andy Thomas, a youth pastor at Rossville Church of Christ, told *USA Today* the coming of the school had laid the groundwork for a "spiritual battle"

pitting "the forces of darkness against the forces of light." His goal, he said, was to convert the newcomers to Christianity, not run them out of town. "Rossville has fallen on hard times," he told the *Chicago Tribune*. "The school closed. This is a popular place for meth. We're like, 'Great, now a witch school.' It feels like we're being attacked."

Some residents, according to the *Chicago Tribune*, sprinkled holy water on the tires of their cars and drove around town to ward off the witches, but Mayor Prillaman said only a half dozen people had called his office or attended meetings to complain. In October 2007, concerned citizens held a meeting in the auditorium of the abandoned high school and listened to a lecture on Wicca by Robert Kurka, a professor at Lincoln Christian College and Seminary. Kurka argued that Wiccans were not dangerous; they simply held incorrect beliefs, and Christians should focus on strengthening their own beliefs in the face of this pagan incursion.[130]

On the last weekend of August 2008, the Witch School sponsored a conference and "Correllian Lustration" in Hoopeston and Rossville for thirty to forty witches. The event included a drum circle, dinner, Wiccan initiations and a blessing ceremony featuring water from the Vermillion River. The *Danville Commercial News* described the proceedings: "Lewis conducts the ceremony, but a First Elder—a woman from Danville—performs the actual Lustration blessing. During the ceremony, Lewis also invokes an oracle, which means he receives a prophecy or message from the ancestors."[131]

In October 2009, the Witch School was on the move again, this time to Salem, Massachusetts. Although most of the famed witch trials of 1692 occurred in Salem Village (now Danvers), Salem has become a mecca of sorts for witch enthusiasts. Ed Hubbard told the *Chicago Tribune* that he had underestimated the difficulty the school would face when it relocated to Rossville two years earlier. The school's Internet service reportedly crashed for days at a time, and it was difficult to find vendors willing to repair their connection. "The churches can scream and yell, but I thought at the end of the day if you proved yourself a good neighbor, people would get past that," he said. "I learned that's not true."[132] After living in Salem for two years, Donald Lewis returned to Illinois before ultimately settling in Florida.

Despite the nineteenth-century conviction that expanding access to public and private education would eradicate popular belief in witchcraft, witch beliefs in Illinois seem as prevalent as ever. The inflexible roles proscribed for witches, witch doctors and folk magic in the nineteenth and early twentieth centuries have given way to a cornucopia of various beliefs. Despite the experiences of Witch School proprietors Donald Lewis and Ed Hubbard,

it is clear that efforts by revisionists to recast witchcraft as a peaceful nature religion have been successful in reducing fear and hostility toward those beliefs among a significant percentage of the population. Newspaper editors, for example, no longer openly mock and ridicule believers in witchcraft. Since the 1990s, and especially in the decade after the new millennia, growing acceptance of nonconventional and alternative beliefs and lifestyles has allowed Wiccan and neopagan organizations and stores to attract new members and patrons. While this community remains small, its continuing presence in Illinois speaks volumes about the longevity of the belief in witchcraft and the tenacious grip the image of the witch has on our culture.

Why does witchcraft continue to have an appeal? As in the past, belief in magic and witchcraft offers the believer a sense of power, control and orderliness in a seemingly random universe. It suggests a deeper connection to nature and opens the door to "secret" or "hidden knowledge" only shared by a select few who have been initiated (or who have initiated themselves) into an exclusive group. For centuries, men and women have sought knowledge of the future, the power to attract health, wealth and love and to take revenge without consequence. Others sought an easy explanation for events outside their control: sudden illness, bad luck and death. Still others sought reasons to isolate individuals perceived as ugly, solitary and foreign. These basic human qualities remain within us. Magical thinking, the attribution of causal relationships between actions and events where none exist, is found in nearly every culture. There is no real reason to assume that the passage of time will erase this type of thinking from human experience or that its particular expression in Western culture—*the witch*—will simply go gently into that good night.

Part II

Beliefs

6
Qualities of a Witch

For over a century, witches represented a malevolent force in frontier Illinois, a force the average person could blame for a variety of maladies. Any misfortune, no matter how small, could be the result of maleficium. "More ample powers for mischief can not be imagined," explained Milo Erwin, author of *History of Williamson County, Illinois* (1876). "The means by which the witch inflicted these diseases were one of the hidden mysteries which no one but the witch understood."[133] While the believer in witchcraft may not have been able to explain *how* the witch executed his or her powers, he or she understood what those powers were.

In fact, the written record offers a clear picture of what magical abilities witches allegedly possessed. This included the ability to shape-shift—to transform him or herself and others into a variety of animals—to steal milk and other goods, to spread disease and affliction to humans and livestock and to control others by making them dance, shake, hallucinate and vomit foreign objects. These specific powers distinguished witches from the witch masters and folk healers who also made their home on the Illinois prairie.

Witches were not born with the power to harm others. In order to become a witch, a person had to make a pact with the devil. The trade-off for eternal damnation in the afterlife was the power to transform into an animal, obtain material wealth and control and punish others through magical means. Several African Americans from Adams County, Illinois, explained to folklorist Harry Middleton Hyatt, "The devil will give you power to do evil things, if you sell yourself to him…[and] you can talk to the devil face to

face, if you sell yourself to him." Some summoned the devil by binding two hatpins and cursing God.

Other methods of calling the devil were much more gruesome. One involved boiling a black cat and scattering its bones at a four-way intersection. Another variant of this theme combined animal sacrifice with cursing God. According to one African American informant,

> *If you want to be a evil fortune teller, take and kill a black cat and take the bones out of the top of the cat's head and a teaspoonful of brains, and a bone out of the cat's neck, a chicken wishbone; then go out to the four corners of the road on a very dark night, if it is raining that would make it still better, holding all these things in your left hand. Then turn your back first on the east, swearing, using the Lord's name in vain; then turn your back on the north, swearing, using the Lord's name in vain; then the west, and the south last. Then kneel down and pray, using the Lord's name in vain again.*[134]

In European American lore, becoming a witch involved writing one's name in the devil's book. According to Milo Erwin, witches received their power after writing their names in their own blood and giving it to the devil.[135] Likewise, in *Legends and Lore of Southern Illinois* (1963), John W. Allen explained, "Some witches become such for only a limited time, others for life. In either case, their names are inscribed in the 'black book' and all must 'sign in blood.'"[136] The already initiated invited some to become witches. The Williams sisters in Franklin County, Illinois, alleged that an elderly neighbor magically transported them to a gathering of witches, where she invited one of the young sisters to give her soul to the devil, "after which she would become a witch in good standing, with the power to bewitch whomever she pleased."[137] Mrs. Ollie Barnard, from Shawneetown, Illinois, related the following story to folklorist Charles Neely: "My great-grandmother wanted to be a witch when she was young. A woman told her that she must sell her soul to the devil to become a witch. This woman had her say, 'I belong to the devil and no one else.' She began saying it, and it began to grow dark. My great-grandmother got scared and said, 'O, my God!' It got light then, and the witch said, 'You've played it now!'"[138] Shawneetown is located in Gallatin County, in southeastern Illinois, near the Ohio River.

The devil allegedly gave newly initiated witches a book with which they could work their maleficium. According to popular lore, these books could be given up at death or passed down to others, and the witch would die if

his or her book was ever destroyed (usually by burning). In the early 1930s, one German inhabitant of Adams County spoke to Harry Middleton Hyatt:

> *About ten years ago a woman out at X (a small town in the county) was a witch. She was always bewitching someone. One day she got real sick and was sick a long time. She sent for the Lutheran preacher. He told her she could not get well or die until she would give up a witchcraft book she had. She said she wanted her son to have the book so he could bewitch. The preacher talked and talked. He talked with her four hours until the sweat just rolled off of him. The preacher told her she could not die in peace until she gave him the book. At last she reached under her pillow and got the book out and gave it to him. The preacher went and put it in the cookstove to burn; and while it was burning, this old witch died.*[139]

Once a person became a witch, he or she had access to specific powers, including the power to transform oneself (as well as others) into a variety of animals. The witch attracted animal companions, most often a black cat. He or she gained the ability to magically steal milk and other goods from his or her neighbors, spread afflictions and disease and control others. Witch balls and feather wreaths were powerful items in the witch's arsenal, granting him or her the power to kill livestock from a distance and torment enemies. In Illinois lore, there is no shortage of tales describing these magical abilities in detail.

SHAPE-SHIFTING AND FAMILIARS

Shape-shifting was a common theme in witch tales. Storytellers claimed witches could transform into any number of animals, including deer, rabbits, cats, pigs and horses. Others claimed witches transformed their victims into animals. Witches who transformed men into horses while they slept and rode them to the Sabbath caused their victims to experience physical and mental exhaustion. Others changed children into animals to take revenge against their parents. A common story, repeated many times and in many locations, involved a game animal that was particularly difficult to hunt. The hunter (usually described as a skilled marksman) found his best efforts frustrated until he loaded his musket or rifle with a silver bullet. Finally wounding the animal, the hunter pursued his quarry only to discover a neighbor crippled in

the same location where he shot his prey. However, silver bullets did not need to cause the wound. Any injury to the magical animal caused an identical injury on the witch, revealing his or her identity.

Pope County is located at the southeastern tip of the state, just north of the junction of the Ohio and Tennessee Rivers. Charles Neely Sr. related the following story to his son, folklorist Charles Neely, who explained that the story circulated the Alcorn Creek neighborhood of Pope County:

> *Uncle Wesley Holt, who was an old settler and part Indian, saw a deer galloping around the field. Being an expert marksman with the old cap and ball rifle, Uncle Wesley decided to have some venison. He shot at the deer and it galloped away. For several days it galloped around the field. Uncle Wesley shot at it several times but failed to kill it. He knew that his marksmanship was good, so he decided that there was something uncanny about the deer. Understanding witchcraft, he decided to try another method. The method was to drill a hole through the lead ball, cut a piece of silver from a dime, and insert it in the hole. He loaded his gun and killed the deer at the first shot. When he came to the deer, it turned out to be old Mary Toombs, who was a witch in the neighborhood.*[140]

Today, Alcorn Creek, a tributary of the Ohio River, is located in the Dog Island State Wetlands.

Witches could also appear in the form of a rabbit. One elderly woman retold the following tale to folklorist John W. Allen. Her parents, who were raised in Hamilton County in southeastern Illinois, told her the story as it allegedly happened to her grandparents. Allen explained:

> *This witch, in order to do evil to the storyteller's grandparents, would take the form of a rabbit and raid their garden, eating the lettuce, sprouts of green beans, and other plants....Repeated efforts of the father, a highly skilled marksman, to shoot the rabbit were futile. Coming to suspect that the animal really was the changed form of the neighboring woman whom he believed to be a witch, the father prepared to use countermagic. When dusk came, the man took his trusted rifle, loaded it with a silver bullet, and mounted guard over the garden plot. A rabbit, really the witch, appeared and began to nibble the lettuce. Not wishing to be responsible for the death of the neighboring woman, even though she might be a witch, the marksman chose to shoot the rabbit in the right front foot instead of a vital spot. The shot he fired was effective, as evidenced by the hobbling gait of the retreating*

rabbit and by the bloody spots left by the wounded foot. If further proof is necessary, it was furnished by the real witch, who appeared next day with a bandaged right hand carried in a sling. The lettuce and green beans were no longer molested.[141]

This legend originates in Irish folklore, which was probably passed down orally among Scotch-Irish pioneers. The story of a man who shoots an enchanted hare appears in *Fairy and Folk Tales of the Irish Peasantry* (1888), collected by William Butler Yeats. In this tale, the hunter follows a track of blood to a nearby home where he finds a woman nursing a wounded leg. Only the silver bullet is missing from this rendition of events.[142]

Witches also allegedly appeared as black cats to annoy and frustrate their neighbors or to observe their handiwork from a safe distance. A German inhabitant of Adams County told the following story to folklorist Harry Middleton Hyatt in the 1930s. "Years ago a woman out in the north end of town was bothered with a big cat around her house all the time," he or she said. "She didn't know if it was a witch or not, but one day she got mad and pick up a stick of wood and threw it at the cat. It hit the cat right on the side of its face, and the neighbor on the next block had the whole side of her face black and blue where that stick of wood hit her."[143] Similarly, another German informant told Hyatt the following tale:

A farmer living out here (a few miles from Quincy) in the country was bothered with a black cat. Every time he would go to the barn a big black cat was around his cows and his cows were giving bloody milk all the time. He could not find out what was wrong with the cows. So one day the cat bothered him so much, that he got after this black cat with the pitchfork, and when he got this cat up in the corner of the barn and was about to kill it, the cat turned into an old woman and begged this farmer for mercy. And after that his cows did not give any more bloody milk.[144]

An African American informant told Hyatt that a trio of witches once transformed into cats to play a twisted game of hide-and-seek with her family:

We had a mammy cat and it got lost and we could not find it. Someone told us they saw a cat and two kittens down in the field, but they could not catch it. One night I went out to pick up some chips and I heard a cat meow. I looked and there sit our cat and two kittens on the fence. I dropped my chips and ran in the house after father. He went with me

to get the cat, and when we got to the fence the cat was gone. Father said, "Don't that beat you." Then I heard the cat again, and it was on the other fence. Then it disappeared, and then we heard the cat under the house fighting. We found out it was not our cat at all. It was our neighbor, old aunt Sarah and her two daughters Helen and Lindy. They had turned into a witch in the form of a cat and two kittens to make us think it was our cat.[145]

Hyatt also recorded a few stories from Adams County residents of German descent of witches who appeared in the form of hogs. One informant recalled this incident:

This old woman, that used to bewitch everyone, would come sometimes in the shape of a pig, just to scare the boys. Years ago when they had the water trough in front of the saloons, this pig would come and drink out of the trough. One night the boys thought they would catch the pig, and they did. Kept pulling its legs to hear it squeal, and the pig just kept squealing all the time. Then they let it go. And the next night that pig did not come. The old woman, that everyone thought was a witch, came and kept walking around the trough. But the boys did not say anything to her. They knew better.

According to another informant,

A woman was walking down Madison Street and passed a neighbor's house and a pig came out of the yard and started after her. She picked up a stick and hit the pig over the neck real hard. The pig squealed and turned around and went back. The next day a neighbor came in with her neck all tied up. I said, "What is wrong with your neck?" She said, "You hit me last night." I said, "Why, I only hit a pig last night." And she said, "Well, that pig was me."[146]

Several tales featured witches who transformed themselves or others into horses in order to go night riding. In some cases, men blamed their fatigue and melancholy on a witch who saddled and rode them while they slept. Others claimed their wives turned into horses and forced them to ride on their backs all night across the plains. According to H.C. Bradsby, editor of *History of Bureau County, Illinois* (1885),

Hunters, even to a recent date, had no doubt but that witches could put "spells" on their guns, or that men were changed into horses, whom the witches would bridle and saddle, and ride at full speed over hill, dale and mountain, and through the air to all parts of the world, to attend the witches' pow-wows at their distant places of rendezvous. They would return the poor human horse to his bed and sleep just before daylight; but, especially in children's hair, would be found the witches' stirrups, that, the child would fully and painfully realize when these tangles were being combed out by the mother.[147]

Recall the case of James Spiva in McDonough County, Illinois, whose brother told him his wife had been turning him into a horse and was the source of his fatigue. Similarly, John Crenshaw of Carbondale, Illinois, related the following story to folklorist Charles Neely that had been passed down to him by his grandmother:

There was a man named Jacobs who lived neighbor to my grandmother. He weighed about one hundred and eighty pounds. One summer he commenced to fall off, and he wasn't sick. There had to be some cause. Folks asked him finally what was the matter. He said that some one in the neighborhood turned him into a big bay horse every night and rode him hard but wouldn't give him any hay or corn. The man said that he was a pretty horse.[148]

Carbondale is located in Jackson County, in southwestern Illinois.

In the following story, which shares similar elements with other accounts collected by Harry Middleton Hyatt, an Irish informant explained how a man came to discover his wife was a witch:

A man married a witch and he did not know it. He would sleep fine, but when he got up the next morning he was all in. One day he said to his neighbor, "I don't know what is wrong with me. I am so tired all the time." The neighbor said, "I spy a horse each night with you on its back. Tonight you act like you are asleep, and in the morning look in the bed and under it and see what you see." So that night after the man was sleeping, his wife turned herself into a horse and put this man on her back, and took him to the pasture and run around and around with him. In the morning he looked and found on the bottom of her feet the prints of the horse's shoe, and under the bed the horse's shoe. That was why this man was not resting. His wife was taking him riding every night through the pasture on her back.

In a different version, the man shod the horse during the night and discovered horse shoes nailed to his wife's hands and feet in the morning.[149]

Finally, in this sad tale collected from a German farmer, a frustrated witch intent on stealing a child transformed her into a lamb to exact revenge on the child's parents. The incident allegedly occurred to a neighbor of the informant's great-grandparents near Plainville, Illinois, which is located several miles southeast of Quincy in Adam's County:

> *My grandfather's parents lived on a farm next to another farm where an old woman lived. They called her an old witch. She did not have any children. The people who lived on the other side of her had three girls. This old witch always wanted the smallest girl. She would ask the woman for her all the time, but the mother would not part with her little girl. One morning this little girl disappeared. Everyone looked for her but they did not find her. About two weeks later a stray sheep came to this girl's parent's farm. They could not find the owner for the sheep so they kept the sheep. When sheep killing time came, the man brought it up to kill, but the sheep looked so sad out of its eyes. It even had tears in its eyes. They would run down the sheep's face. This man started to kill this sheep the second time, and the tears run down its face. That old woman happen to be there that time, and she told this man to get a skunk and cut off some of its tail and wipe the blood across the sheep's eyes. Then bury the tail, and when the tail was rotten, the little girl would come back. And in about three weeks the sheep disappeared one day and the little girl came walking in.*[150]

Other stories regarding enchanted animals were closely related to tales of shape-shifting. According to popular belief, witches had the power to control animals. Known as "familiars," or "familiar spirits," these creatures assisted the witch with his or her magical work. These tales, though present among the German inhabitants of Adams County, Illinois, were less graphic than their European counterparts, who often described the witch feeding his or her familiars from extra teats. In American stories, a witch's familiar was simply a nuisance or a harbinger of bad luck. One informant told Harry Middleton Hyatt,

> *Years ago I lived by a woman that I thought could put a spell over you. I tried to be good to her, because I was afraid of her, but one day we fell out over a child's fuss. Not thinking, one day I let her oldest girl have something, and in a few days when I came home from town and started up the front*

yard steps, a big black cat kept getting in front of me. I thought it was a cat and started to pick it up, when it went right through my fingers. When I got to the porch, there it was again; and I gave it a good kick. The folks on the porch said, "What are you trying to do?" I said, "I am trying to kill a big black cat." And ever since that, every two years I have some very bad trouble. The bottom just falls out for me. Everything will go wrong. I know that woman has never taken the spell off.[151]

According to another German resident of Adams County,

I know a woman that was always seeing a big black bug crawling on the ceiling every night. She would not see it until she got in bed, then it would come and crawl over the ceiling right above her bed. Her grandma was a witch and had bewitched that bug on the ceiling. She could not sleep, so she went to the priest out here on X. Street and he prayed for her and took the spell off, and she never saw the bug any more.[152]

The ability to manipulate and shape-shift was not the only power over animals ascribed to witches. While frustrating hunters and galloping through the night as a horse was relatively benign behavior, witches were also believed to have the ability to enrich themselves at the expense of their neighbors, threatening them with starvation and poverty. When times became tough, exasperated dairy farmers sometimes looked for a supernatural explanation for their misfortune. Witches, then, were accused of stealing a basic nutritional staple: milk.

Stealing Milk

Dairy cattle were important to families on the frontier. Not only did they produce fresh milk, but their milk was also used to make luxury foods like cream, cheese and butter. If times got tough, cattle could be slaughtered for beef. When cows stopped producing milk, a pioneer family was at risk for starvation. Not understanding proper nutrition, many pioneers blamed *maleficium* when their cows went dry or gave bloody milk. A neighbor, especially an elderly woman, who had no shortage of milk and butter was immediately suspect. For example, according to Alexander Davidson and Bernard Stuvé, authors of *A Complete History of Illinois from 1673 to 1873*, "An

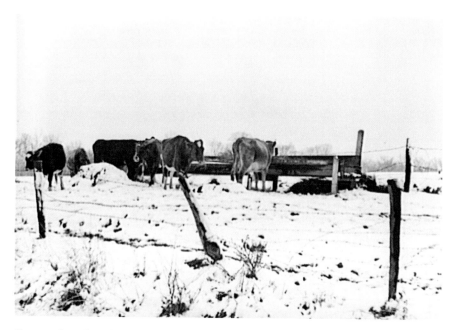

Cows such as these in Williamson County, Illinois, sustained farmers for generations. *Photo by Arthur Rothstein, 1939; Library of Congress, Prints and Photographs Division, Washington, D.C.*

old woman living on Silver Creek was very generally accredited with the power of witchcraft, which, it was believed, she exercised in taking milk from her neighbor's cows at pleasure, without the aid of any physical agency."[153]

Without the aid of any physical agency was not entirely true, for those who believed in witchcraft concocted a technique in which the witch used a towel and rack to extract the milk. In the nineteenth century, a towel rack, rail or horse was a simple wooden device with two to six horizontal bars supported on a stand that could be plain or decoratively carved. Towels were hung over the bars to dry. The image of an old crone hunched over her towel rack, stealing their livelihood, haunted midwestern dairy farmers.

The following tale comes from Belleville, Illinois, a city in St. Clair County, east of St. Louis. A man named Henry Juenger Sr. related it to Esther Knefelkamp, who told it to folklorist Charles Neely in the 1930s. "This old lady had several towels hanging on her back porch. With a towel hanging before her, she would milk the neighbors' cows from the lower two corners; when she was finished she would have several large foaming buckets of wholesome milk."[154] Juenger was a neighbor of the elderly woman, and he also claimed used to come in the form of a black cat to bewitch horses in the

neighborhood. According to John W. Allen, a witch named Eva Locker from Williamson County "could milk other people's cows by the simple process of hanging a towel on her rack. It was allowed to hang there several minutes, after which she could take the towel and wring the accumulated milk from its fringe."[155] Milo Erwin, author of *History of Williamson County, Illinois*, also noted the practice but said witches hung the magic towel over their doors.[156]

An Irish informant from Adams County, Illinois, told the following story to folklorist Harry Middleton Hyatt in the 1930s:

> *A farmer had a lot of Jersey cows and he could not get any milk. He was wondering why. One night when he was driving his cows up to the house, he happened to look over to his neighbor's house, and this woman had two large white towels in the window and was milking these towels just as fast as she could. And she was milking this man's cows' milk into her own bucket, and that was why this man was not getting any milk.*

German immigrants told similar tales. One told Hyatt,

> *A friend of my stepmother was living in a house with a woman. Everyone thought this woman was a witch and were afraid of her. One morning this woman came in to my stepmother's friend's room. She had a big towel hanging behind the door, and this witch went behind the door where the towel was hanging, and this woman could hear something just dripping and dripping behind the door. All at once this woman came from behind the door with a bucket of milk. The neighbor's cow next door did not give any milk that morning. And they say this witch milked the neighbor's cow right through the window and into the towel.*[157]

A variant of the technique involved inserting pins into the towel. According to H.C. Bradsby, "Witches would constantly milk their neighbors' cows. This, it was believed, they could do by fixing a new pin in a new towel, one for each cow milked, and hanging the towel over the door and then by incantations the milk would be extracted from the fringes of the towel, after the manner of milking a cow." The author could not help noting sarcastically, "Singularly enough, the cows were never milked by the witches, except when they had about gone dry for the want of proper feed."[158]

In other accounts from Illinois, authors do not mention the use of pins, but in the following story from southwestern Indiana, the storytellers explicitly described the practice. A group of nomads from the Oakland

City area related the tale to the informant's father, whom they approached for help with disposing of the witch. "They said there was an old woman who lived near them in Martin County who was a terror to all the country around.…They said that before they moved down here they had four cows but could not get any milk from two of them at any time—they were always milked dry. The old witch did not have any cows but always had plenty of milk and butter."

Naturally, they sent someone to investigate:

> *One morning one of our women went up to the old witch's house and saw her doing something with a towel which was hanging in a small window. While the witch's back was turned she determined to watch and find out what was being done. The witch first stuck a pin in the towel and named it for one of our cows. Then she took hold of the fringe and began to milk it as if she were milking a cow. When she had finished that cow she put another pin into the towel and named it after our other best cow and proceeded to milk her in the same way.*[159]

This technique was not used exclusively to pilfer milk. In the following account, related by an Irish informant to Harry Middleton Hyatt, a witch used the towel-wringing technique to steal his molasses:

> *A man out in the country went to town to buy several barrels of molasses. He had to pass an old woman's house that everyone called a witch. On his way to town when he went by, she had a large white towel hanging in the window and a large white kettle under the towel. On his way back this woman was at the window pulling on the towel just like she was milking. Just when his wagon got by her door, the barrels in the wagon started to dancing and danced all the way home. When the old man got home he did not have any molasses in his barrels. The old witch had drained out every drop of his barrels into her kettle in the window.*[160]

Witches were accused of damaging livestock in other ways. In Chicago in 1903, residents of the neighborhood around the West North Avenue police station, near the Chicago River's north branch, believed their cows suffered from maleficium. The witch allegedly fashioned wax into the shape of a cow. "Then pins, over which incantations have been recited, are thrust into the waxen mass and the wax is set before the fire." When the wax began to melt, the cow suffered in whatever part of its body the witch had stuck pins.[161]

This is an example of sympathetic magic relying on similarity, meaning a person perceives a magical link between two objects because they resemble each other. Pricking a pin in one will produce pain in the other. According to Sir James Frazer, author of *The Golden Bough* (1890), "[T]he magician infers that he can produce any effect he desires merely by imitating it."[162] In other words, like produces like, or an effect resembles its cause.

While witches could threaten their neighbors with starvation and malnutrition, their neighbors also accused them of spreading sickness and disease. This was, perhaps, a witch's most dreaded power, one that struck without warning and left rural doctors bewildered. Wherever a doctor was at a loss for a cause or cure, many Illinois residents whispered that witchcraft was to blame.

AFFLICTION

Disease was an ever-present threat on the nineteenth-century American frontier. Smallpox, diphtheria, yellow fever, cholera, tuberculosis and milk sickness were common, and the causes of these diseases were not well known. Milk sickness in particular plagued the midwestern frontier, made even more frightening because its origins appeared so mysterious. It was caused by drinking milk or eating the meat of cattle that had consumed white snakeroot plant, which grows in the woods along the Ohio River and its tributaries. According to historian Walter J. Daly, "Ordinary settlers and their doctors found it unpredictable, untreatable, and highly fatal. Milk sickness killed many, frightened more, and caused local economic crises. Villages and farms were abandoned; livestock died; entire families were killed."[163] Symptoms included abdominal pain, severe thirst, vomiting, constipation, tremors, delirium, coma and death.

Little by little, pioneers like Anna Pierce Hobbs of Hardin County, Illinois, learned the cause of the illness, but their knowledge and experience went unrecognized by the broader medical community. Most people could not make the connection between the milk they drank and this illness because cattle often showed no symptoms of the disease. Pioneers turned to folk cures and dubious "medicine men" who also doubled as witch doctors. Witch doctors were needed because, according to popular belief, maleficium, not germs, viruses or poisoned vegetation, caused these mysterious illnesses.

An illustration of white snakeroot (*Ageratina altissima*) and its cousin, boneset. *From* Field Book of American Wild Flowers *by F. Schuyler Mathews, 1905.*

So powerful were witches that many believed they could cause blindness, sickness and even death with a touch or glance. African Americans in Adams County, Illinois, advised Harry Middleton Hyatt, "If a hoodoo person wants to show you something, let them put their own hand on it. You keep yours off, for they can poison you like that," and "This hoodoo woman could rub her hands over your eyes and you will go blind in one night; and she can rub them again over your eyes, and you can see."[164] Many were apprehensive about accepting gifts from suspected witches, especially food.

A German informant related the following tale to Harry Middleton Hyatt in the early 1930s:

> *A farmer was plowing in the field and this woman, that bewitched the horse and everything she could, was down by the fence and said to the farmer, "I guess you are hungry" and gave him a sack of cookies to eat. He took the cookies. He was afraid not to. Just as soon as he got over to the other end of the field he buried them in the ground. He told me that he would not eat those cookies for anything. If he did, she would have him bewitched and he would have died.*[165]

The afflicted blamed simple illnesses, such as food poisoning, on witchcraft. A German informant from Adams County related this account to Harry Middleton Hyatt:

> *My mother was going away on a trip about sixty years ago and I was about fourteen years old. She didn't want to leave me alone, because we had an old woman on our block that we thought was a witch. The woman heard mother was going away and wanted her daughter to stay with me, but mother was afraid of this woman and went and got another girl to stay with me. This made the old woman angry, and just before my mother started, this old witch came to the fence and called me, and said, "Here is a pan of milk for you to drink." The pan was so full I could not carry it. She said, "Drink a little off of the pan, then you can carry it without spilling it." Not thinking, I did. And as soon as I got in the house I took real sick. I almost died and mother had to put her trip off over her bewitching that milk just because she was angry over mother not getting her girl to help me take care of things while she was away.*[166]

Gifts from an elderly neighbor were suspect, especially if the neighbor had a negative reputation. With one bite, the victim could become seriously

tormented and ill. In the following story from another German inhabitant of Adams County, Illinois, a woman narrowly escaped bewitchment after receiving a gift from a witch's garden, but her husband succumbed after unwittingly partaking in the hexed produce:

> *A neighbor gave another some cucumbers, and this woman that gave her the cucumbers could put an evil spell on you. So this woman did not eat any, but her husband did. That night after her husband went to bed, they could just hear him fighting with someone downstairs. He was lying on a couch. He told his wife that this neighbor came and was sticking him in the ribs so he could not stand it, and he scratched and scratched. The next morning this man's arms were all swollen up so he could not do anything. And this woman was so scratched up they took her to the hospital. She told at the hospital that she had a fuss at home, but it was this man that scratched her up, when she came to his couch that night in the shape of some object. This woman died, and as soon as she was dead, this man's arms got well again and all the swellen [sic] left.*[167]

Sharing or gift giving has traditionally been an expression of friendship or affection, gratitude and neighborliness. The word "gift," however, has another connotation, one not lost on the German population of Illinois. *Gift* in German means "poison," and witches, through their gifts, allegedly had the power to do just that. In two of the previous stories, neighbors accepted the witch's gifts out of common courtesy but discarded them as soon as they could. Those who were foolish enough to partake of the gift became afflicted with horrible pains and torments. By spreading physical illness through purported acts of generosity, witches upset the balance between neighbors at a time when sharing and exchanging goods was not only common practice, it was a necessary element of community life.

Controlling Others

Another power the devil allegedly granted witches was the ability to control others. Believers accused witches of tormenting their neighbors with fits, jerks and fainting spells. Witches could cause their victims to go into a trance, climb walls, vomit pins, nails, and other objects, sing or speak in tongues, wet themselves, howl like a dog and crawl on their hands and feet and even

hallucinate. Some believed that in exchange for possessing this power over others, the devil mandated that his servants use it. According to one German resident of Adams County, Illinois, "A witch is one that sells her soul to the devil and she has to keep someone in her power all the time; if not, the devil will make her suffer untold agony."[168] In the case of the Williams sisters of Franklin County, Illinois, an old woman allegedly bewitched them in retaliation for having refused her offer to transform them into witches. The girls ate flies, convulsed and danced on their rooftop, screamed and conversed in a strange language.[169]

Another German resident of Adams County described the following event, which allegedly occurred thirty years prior (about 1900):

> *A witch was living at Thirteenth and Ohio Streets and she was mad at her daughter because she stayed out all night, and a witch has to put a spell on someone when they are mad. She called in the neighbor girl to wash the dishes. This other woman did not want her daughter to go. After she went, the mother had such a funny feeling about her daughter, so she went over to see what her daughter was doing, and she was standing up by the sink just like dead. She could not move. The woman said, "My God, what did you do to my daughter? I am going to have you arrested." The witch said, "O, do not, I will take the spell off. I just had to put the spell on someone. My daughter was not here and I was so mad." So she took the spell off of my daughter and I took her home.[170]*

Most tales of bewitchment in Adams County came from residents of German descent. Harry Middleton Hyatt collected from that community over a half dozen accounts of witches making children and adults commit a variety of unusual acts through maleficium. Through these tales, a picture emerges of family members bewildered by their loved ones' bizarre behavior. Some called on witch doctors or hoodoo healers for help, especially when traditional doctors and medicine failed to alleviate or even explain their condition. One man explained:

> *A boy forty-two years ago, only fourteen years old, was living just three blocks from me on Madison Street. A woman in the neighborhood bewitched this boy and everyone else. This boy would just crawl up the wall all the time. It would take several men to hold him down. It was very sad. My aunt would go there all the time to help. At last they found an old negro man healer and he said, "I will fix that old witch." And when he started*

to working on the old woman, this boy started to vomiting. The first day he vomited up a bundle of sticks with a string tied around them, and the second day a bundle of sticks and the third day a bunch of keys with a string tied around them. After that he got well and they did not have any more trouble with him crawling up the wall.[171]

In the following story from Quincy, Illinois, a family contacted a hoodoo doctor after their local physician could not cure their daughter of her embarrassing behavior:

A little girl out in the south part of Quincy years ago was just terrible. She would spit at everyone that would go by, take off her clothes. The doctors or no one could do a thing for her, so they thought they would get a hoodoo doctor. And he said the little girl was bewitched. He told them to put a poker in the stove and keep poking the fire, and if anyone did have the little girl bewitched, they would come. So they started to poking the fire, and it was no time until a neighbor came and knocked on the door that never did come to the house, and said, "Open the door. I am suffering." But the people would not let her in. And the woman went home sick and the little girl got well.[172]

Witches also allegedly tormented their victims with hallucinations. One family in Adams County requested the services of a priest when their son claimed that bees were pestering him at night. "My brother was bewitched years ago," a man told Hyatt. He continued:

I was only a boy then about twelve years old and he twenty-one years old. We both slept in the same room. And every night just at twelve o'clock he would wake up crying and jump out of bed, saying his pillow was full of bees, and run through the whole house, saying the bees were after him. He did this for several months. And one night when he jump[ed] out of bed, he said, "Oh, look, there is a big bee after me" and grab[bed] his hat at the same time and hit this big bee. Just as he hit the bee I saw a big white feather come from under a chair and go over to the door. I said, "Did you hit the bee?" He said, "I did." And just then we heard a noise. It sounded like someone fell down the stairs. We knew then my brother was bewitched. The next day my mother took him over to X. Church to see the priest. He prayed over him several times, and he never did hear any more bees in his pillow.[173]

TOOLS OF THE TRADE

Although witches were believed to bewitch by a variety of nonphysical means, occasionally they required physical aids to commit their maleficium. These included hardened spheres of animal hair called hoodoo balls or witch balls, as well as wreaths, birds and other objects made from pillow feathers. Believers offered these items as physical proof of the existence of witchcraft.

Witches were much feared for their apparent ability to destroy cattle and other livestock with hardened balls of hair. Superstitious farmers found their beliefs justified when they dissected their deceased livestock and discovered the balls in their stomachs and digestive tracts. By the 1850s, however, the medical community had generally discerned a more mundane explanation. In *On the Nature and Treatment of the Diseases of Cattle* (1859), Boston veterinarian George Dadd explained that some animals had a habit of licking themselves, which caused a large quantity of indigestible hair to accumulate in their stomachs. "These balls sometimes accumulate material until they are bigger than ordinary sized goose eggs," he explained. "It is not surprising that death ensues from the irritation of such an indigestible mass in the stomach of an ox or cow, and it is also not surprising that many deaths of cattle cannot be accounted for by their owners."[174] Dadd noted that "not a few people at this day" believe witchcraft was the origin of the hairballs.

Cross-section of a trichobezoar, or hairball, found in cattle. *Courtesy of Anatomical Division, National Museum of Health and Medicine in Silver Spring, Maryland.*

These round masses of indigestible matter found in the stomach, called bezoars, have a long history in traditional medicine. "Bezoar" comes from the Persian word *pād-zahr*, meaning "protection from poison" or "antidote." Hairballs are called trichobezoars. For over two millennia, the Chinese believed trichobezoars from cattle possessed medicinal properties.[175]

While Williamson County's Eva Locker infamously possessed the ability to kill cattle by shooting them with balls of hair, Harry Middleton Hyatt recorded several accounts of hoodoo balls in Adams County, Illinois. Possessing a vague understanding how the balls are made in the digestive tracts of cattle, a German informant told Hyatt, "A cow licks her hair and that hair goes down in the left side of the pouch and that forms a ball, and if you have one of those in your hand you can bewitch anyone." More concerned with the power the balls had to cause harm, an African American told Hyatt the following story. "Someone put a hoodoo ball under my mother's front doorstep years ago and when she started to go through the door she could

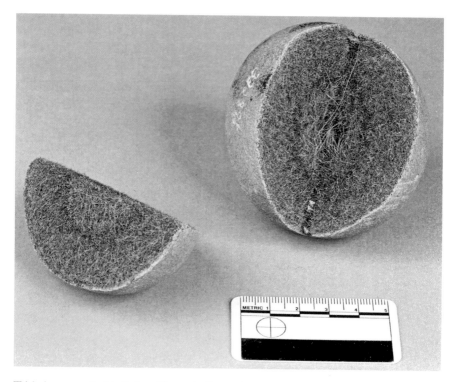

Trichobezoar, or hairball, found in cattle. Some pioneers called these "witch balls" and believed they had magical properties. *Courtesy of Anatomical Division, National Museum of Health and Medicine in Silver Spring, Maryland.*

not move. She just stood there. They found the hoodoo ball and threw it in the stove and all kind of light shot up from it. The lights were just beautiful. My mother could walk right away as soon as that ball started to burning."[176] So witch balls were not just confined to the stomachs of cattle—many saved them for their alleged power.

Hoodoo balls, or witch balls, were sometimes used for good. One early pioneer of Effingham County, in south central Illinois, used them to remove spells and charms. According to William Henry Perrin, author of *History of Effingham County, Illinois* (1883), "These were made of deer's and cow's hair, were large, and held together by long string. They constituted his *materia medica.*" When other pioneers presented the afflicted, "He would doctor them by standing over them, moving about in a mysterious way his witch balls and muttering a strange guttural jargon, and this was repeated from day to day until the witch would fly unseen away in sore agony and distress and the cure was complete."[177]

Additionally, witches allegedly used wreaths, birds and other figures made from pillow feathers to torment their victims. Night after night, believers imagined, the witch snuck into the victim's bedroom, pulled a partially completed feather wreath from his or her pillow, carefully completed another section and placed it back in the pillowcase. As long as the figure remained imbedded there, the victim suffered. Folklorist Harry Middleton Hyatt recorded over a dozen accounts of these feather fetishes among the German population of Adams County. In nearly every tale, the victim suffers from an illness for which doctors have no cure. Only the timely intervention of a concerned individual, having knowledge of the existence of witchcraft, can save them. If the witch completed this bizarre creation, the victim died.

"I think that if you find a wreath of feathers in your pillow, you have been hexed and will die if your wreath is finished; and if it is not, you won't die until it is," a a twelve-year-old German girl explained to Hyatt. "My reasons are that I know a lady who had been hexed, and they opened her pillow and found a wreath that was not quite finished, and they left it there awhile; and in a week she died, and they opened her pillow and found that the wreath was finished." Another informant told him, "I had a niece that had been sick a long time. Some of the family thought she was bewitched, so they opened her pillow and found several pretty wreaths. They were all finished, and she died. If the folks had of found those wreaths before they were finished, she would not have died."[178]

The following is a typical story featuring all the elements of the feather wreath motif: a child suffering from an unknown illness, a concerned neighbor

WITCH WREATH.

Illustration of a witch wreath presented to the museum of the University of Pennsylvania by Professor William Romaine Newbold. *From the* Herald Democrat *(Leadville, Colorado), March 25, 1898.*

with knowledge of witchcraft, the unfinished wreath and the exposure of the witch. It comes from Belleville, Illinois, which is located east of St. Louis. A woman named Mrs. John Becker related it to Irene Mache, who told it to folklorist Charles Neely:

> *Doctors seemed to be at a loss as to just what was troubling Clarence Manners. The child had been ill for a period of five weeks, getting weaker day by day. One day a neighbor came in to see Clarence and told his mother doctors could do the child little good, for he was bewitched. She suggested they look into the pillow upon which Clarence rested his head. Upon opening the pillow a wreath formed by the feathers was found. The wreath was not entirely finished, the neighbor explained, and for that reason Clarence was still alive. At the suggestion of the*

This feather wreath/crown from rural Arkansas, circa 1860–1930, was approximately three inches in diameter. *Photo by Lori Kimball.*

neighbor the wreath was placed on a chair and a rope was used to beat it until it was demolished.[179]

Coincidentally, at the same time, bruises appeared all over an old lady living in the neighborhood, indicating that she was the culprit. After Mrs. Manners destroyed the wreath, her son recovered. Although Neely did not reveal the ethnicity of his informant, nineteenth-century Belleville was a predominantly German community. By 1870, an estimated 90 percent of the city's population was either German born or of German descent.

In the following stories from Adams County, victims discovered feathered objects other than wreaths in their pillows. Though the objects are different, the general motif remains the same, and in both instances, the spell was broken by burning the fetishes:

My daughter was sick all the time. She could not eat or sleep. Some neighbor told her when she could not sleep to get up and throw her pillow on the floor

and curse it good, then go back to bed; and if she went to sleep, someo:· has a spell on her. One night she could not sleep at all, so she got up an· threw the pillow on the floor and cursed it good, then went back to bed. Sh· went right to sleep. The next day she told this neighbor. She said, "You are bewitched, open up your pillows and see if you can find anything." She did, and found a bird, butterfly and a wreath almost finished. She put the wreath in the stove to burn, but the bird and butterfly was so pretty she didn't want to burn them, so she put them on the mantelpiece to keep. That night she could not sleep again. She told the neighbor, and she said, "What did you do with the things you found in your pillows?" Then she told her. And she said, "You burn everything up." And she did, and the spell was broken; and she got all right after that.[180]

I knew a boy out here in the south part (of Quincy) years ago that was sick all the time. They done everything for him and try everything anyone would tell them, but it would not do him any good. Some of the neighbors thought he was bewitched, but the folks didn't. But at last they went to looking in the bedtick and pillows to see if they could find anything, and in one of the pillows they found a rooster all done but a little of its tail. If that tail had of been done, that boy would of died; but they took the rooster and put it in the stove to burn; and after that the boy got well.[181]

An Ordered Universe

Although witches were considered an evil force in possession of unnatural powers, the fact that those powers were specifically defined showed there were limitations to what a witch could do. A witch could not simply wave a magic wand or wiggle her nose (elements of contemporary popular culture that did not appear in midwestern witch lore) and have whatever he or she desired. Illinois farmers, for instance, understood that milk did not simply materialize out of thin air. It had to be squeezed from something, so even though the witch used magical means to steal milk, he or she still needed to operate within the same natural framework as the farmer. First the witch needed a towel (something that absorbed liquid). Then he or she needed a rack or door to drape it over. Finally, the witch needed to mimic milking the cow by squeezing the ends of the towel. In some cases, he or she also had to stick pins into the towel and name them after specific cows he or she

intended to milk dry. Without these physical aids, the witch could not work his or her magic.

There were mechanics at work in this process, a process that demonstrated the witch was subject to certain natural laws. Furthermore, everyone had access to these laws. As later chapters will demonstrate, not only was there a magical countermeasure for every hex a witch cast, but the average person could even use witchcraft techniques for his or her own benefit without the risk of eternal damnation. On the Illinois frontier, the old English distinction between white and black magic prevailed. Witch masters, folk healers and anyone with proper knowledge could affect the natural world through supernatural means. A witch, then, was not necessarily a person who used magic, or even a person who used a magical charm to harm or influence another, it was a person who had given his or her soul to the devil. The witch carried out the devil's handiwork by habitually endangering the health and livelihood of his or her neighbors. Like predators, disease and natural disasters, the witch was a regrettable part of the natural order.

7

Defeating Witches

hile many Illinois pioneers feared witches, they also believed there were ways to combat maleficium and eliminate witches. For every hex there was a counter-hex, and the methods for removing hexes were as diverse as the afflictions they were meant to cure. Pins, nails, needles, knives, silver and a variety of spices were all employed in the fight against witchcraft. Boiling and burning were also utilized. If a witch proved too powerful for folk remedies, the afflicted called for the aid of witch doctors or witch masters. Curiously, although believers in witchcraft identified it as the work of the devil, few witch cures had religious connotations. Illinois residents of German descent had several remedies involving crosses or cross-shaped objects, but the majority of cures were secular. Witch masters were also secular figures, and although there are a few stories of the afflicted calling on pastors or priests, they more often than not sought help from witch doctors, hoodoo doctors, wizards or other individuals with purported supernatural power.

Before the hex could be broken or the witch destroyed, however, he or she had to be identified. Identification of the witch could involve something as simple as noticing unusual behavior or witnessing the witch perform some incredible feat. In the early 1930s, an African American informant from Adams County, Illinois, explained to folklorist Harry Middleton Hyatt, "About eight years ago I was running with a witch and didn't know it until one day we were out picking some fruit, and she was all dressed in black. All at once I look and she was gone. Then she appear[ed] right away wearing a white dress. Then I knew she was a witch."[182] In many witch tales, narrators

explained that the accused parties were known to be witches for many years, suggesting that some Illinoisans identified their neighbors as witches through patterns of behavior and other interactions over a long period of time. Characters like Eva Locker and Mary Toombs in southern Illinois developed regional reputations for their purported abilities.

While witches could be detected through simple observation, many Illinoisans employed methods to determine whether they had been bewitched. In the following story, a German American informant told Hyatt about a method involving dropping sticks in water. Reminiscent of the eighteenth-century practice of witch dunking, if the wood floated (as it did naturally) there was no maleficium at work. If the wood sank, then maleficium was confirmed. He explained:

> *A man had a bunch of hogs. They were sick all the time. He just could not get them fat. One day he told a neighbor about his sick hogs. This neighbor said, "Maybe someone has them bewitched. I will tell you how to find out. You take nine pieces of wood and drop them in a tub of water and if they sink, the hogs are bewitched; if they stay on the top of the water, they are not." So the farmer drop[ped] the nine pieces of wood in the tub and every stick went to the bottom.*[183]

Others used more surreptitious methods. According to one Illinois resident of Irish descent, "If you want to find out if anyone is a witch, place a pair of open scissors under her chair; and if she is a witch, she will not be able to get up out of the chair."[184] More often than not, detection of the witch involved refusing to loan a household product to a neighbor. If the neighbor continued to beg and insist, or became ill, believers identified him or her as the guilty party.

COUNTER-MAGIC

Once the witch was identified, his or her spell could be broken. There were a variety of ways the afflicted could break a spell. In addition to pins, nails, needles, knives, silver and spices, some employed coffin nails and cow manure and even amputated a piece of the afflicted animal's ear. In the following story, a German American informant told Harry Middleton Hyatt how coffin nails could be employed to break a witch's spell:

Eighty years ago my grandfather had a cow and she would sweat all the time. The cow would have a drop of water on every hair. He thought someone had the cow bewitched, so he went to a healer and he told him to go to an undertaker and ask for some old rings off of a coffin. Years ago whenever they would dig up someone that was dead, the undertaker would always save all the old rings, hinges and nails off of the coffin, and if you could get them, they would always take off the spell if someone had you bewitched. So this undertaker let my grandfather have two old rings and he hung one ring on each of the cow's horns one night, and the next morning the cow was all right and did not have any more sweat.[185]

Superstitious dairy farmers also believed cows that gave bloody milk were bewitched. One cure involved rubbing the afflicted cow's manure over its udders. "Mrs. K. had a cow, and the neighbor lady next door bewitched her cow," a German American farmer from Adams County explained. "The milk would have blood in it all the time. So a man told Mrs. K. to say some holy words and put the cow's manure all over the cow's bag. In a few days the lady next door lost her own cow."[186] An Irish American remedy for afflicted animals involved cutting off a corner of the animal's ear and nailing it to a tree. The following is a typical tale illustrating this method:

A farmer was peddling apples one day and he drove by a witch's house. She wanted some apples but said she had no money to pay for them. He said, "I can't give my apples away without money." She begged and begged but the man would not let her have the apples. Then they had a fuss and his horse fell down and broke its leg. The man went and cut off the corner of the horse's ear and nailed it on a tree close by. The horse got up and walked. The witch started to howling, "Take that ear off the tree." She was suffering. But the apple man would not do it. He left and let her suffer.[187]

Counter-magic typically involved common household items like pins, nails, needles, knives, forks, silver and spices. While boiling and burning could be used on their own (boiling a cow's bloody milk, for example), they were also used in combination with the aforementioned materials. Effigies or drawings of the witch enhanced the potency of the cure. These cures often appeared materially no different from the methods of the witches themselves. This was the "white magic" that so confounded educated elites like Cotton Mather in the late seventeenth century. Nearly two centuries later, pioneers

on the Illinois frontier still employed these magical folk remedies to alleviate maleficium and eliminate witches.

Pins, Nails, Needles and Knives

Today, piercing an object with pins or needles is commonly associated with causing harm, but on the Illinois frontier, the practice was employed to alleviate affliction caused by maleficium. Pins, nails and needles could also be burned or heated. Ollie Barnard from Shawneetown, Illinois, related the following account to folklorist Charles Neely in the 1930s. "Uncle Charles Lowry was accused of killing a witch one time," she explained. "A witch in the neighborhood bewitched him. Some one told him to put a needle under the hearth and burn it. He got a needle and put it under the hearth. The witch sent over to his house to borrow a needle. He wouldn't let her have it. She sent for him and wanted to borrow a needle to pick her teeth. He refused and she died."[188] Shawneetown is located in Gallatin County, in southeastern Illinois, near the Ohio River. The story had been passed down through Barnard's family.

Another method, found among German American communities, involved piercing the heart of an afflicted animal. One informant from Adams County wrote to Harry Middleton Hyatt, "To cause a witch to die within one minute: Obtain a piece of the heart of the cattle which has been bewitched. Then take a little butter and fry the piece in it. Then take three nails from the coffin of a corpse and pierce with them the heart through and through, and while piercing the heart the witch will die at the same moment." Another explained, "If you are bewitched, boil a beef heart and while it is cooking, keep sticking it with a needle; the witch will have the same pains, and the spell upon you will be broken."[189]

African Americans also believed in piercing as a cure for witchcraft. One informant from Adams County explained, "If you want to kill a witch, take and draw her picture on a large cardboard and drive a nail through her heart; and every morning take a hammer and hit this nail once on the head for nine days, and on the ninth day she will fall dead."[190]

Another technique involved heating a nail and dropping it into milk or cream. In the following account, related by a German American resident of Adams County to Harry Middleton Hyatt in the early 1930s, not only was a hex lifted through this method, but it also exposed and harmed

the malefactor. As in stories of wounds inflicted on enchanted animals appearing on the witch, the hot nail dropped in cream magically burned the troublesome neighbor:

A woman wanted some butter from her neighbor. The neighbor got tired of loaning her butter, because she would not bring it back. She had been borrowing for some time, so she said she did not have any. When she started to churning the next day, this woman (the lender) tried and tried to get butter, but it would not come. So she went and told another neighbor she believed this woman that she didn't let have the butter had bewitched her cream because she could not get butter. This woman told her to go home and put a nail in the fire, and when it got red-hot to drop it in the cream. This woman went home and put the nail in the fire, and when it got red-hot dropped it in the cream, and the butter came right away. And this woman that had the cream bewitched got a blister on her side just the size of that nail.[191]

This technique was not unique to German American communities in Illinois. A story from Giro (also known as Buena Vista), in southwestern Indiana along the White River, shares similar elements. According to Ronald L. Baker, author of *Hoosier Folk Legends* (1982), Giro was a German settlement where belief in witchcraft flourished. In this story, a woman named Mrs. Brown labored for hours over a wooden churn, trying to make butter without success. She concluded that a witch had put her foot in the cream, "So Mrs. Brown hurriedly heated an iron and dropped it into the contents of the churn, thus burning out the foot that was in her cream. It was only a matter of seconds that she had a generous supply of nice yellow butter." The next day, Mrs. Brown stopped by a neighbor's house and found that the neighbor's foot was badly burned.[192]

Among the German American residents of Adams County, there was a particular method of dealing with witches that involved cutting or stabbing milk they believed had been hexed. By magical means, the act of stabbing the liquid produced similar injuries in the witch's body. "A woman had a cow and it gave [bloody] milk all the time," one informant told Harry Middleton Hyatt. "She tried everything but could not do any good, so someone told her it was bewitched. So she got a witch doctor and he took a steel knife, it must be steel, he took two knives and went to cutting the milk. He just kept cutting and cutting the milk. And the woman that had the cow bewitched came with her face all cut up." Another explained:

A baby in the family had always been sick. They were buying milk from a woman. Some people thought she was a witch, but these people liked her very much and did not think she was a witch. So this other woman said, "Boil the milk until the fisk comes on the milk, and then take a fork and keep sticking it in the fisk." They did this and the neighbor woman that was selling the milk to them came running in with her face all covered with holes. So they found out she was a witch and stopped getting milk from her. And the baby got well. [193]

Like the aforementioned technique of heating a nail and dropping it into milk or cream, not only was a hex lifted through stabbing the milk, but it also exposed and harmed the malefactor.

Boiling pins in milk also appears in traditional Irish folklore. In one story from Donegal County in Northern Ireland, a woman's cow stopped giving milk. To draw out the offending witch and break the curse, the farmer boiled nine pins in a pint of milk. The witch appeared at the door complaining of being pricked by pins. [194] This suggests Scotch-Irish frontiersmen brought the technique to Illinois, where it spread to twentieth-century German immigrant communities.

BOILING AND BURNING

Although much of the previously mentioned counter-magic called for boiling or burning in combination with metallic objects like pins, nails, needles and knives, boiling or burning was also applied in other ways. The technique utilized in the following tale from Quincy, Illinois, shares similarities with the technique of stabbing boiling milk or cream but with less overt violence. Still, the result was the same: the hex was lifted and the witch exposed. In a twist, however, the accused witch recovered from her injuries and became friends with her former victim:

Sixty years ago a family were [sic] living out in the south part of Quincy. A neighbor came to borrow all the time from them and would not pay it back. So one evening she came for something and they would not let her have it. She went home angry over it. And the next morning when this man went to milk his cows, he got bloody milk. She had bewitched them. Another neighbor came in and he said, "Take that bloody milk and put it on the stove

to boil and start to beating it and saying all the time 'I beat the devil, I beat the devil.' Just keep saying this over and over and they will come to borrow again." This woman that was a witch had two children, so when they were beating that bloody milk, one of the children came and wanted something. The people would not let her have it. In a few minutes she sent the other child to borrow, and this child said, "Mother said to take that off the stove" for she was burning. But they would not take it off. In a few minutes the old woman came and said, "My God! Take that milk off the stove. I am burning to death. If you will, I will never do that again." And they took the bloody milk off the stove. And they were all friends after that.[195]

In many of these tales, the witch appeared while the counter-magic was taking effect. Superstitious Illinoisans believed injuries from the boiling liquid physically manifested on the witch, forcing him or her to come to their door to seek relief. A German American resident of Quincy, Illinois, described the process of injuring a witch by boiling water to Harry Middle Hyatt in the 1930s:

About thirty years ago a woman was living at Twelfth and Monroe Street. She would get sick all the time. They could not find out what was wrong. The doctors could not help her. Every time she would get sick, all the dishes in the cupboard would rattle, just like they were all going to fall out. A neighbor told her daughter, "Maybe your mother is bewitched. The next time she has a sick spell, go and put a pan of cold water on the stove and let it boil good, and if your mother is bewitched, the witch will come when it is boiling." So one day the mother was sick, and she put a pan of cold water on the stove. When it was boiling good, a neighbor woman came running in the house and said, "Please take that water off the stove. I am just burning up inside. I just cannot stand the pain. If you do, I will never harm your mother again." They took the pan off the stove. The neighbor went home. And the woman never had any more sick spells. And the dishes didn't rattle any more.[196]

This technique also appeared in use in Indiana. A sixty-seven-year-old man from Jasper in south-central Indiana related a similar tale to folklorists from Indiana State University in Terre Haute in March 1968. The man said the incident occurred in the late nineteenth century to a young woman who was a family friend. The young woman had been sick for many years, until a traveling umbrella mender offered to break the spell. He explained:

They [the girl's parents] *were told to fill a kettle with water and build a fire under it, and when this water would come to a boil the responsible person would appear. So they got busy and filled the kettle with water and started a fire under it. It so happened when the water started to boil, that this neighbor woman came screaming across the field and really screamed, so this hobo told her that if she wouldn't take the spell off she'd have to keep suffering, so she agreed. And the woman, this young woman, incidentally, lived to be a ripe old age.*[197]

Others believed that burning objects belonging to the witch could break spells. Superstitious Illinoisans accused witches of hiding things like feather wreaths, hoodoo bags and witch balls on their person or property. When discovered, the fastest solution was to burn these items. An African American informant told Hyatt, "I found a hoodoo bag in my yard one day. I guess someone was trying to hoodoo me. I opened it and found salt, pepper, chicken feet, a rabbit foot, ashes, and a little piece of razor. I took and burned it up. So the spell was broken." Another resident of Adams County told him, "I had such a pain in my shoulder all the time. I just tried everything. One day I happened to think that this woman, who we thought was bewitching everyone in the neighborhood, gave me some hollyhock seeds to plant. And I went and took them and put them in the stove and burnt them. After that the pain left my shoulder and I got all right."[198]

SILVER

For over a century, pioneers believed silver was a powerful weapon against witchcraft, and in nineteenth-century Illinois, coins were the most readily available source of silver. Before the Coinage Act of 1965, dimes consisted of around 90 percent silver and 10 percent copper. In addition to being composed of precious metals, dimes issued prior to 1837 were slightly larger than today, with a diameter of 18.8 millimeters and mass of between 2.5 to 2.67 grams. Dimes could be worn as amulets, boiled in water or melted down and molded into bullets. Pioneers also manufactured silver bullets by drilling a hole in a musket ball and inserting a folded dime. Smoothbore muskets, which were still in use on the frontier after the development of the rifled musket in the 1840s, were versatile weapons that could fire a variety of homemade ammunition. Witch tales frequently ended with the protagonist

Lead musket balls, circa 1860–1865. *Author's collection.*

drawing an effigy of the witch and shooting it with these silver bullets, which either broke the spell or destroyed the witch. The improvement and increase in popularity of breech-loading rifles and standardized ammunition gradually eliminated this practice.

In this typical tale, told by an Irish informant from Adams County, Illinois, to folklorist Harry Middleton Hyatt, the process by which the protagonist manufactured a silver bullet was explained in detail:

> *Some people were living by a witch and she was always borrowing from them or giving something. They always had trouble. She came to the house one day and wanted to borrow lard. The man of the house said, "No. And I don't want you to come here any more." The witch said, "You must let me have the lard for I am sick and must have it." The man let her have the lard and said after she was gone to fix her so she will not come back any more, he drawed [sic] the old woman's picture on a piece of cardboard and took it out in the orchard and tacked it on a tree. Then went to the house and got a piece of silver and beat it all up into a silver bullet. You can always kill a witch with a silver bullet. That night just at twelve o'clock this witch*

started in the yard. This man shot through her picture on the tree and the old woman drop[ped] dead.[199]

Charles Neely Sr. related the following story to his son, folklorist Charles Neely, who explained that the story "was current in the southern part of Pope County a number of years ago." In addition to a silver bullet, it also featured the motif of refusing to loan something to an accused witch:

Uncle Wesley Holt was sick with chills and fever. Medicine would do him no good. He decided at last that Old Man Toombs, the husband of Mary Toombs, had bewitched him. To break the charm he drew a picture of Toombs and shot at it with a lead ball and missed the picture. Then he bored a hole through a ball and inserted a piece of silver. Then he shot again and hit the picture between the knee and the ankle. A few minutes later one of the Toombs children came over to borrow some coffee. He refused because to borrow something would break the charm. After that Old Man Toombs was afflicted with a sore on his shin as long as he lived.[200]

Pope County is located at the southeastern tip of Illinois, just north of the junction of the Ohio and Tennessee Rivers.

In another incident that allegedly occurred near Quincy, Illinois, a local entrepreneur hired one of his workers to shoot a drawing of a witch he believed to be disrupting operations at his sawmill. In this tale, the worker had to hang his drawing near where the witch walked into her yard and shoot it with a silver bullet as she passed by:

Years ago down here in the bottom around Quincy a man had a sawmill. He had an order for seven thousand feet of lumber. He just could not get it out. He had been working on this order for about three months. Something went wrong all the time at the mill. An old witch lived down near his place and was always hanging around. He thought she was bewitching his sawmill. He said to one of his men, "I will give you a dollar if you will take a piece of silver and make me a silver bullet to kill that old witch." The man said, "I will not do it. I don't want the law after me." The sawmill man said, "The law cannot get you, if you shoot her picture and kill her." So he made a silver bullet himself and put it in the gun. Then he went and drew her picture on a piece of cardboard and put it on a tree right where this old woman would come into the yard. That night when the old woman started

in the yard, he shot a hole right through her heart on this picture. When the old witch got even with this picture on the tree, she fell dead.[201]

Bullets were not the only way to use silver to alleviate maleficium. One folk remedy was to boil silver in water and allow the afflicted animal to drink the concoction. According to William Henry Perrin, author of *History of Effingham County, Illinois* (1883), "If cattle were sick, it was the witches and nothing would do them any good except 'silver tea.' This tea was made by boiling a silver coin in water for a long time and giving the water to the sick brute."[202] Silver, particularly from dimes, could also be worn as charms or jewelry. One African American informant from Adams County explained to Harry Middleton Hyatt, "If you think you are hoodoo, put a dime in your right shoe, and if you are, the dime will turn black; then with it (putting the dime in your shoe), the spell will go back to the person that hoodoo you, and they will get the poison." Another added, "If you will take a dime and bore a hole in it and wear it all the time on you somewhere, you can't be hoodoo," and "If you tie a dime around each ankle, you can't be hoodooed."[203] This belief was not exclusive to African Americans. One Irish American resident of Adams County told Hyatt, "To keep the witches out of the house, place a dime under the fireplace."[204]

SPICES

Common household spices and other cooking ingredients, like pepper, alum, tallow and cornmeal, were also used to ward off witchcraft. Alum powder, found in the spice section of many grocery stores, was used in pickling recipes as a preservative to maintain fruit and vegetable crispness. Tallow is beef or mutton fat that can be kept at room temperature for extended periods if sealed in an airtight container. Both ingredients were common in frontier kitchens. Salt, long associated with purity and spiritual cleansing, was sprinkled around the home. Both African Americans and German Americans in Adams County told Harry Middleton Hyatt to use salt if he wanted to keep witches away. "If you see someone coming to your house and you think they want to hoodoo you, run and put some salt around the door," one informant told him. "They will come in and they cannot hurt you." Another said, "If someone comes to your house and you think they are putting an evil spirit on you, just as soon as they leave, sprinkle salt all

around the chair they were sitting on and put a little on the seat of the chair, and they can't do you any harm."[205]

The combination of salt and pepper was also a powerful abstergent. Like salt, the use of salt and pepper crossed ethnic lines. Two African American informants told Hyatt, "If you think someone has a spell on you, put red pepper and salt in all four corners of the room. It will take the spell off. If someone come to your house and you don't want them to come back, take salt and red pepper and mix good, and throw it at them as they are leaving." Similarly, a German American told him, "If you think someone is trying to do you harm, take and put salt and pepper together and take it to your front gate and throw it around, and if they come to your house, they will not be able to step over that salt and pepper."[206]

Other counter-magic involving household goods resembled recipes, with a variety of ingredients. When interviewed by Harry Middleton Hyatt, African American residents of Adams County in particular described elaborate recipes for breaking spells:

> *The old man eighty-four years old told me he went down to Washington Park this fall. Someone hoodoo him. He was sitting on the bench, and when he wanted to get up and go he could not get up. Someone had to help him up and to the car. So the next time he went down, he said he was going to fix his shoes, so if he walked over any hoodoo balls it would not hurt him and he would be able to get up off of the benches. So he went and burned some alum, some salt, and took some tallow, and put that all together and put it on the bottom of his shoes. That will keep anyone from hoodooing you. After he put that on his shoes, he went down in the park and did not have any more trouble.*

Another said, "If you think you are hoodooed, take one pint of salt, one pint of corn meal, one pint of your urine. Put that in a can on the stove at twelve o'clock at night and cook until it burns. Then throw the can and all away and your hoodoo spell will be off."[207]

CROSSES

Religious objects did not feature strongly in Illinois witch lore, but Harry Middleton Hyatt did collect some examples from the German American

residents of Adams County. Crosses could act as a barrier—a force of protection—and were used to break spells. According to one informant,

> *A neighbor was very sick, and the next door neighbor man told this neighbor not to let his wife in, that she was always practicing evil power on the sick. They said, "How can we keep her from coming in the house?" He told them to put a cross over all the windows and doors, and she will not be able to come in. They went and put a cross over every opening, and the next day when this woman went to see her neighbor, she could not get in the door, she had to holler through the window. And this woman got well after that.*

Another said, "If you think someone has a spell on you, take a fork and a rusty nail and cross them and stick them in the ground. This will break the spell." A third counseled to make the sign of the cross three times (invoking the Holy Trinity) when you meet a man or woman who you think is a witch.[208]

WITCH DOCTORS

When folk cures failed, superstitious Illinoisans turned to witch doctors, hoodoo doctors, wizards or other individuals with purported supernatural power. Based on folklore accounts and newspaper articles, witch doctors apparently offered their services in Illinois and neighboring states as late as the 1930s. When none were available in their area, Illinoisans crossed the Mississippi River to cities like Hannibal, Missouri, and Keokuk, Iowa, to obtain their services. It makes sense that people who believed themselves to be suffering from witchcraft would seek a cure and that some enterprising individuals would step forward to provide that cure.

The witch doctor is found in many cultures, but the American frontier tradition was directly imported from Great Britain. Many seventeenth- and eighteenth-century English pamphlets, like the *Old-Bayly* proceedings report for June 1–2, 1682, mention witch doctors, whose methods often differed little from the witches they sought to combat. The *Old-Bayly* report concerned the trial of a sixty-year-old woman named Jane Kent, who was indicted for "using several Diabolick arts" involving the death of a five-year-old girl named Elizabeth Chamblet. Elizabeth's father had sold the elderly woman two pigs but refused to relinquish them without receiving payment

beforehand. Soon after, his daughter Elizabeth "fell into a most piteous condition, swelling all over her body," and later died.

Fearing for his wife's safety, the father consulted a doctor who "advised him to take a quart of his wive's water [urine], the pairing of her nails, some of her hair, and such like, and boyl them." After mixing the concoction, he swore that Jane Kent screamed in pain and became bloated. Other persons testified that the old woman had a teat on her back and other unusual marks. Despite that testimony, the jury found her not guilty because she produced "evidence that she had lived honestly, and was a great pains-taker, and that she went to church."[209]

On the Illinois frontier, there was often no distinction between a doctor who treated common illnesses and one who combated witchcraft. These men carried on the tradition of the old English concept of the "good," or "white," witch. According to H.C. Bradsby, editor of *History of Bureau County, Illinois,*

> *The first step toward a cure probably was the appearance of the "wizards." These were men, witch doctors, who were supposed to possess all the evil power of the witches, but instead of generally exercising them for bad purposes they would cure those afflicted by witches, and in many occult ways thwart the spirits in their fell works. These witch doctors boldly stood in the way of the malevolent influences of the bad spirits. Hence they were called witch-masters, and from patient to patient they practiced their profession as regular physicians.*[210]

Residents of Adams County, Illinois, ascribed a variety of powers to witch doctors. According to one German American resident, a woman must go to a male witch doctor and a man must visit a female witch doctor if they fell victim to a hex. According to another, "A witch doctor can tell if you are bewitched when he looks at you, for if you are, he will see white clouds floating around you." Others utilized the age-old remedy of silver to aid their diagnosis. "If you are sick, a hoodoo doctor can tell if you are sick or hoodoo by putting a dime in your mouth, if the dime turns black, you are hoodoo; if it don't, you are just sick," an African American informant explained.[211]

Sometimes the afflicted called a witch doctor at their own peril. Tina Goodwin of Carbondale, Illinois, related the following incident to folklorist Grace Partridge Smith shortly after World War II:

An old lady, Grandma Anderson, told a story about a woman who was very sick. Someone in the invalid's family went to a witch doctor in the neighborhood to see if she couldn't give them a remedy for the sick woman. So the witch doctor gave them an object that looked like a curry-comb and told them to put it on the sick woman's chest, teeth down. *It pressed fearfully on the woman's skin but she endured it for several days. She woke up one night and couldn't stand it any longer. She was in such pain, she decided to turn the object over so the flat side would be on the chest and the teeth side* up. *This made her much easier. Later they found out that the witch doctor was very sick with her chest inflamed and bleeding.*[212]

Harry Middleton Hyatt recorded several tales of local residents of Adams County calling on witch doctors when they suffered maladies they could not explain. These stories were cross-cultural, coming from both German and African American informants. In one incident, alleged to take place near an unincorporated community north of Quincy called Rock Creek Station, a German American farmer sought help from "an old colored woman" when he feared a man was using witchcraft to take his farm. Some witch doctors used salt and other common remedies, while others informed the victims of what to look for if they wanted to alleviate the spell. Midnight featured prominently in two of the tales as the hour the witch appeared, as well as the act of walking or reciting something backward.[213]

When medical science seemed to have no cure, superstitious Illinoisans turned to witch doctors for help. An African American resident of Adams County explained to Harry Middleton Hyatt, "My uncle was hoodoo. Someone put a lizard and a beetle bug in his arm. You could see them run up and down his arm. He would just have fits every time the lizard and beetle bug would move, he was in so much pain. His arm got as large as a stovepipe. They had one doctor after another and he could not help." Much to his relief, a hoodoo doctor was nearby and offered to remove the spell:

First thing he done was to throw salt all around the room. Then he took a bottle out of his pocket and chew up some roots and spit that in that bottle. Then he put a heavy cord string around this man's arm, right where those things were, and tied it real tight. Then he cut his arm and let all that blood run in that bottle. The hoodoo doctor put the bottle on the shelf and said, "Don't look in it until I come in the morning." And said, "The man that hoodoo you will come tomorrow at twelve o'clock." Coincidentally, at exactly Midnight, the man responsible for tormenting him ran past his home

at the proscribed time. When the hoodoo doctor came the next day to show us what was in the bottle, and there was that lizard and the beetle bug that came out of his arm in the bottle, and the man got well right away.[214]

Despite their best efforts, witch doctors were not always successful, as the following story from a German American resident of Adams County illustrates. In this case, the witch proved to be too wily in her animal form to catch:

A little girl was crying all the time. She would cry every night. The doctor could not find out what was wrong. And a witch doctor came along. He said, "Someone has your little girl bewitched. Someone is squeezing her kidneys and making her cry. You watch tonight at twelve o'clock and a black cat will go through the yard and your little girl will be better. Try and kill the cat if you can." They had all the neighbors looking for the cat, but when it went through the yard at twelve o'clock, they could not kill the cat.[215]

The line between witch and witch doctor sometimes blurred. As World War I raged overseas and Chicagoans prepared to celebrate Thanksgiving, a modern-day witch hunt threatened to erupt in the near-western suburb of Melrose Park. Incorporated along the Des Plaines River in 1882, the village of Melrose Park was predominantly settled by Italian immigrants. In 1915 and 1916, an elderly woman named Carmella Vosella became known as the "Melrose Park Witch," though she insisted she was Christian and only used her powers for good. Carmella's practice of selling old Italian charms and folk remedies came to light in a series of legal proceedings that had Melrose Park police chief Henry Pein vowing, "We are going to rid Melrose Park of witchcraft."

On Saturday November 20, 1915, a man named Tony LaRocca appeared in a courtroom in the neighboring suburb of Oak Park to answer charges that he threatened Carmella Vosella with a revolver. At the trial, LaRocca caused a sensation by claiming Carmella was a witch and "chaser of devils" who beat the devils out of their human hosts—"all of which may be efficacious for devils, but inconvenient anatomically," quipped the *Chicago Daily Tribune*. Following the trial, Dr. P.B. Klonks, Melrose Park board of health president, called the charges "bunk," despite the insistence of LaRocca's attorney, Clarence Baseler, to the contrary.[216]

Not everyone in Melrose Park considered the accusations of witchcraft bunk. On the night of Tuesday, November 23, police arrested Carmella at her home on North Twenty-First Avenue following interviews with her

'WITCH' HELD FOR INQUIRY INTO STORIES

Mrs. Carmella Vosella of Melrose Park Arrested; Police Will Lay the Charges Before Hoyne.

Woman Declares People She Has Befriended 'Have Gone Crazy' and Denies Their Stories.

Mrs. Carmella Vosella, "the witch of Melrose Park," was arrested last night, following investigations into her alleged practice of witchcraft in Melrose Park, conducted by the village police and the president of the village board, Charles J. Wolf. Mrs. Vosella was arraigned at once before Justice of the Peace Frank R. Vosburgh, who continued the case until December 1 to permit further investigation by the police.

Several of the alleged victims of Mrs. Vosella were visited yesterday by Chief of Police Pein and questioned as to their charges that the woman had conducted a sorcery business in the village with highly remunerative results. After the investigation Chief Pein announced he would bring the evidence collected before State's Attorney Hoyne to-day, and that charges would be brought against the "witch" by the village to be submitted to the December grand jury.

Assistant State's Attorney Michael F. Sullivan said last night that if the charges against the woman were found to be true he would ask the grand jury for an indictment, charging the operation of a confidence game.

alleged victims conducted by village board president Charles J. Wolf and Chief Pein. Henry Pein was appointed Melrose Park's first police chief a year earlier. He was a clean-cut man with a tidy mustache, and his uniform included a large white derby and black bowtie. In 1923, Pein was shot in the arm and pelvis while trying to apprehend a suspect. He survived and retired six years later.[217] Among the alleged victims was Carmelia DeMarco, who accused Carmella of causing the death of her son. Carmella was the boy's godmother. She was arraigned before Judge Frank R. Vosburgh the next day, and Vosburgh continued the case until December 1 to permit further investigation by police. Chief Pein delivered his evidence to State's Attorney Hoyne and announced the village would seek charges against Carmella for running a confidence game.

Father Benjamin Franche, pastor of Mount Carmel Catholic Church, alleged there were more witches in Melrose Park, but village president Wolf found that allegation groundless. "The only other person who might be engaged in sorcery is Mrs. Vosella's brother-in-law," he told the *Chicago Examiner*. "This man, whose name we have not learned, was mentioned in the charges against Mrs. Vosella, and is now under police surveillance. We have no real evidence against him yet."

"'Witch' Held for Inquiry into Stories." *From the Chicago Examiner, November 24, 1915.*

While Carmella denied taking her accusers' money, she did not deny helping them with the aid of supernatural means. "No, I can't tell you [what] I used to cure them," she said. "It is a secret, but it is nothing wrong. I never beat or threatened anyone." She continued, "Look at this crucifix. I always carry it, and yet they say I get my powers from the devil. The policeman told me I would have to go before the grand jury, and all because the people I have tried to help have gone crazy." Her attorney, Geatane C. Guarini, countered the charges by arguing that "other witches operated unmolested in the village."[218]

At a court hearing, a man named Samuel Culguizza (Gugliuzza) testified that he paid Carmella to relieve him from his partial paralysis. Relief, however, quickly turned to torment. He explained:

> *I was paralyzed in my right side. I was told Mrs. Vosella could cure me. She told me I wasn't sick at all. She said there were a lot of devils in me and she would drive them out for $200. That was almost all the money I had, but I wanted to get well, so I paid her $200. She called in her brother-in-law and threw me down on the floor and beat me with a club. Then she and he both walked on me and pulled my ears and my hair and slapped my face. That was to drive out the devils, she said. But the devils wouldn't go away unless I paid her more money. So I have her more. She always wanted uneven amounts—one time it would be $7.33, another $10.11, and so on. I had to have the right change. Then she made me bring her oranges and knives to use, because she said I was full of devils and it would be a hard job to get rid of them all.[219]*

Tony LaRocca's wife testified that she paid $100 to Carmella for similar relief from evil spirits. LaRocca was the man whom Carmella originally accused of threatening her with a revolver.

Despite this testimony, on December 11, 1915, Judge W. Stevens Lewis dismissed the charges for lack of evidence.[220] Carmella's legal troubles did not end there, however. Clarence J. Bassler, attorney for Samuel Culguizza, filed a separate lawsuit against Carmella to recover $107 he allegedly paid her to cure his paralysis. At some point between December and April, when the suit went to trial, Culguizza died, leaving behind a widow and sixteen-year-old son, James. James testified that Carmella's "cure" involved slapping his father's hands with the flat of a knife, clubbing him on the floor and kicking him in the ribs. A cement worker testified that he saw Carmella "pursuing Gugliuzza three times around her basement until she caught him

and began to whip him." Carmella denied beating him or receiving money from him; however, she did not deny trying to cure him with the aid of "a charm she had learned in Italy."[221]

In 1904, a startling case of suicide shed light on the world of witch doctors, revealing much about their practice in small-town Illinois. That September, in Quincy, after several months of battling deep depression, a nineteen-year-old girl named Bessie Bement committed suicide in the home of her grandmother Elizabeth Weisenberger by drinking carbonic acid. Quincy, then a bustling town of over thirty-six thousand people on the Mississippi River, is the Adams County seat and was a bastion of abolitionism prior to the Civil War. Quincy was primarily founded by Yankees from New England, but in the 1840s, German immigrants changed the character of the town. They settled in tightknit communities on Quincy's south side and kept so many milk cows that the neighborhood became known as "Calftown." Weisenberger and her granddaughter lived on State Street, just a few blocks west of the Mississippi River.

In mid-August, Bessie Bement and a friend named Zimmerman visited the home of Dr. Franz Bacher, which was located on Broadway Street near where Blessing Hospital is today. The *Quincy Daily Whig* described Dr. Bacher as

GIRLS' SUICIDE REVEALS DEATH BY "WITCHCRAFT," STARTLING METHODS OF AGED QUINCY "DOCTOR"

Investigation of the Case of Bessie Bement, Goaded to Take Her Life, by an Imagined Evil Spirit, Brings Forth Facts Like a Chapter on the Black Arts.

DEVOTEE OF NECROMANCY MAKES HIS STATEMENT

Tells, in Common-place Way, How the Girl Was "Treated" for "Witchery" and How the Laying Aside of a Charmed Belt May Have Cost Her Life —"Doctor" Has Student and Devotees—Remarkable Conditions Disclosed.

"In the case of Bessie Bement it now is stated that she was not entirely personally responsible for her deed of self destruction, it is stated by Dr. F. Bacher that Miss Bement applied to him for advice as she thought that she was bewitched. Dr. Bacher told her to examine her pillow. She did so and found a reeth in it, a combination of a string with feathers attached to it. Dr. Bacher told her to burn it, which she did, as far as known. It is stated that she was mostly downcast, and acted as though she was not entirely responsible for such a deed as to commit suicide. Miss Bement received some medicine from Dr. Bacher after which he heared nothing from Miss Bement until he seen the notice in the Whig that Miss Bement had committed suicide."—Formal written statement on Bement case by E. W. Knopfmeier, "Student to "Dr." Bacher.

"Girl's Suicide Reveals Death by 'Witchcraft'." *From the* Daily Whig *(Quincy, IL), September 28, 1904.*

"stooped beneath almost 80 years, gray, thin and feeble," a man who walked with a cane and possessed a "quavering voice." An immigrant from Forst, Germany, he practiced his own form of medicine in a one-story modestly furnished home set back on the lot. His nephew E. William Knopfmeier was his student and assistant and had traveled from Indiana to study under him. "Don't call me a hoodoo doctor, please," he asked the *Daily Whig* reporter who dropped by to interview him after the suicide. "I have been practicing medicine since 1873, and I know when a person is suffering from a visitation of a hoodoo or bewitchery," he explained. "Why, it is bewitchery that fills our insane asylums—poor people, there suffering and pining away because their physicians doctor them for something else, when they are under the spell of some hoodoo. I believe in medicine, but only a very little of it."

During the interview, several visitors called on the doctor to inquire about cures. Several years earlier, in 1901, Dr. Bacher had been arrested for practicing medicine without a license, but the jury acquitted him because his practice predated the state law requiring doctors to possess a medical license. Editors at the *Daily Whig* questioned several state's attorneys in the area about pressing charges against Dr. Bacher, but they explained there "was no law against practicing necromancy, the black art, or any other of the numerous fakes."[222]

When Bessie Bement called on Dr. Bacher complaining of lethargy and depression, he told her to examine her pillow. She returned the next day with a bundle of feathers wrapped in string, which Dr. Bacher's nephew referred to as a "reeth." Dr. Bacher instructed Bement to burn the feather wreath and gave her steel belt to wear, which he sprinkled with an unknown powder. The belt was described as a little more than an inch in width. She then left and attended the St. Louis World's Fair for several weeks. On their way home, she allegedly told relatives that she would gladly die if it meant shaking off the curse from the wreath. Shortly thereafter, she drank carbonic acid.

According to Dr. Bacher, it was her failure to wear the steel belt while she was away that led to her relapse and suicide. The *Daily Whig* was outraged at this explanation:

> *Therefore, she died. So the facts disclose. Died, because of a false fear impressed on her credulous mind by combined ignorance and craft, died by poison self-administered rather than longer endure the imagined ills of witchery; died because in the nooks and corners of the great world there are still believers in dream books, charms and witch broth, and pretend wizards*

BESSIE BEMENT, THE YOUNG SUICIDE, CONSULTED DR. BACHER

For Relief From Uncanny Spell—Was Told to Look Under Her Pillow for a "Reeth"—Found, Then Burned It, and Was

Given a Belt of Steel to Wear—Autopsy Was Held on the Body— Funeral Today.

It will be remembered that at the inquest over the remains of Miss Bessie Bement, the unfortunate girl who committed suicide Monday morning at 326 State street by taking carbolic acid, Mrs. Joe Bowen, a witness, testified that the girl had told her that she appeared to be bewitched and felt as though she was petrifying.

This notion that she was under the spell of some uncanny spirit actually led her to consult one said to be possessed of the skill necessary to combat these evil influences. This is "Dr. Franz Bacher," as designated by a sign board nailed to the wall of No. 1025 Broadway. With the doctor lives his nephew, a bright young man, who says that he came to Quincy some two years ago from his home in Indiana for the purpose of studying under his uncle and then attending college and becoming an M. D.

"Bessie Bement, the Young Suicide, Consulted Dr. Bacher for Relief from Uncanny Spell." *From the* Daily Whig *(Quincy, IL), September 28, 1904.*

to take advantage of credulity, innocence and superstition—a suicide to escape the "reeth."[223]

The case of Bessie Bement and Dr. Bacher reveals that even after the turn of the century, some residents of Adams County, Illinois, continued to seek out "doctors" to cure them of what they believed to be hoodoo or witchcraft. When Dr. Bacher instructed the young woman to look in her pillow for feathered wreaths, he was repeating age-old advice passed down from his pioneer predecessors. Was this frail, elderly man simply a relic of this earlier time, or did the presence of an apprentice suggest the tradition would be carried into the twentieth century? According to historian Owen Davies, Dr. Bacher's nephew, Knopfmeier, failed to continue the family business. He was drafted in World War I and became a clerk.[224] In a conclusion that would have satisfied editors at the *Quincy Daily Whig*, today, Blessing Hospital's campus sits over the former location of Dr. Bacher's tiny office on Broadway Street, serving as a fitting metaphor for the triumph of modern medicine over folk cures and superstition.

STATE IS TO INVESTIGATE

Medical Society Orders Attorney to Look Into Bement Case.

DETECTIVES CONFIRM THE STORY

Secure Belt Which Was Given by Bacher to Ward Off Witchery.

THE AUTHORITIES STAND STILL

State's Attorney Will Look Up the Law, He Says— Bacher Is Mum.

"State Is to Investigate: Medical Society Orders Attorney to Look into Bement Case." *From the* Daily Whig *(Quincy, IL), September 29, 1904.*

Folk Magic

The work of folklorist Harry Middleton Hyatt revealed that there were, quite possibly, three types of aspiring magic users on the Illinois frontier. While witches were people who purportedly sold their souls to the devil in exchange for occult powers, and witch masters used magic to combat witches, there also existed a third category: the common person who attempted to use magic to gain advantage over his or her neighbors. In the course of interviewing residents of Adams County about their beliefs regarding witchcraft, dozens of informants from all backgrounds told Hyatt how to influence people and events through magical means, without the aid of an emissary.

These accounts included simple superstitions, such as "If you have not seen anyone for a long time, take their picture and put it behind the looking-glass and they will come soon," as well as more elaborate rituals and potions. For example, "If you want to put a spell on someone, take a bottle and put a penny in it and two live cockroaches, and put it on their doorstep so the party will have to pick it up. And you will have a spell over them as long as they have the bottle in their hand."[225] Though closely resembling the magic allegedly used by witches and witch masters/doctors, users did not consider themselves to be either, much like a person who rotates his or her own car tires does not consider him or herself to be a mechanic.

If these informants are to be believed, a rich subculture of folk magic existed in Adams County. The lack of this folk magic in other folklore accounts could mean that Adams County was somehow unique among other counties in Illinois, or it could mean folklorists like John W. Allen and

Charles Neely did not record them. *Legends & Lore of Southern Illinois* (1963) only hinted at these beliefs. John W. Allen observed that southern Illinoisans had particular superstitions about animals, weather and the celestial bodies. For instance, "Everyone knew that the worm of a rail fence should be laid in the light of the moon," he explained. "Unless this precaution was observed, the bottom rails would sink into the ground. When laid during the moon's increase, the rails remained on the surface of the ground, lasted longer, and besides, the fence remained a bit higher." Likewise, bacon from hogs killed in the light of the moon was allegedly meager and fatty, while bacon from hogs killed in the waning phase of the moon was juicier and retained its bulk.[226]

Only one bit of folk magic appeared in Allen's collection of southern Illinois folklore—a spell for blinding an enemy using a frog. "Anyone wishing to bring misfortune upon another can do so by proper use of a frog," he explained. "To do this, the frog is captured, placed in a jar and allowed to starve and dry. It is then ground into powder and some of this powder is placed beneath the hatband of the intended victim. Blindness will result."[227] An anonymous African American resident of Adams County prescribed a nearly identical method in *Folk-Lore from Adams County, Illinois* (1935). "If you are mad at someone and you want to do them harm, take a frog and put it in a bottle and let it starve, then dry that frog and make a powder of it, and put that powder under their hatband without them knowing it, and the poison will go down in their eyes and they will go blind," he explained.[228] At the very least, this shows that this particular bit of folk magic appeared in both southern and western Illinois. Perhaps others did as well but were never recorded.

The following accounts of folk magic are exclusively taken from Harry Middleton Hyatt's *Folk-Lore from Adams County, Illinois*. Unfortunately, there are no other sources available. We can only assume, like the blinding powder made from frogs, at least some of the beliefs regarding folk magic were shared in other regions of Illinois, but this assumption cannot be confirmed. Another problem with Hyatt's collection was the anonymity of its sources. Hyatt labeled each account with the race and ethnicity of its contributor—"Negro," "German," "Irish" and so forth—but omitted any other identifying information. Each account is numbered consecutively, but there is no way to determine whether more than one account came from the same source. What we do know is when and where Hyatt conducted his interviews. He explained in his preface, "At least ninety-five percent of the present collection was gathered within the ten square miles comprising Quincy and its immediate environs." So the following examples of folk magic

were obtained in the early 1930s from a few hundred individuals living in a ten-square-mile area in Adams County, Illinois.

Given these facts, it is problematic to conclude that a widespread belief in folk magic existed throughout Illinois. It would be safe to assume, however, that individuals in neighboring counties shared at least some of these beliefs. More than simple superstitions, they were carefully thought out potions, spells and charms for manipulating people and events by supernatural means. These potions, spells, and charms were designed to bring love, attraction and money to the user and spread affliction, insanity and even death to his or her enemies. Reptiles and amphibians also featured prominently in folk magic. The following accounts are a small sample of Harry Middleton Hyatt's collection, but they give a well-rounded picture of folk magic as practiced in western Illinois at the dawn of the twentieth century.

LOVE AND ATTRACTION

Winning love, attracting a man or woman and keeping them faithful was (as it always has been) a primary concern, and much of the folk magic Harry Middleton Hyatt recorded was dedicated to those ends. It comes as no surprise that African, German and Irish Americans all expressed those concerns, but it is surprising how similar their beliefs were when it came to obtaining love and faithfulness by magical means. Given the similarity of accounts spanning different cultures, it seems residents of Adams County were not shy about sharing magical prescriptions across their community. Blood, particularly a woman's blood, featured prominently in these spells, but pubic hair and urine also played a role. It makes sense that fluids and hair from the pubic region would form the basis for love spells. Most love spells were examples of what Sir James Frazer, author of *The Golden Bough* (1890), called contagious magic. Contagious magic involved the use of physical ingredients that were once in contact with the person or a thing that the user intended to influence. The physical proximity of material items, such as hair and blood, and the ingestion or binding of these items, was believed to increase the spell's potency.

Blood featured prominently in love spells dedicated to keeping a loved one faithful. According to one African American informant, blood from a woman's arm (mixed with tomato juice to disguise it) should be dropped in soup and fed to her husband or lover to keep him faithful. "If you will make

vegetable soup and put something red in it, like tomatoes, and a few drops of your blood, it will make him love you forever," he or she explained. "I know a woman that had a man and he was running with every woman he saw. She made a big pot of vegetable soup and put something red in it, and a little blood out of her arm; and say, he got so tame that he never went away from the house any more and would not look at another woman."

Others, including both Irish and African American residents of Adams County, advocated putting drops of blood in their husband's coffee. "If you want to keep your beau or husband, take two drops of blood out of your arm and put it in his coffee, and they will love you forever," an Irish American informant told Hyatt. "I had a beau once and I thought a lot of him. I thought I was going to lose him, so I took two drops of blood out of my arm. My, but my arm was sore, for three weeks; but after I put the two drops of blood in his coffee, he could not do enough for me." Ingestion was not the only method for winning loyalty through shedding blood.

Another technique involved writing the name of your loved one on a piece of paper in your own blood. According to one African American informant, "If you want to make your sweetheart love you, take a needle and pick your ring finger of your left hand until it bleeds. Then take that blood and write his name and your name on a piece of paper. Draw a circle around the names with the blood. At nine o'clock at night bury that paper in the ground without anyone knowing it, and he will always love you." More explicitly, a German American resident of Adams County added, "Let a woman write her sweetheart's name with some of her menstrual blood, and he will fall in love with her."[229]

Other spells for winning faithfulness involved an assortment of various techniques, including the use of bodily fluids, hair, precious metals, writing, boiling and burying. One example of a highly elaborate spell came from another German American resident of Adams County. He or she explained, "To bring your husband or beau back, take a piece of gold, a piece of silver, some of his urine, a lock of his hair, a lock of your hair; put that all in a bottle and fill the bottle with whiskey. They just can't stay away from you as long as you keep that bottle." An African American informant explained a much simpler technique to Harry Middleton Hyatt. "If your husband is running with someone, take some of his hair out of his head and put it in some of your urine and boil it," he or she said. "Then bury it under the door and he will not go with her any more." Other spells involved sprinkling the jilted lover's urine under his or her bed or writing compliments about the target on a piece of paper and burying it. When the paper rotted, the practitioner hoped, his or her unfaithful love would return.[230]

A cross-cultural prescription for making a person fall in love involved using strands of hair from either the pursuer or the pursued. This hair included pubic hair as well as hair from the target's head. According to a simple Irish American spell, "If you want to catch a man and keep him, take three hairs out of his head and three hairs from your private hair. Tie these together and bury them, and you will sure get him and keep him."

Bringing the practitioner's pubic hair in physical contact with something belonging to the target was believed to be a powerful influence over them. "Pull out a few hairs from your privates and put them in the hatband of the man you want to love you. These hairs will lie against his brain and make him crazy about you," a German American resident of Adams County explained. Sometimes just placing the hairs somewhere on the target was good enough. An African American informant told Harry Middleton Hyatt, "If you want to catch a man, take some of your private hair and put it in his coat pocket and do not let him know it, and you will sure get him." Another hoodoo love spell involved taking a few strands of the target's hair, sewing them into a red flannel bag and burying it two inches in the ground under their doorstep. In order for the magic to work, a piece of pine board must be placed over the bag before it is buried.[231]

MONEY

Although a handful of spells for obtaining money appeared in *Folk-Lore from Adams County, Illinois*, it was not as much a concern as might be expected. Two prominent examples come from African American informants interested in plying money from their husbands. Both involve variations of sprinkling ingredients mixed with red pepper around the house for several days. "If you want your man to give you all of his money, take a pinch of salt, a pinch of red pepper, and put it in a cup of chamber lye and sprinkle it around in his room," one explained. "Do this every day for a week and he will give you all of his money." The other told Harry Middleton Hyatt, "If your husband don't give you his money, take your urine and put red pepper in it and sprinkle it through the house, then sweep it up into one corner of the room. Do this for three days and he will give you his money, I know a woman that is putting her urine and red pepper through the house right now, and her husband is giving her every cent of his money. She told me it worked fine."[232]

Affliction

Judging by the number of spells Harry Middleton Hyatt recorded for tormenting a neighbor, early twentieth-century residents of Adams County were preoccupied with using folk magic to commit maleficium. These spells were designed to cause sickness, pain, insanity and hair loss in the victim, utilizing a variety of techniques, including writing the victim's name on a piece of paper, driving a nail into the victim's footprint, putting ashes or sulfur in the victim's clothing and urinating on the victim's comb. According to one German American informant, "I had an enemy. She was talking about me all the time and saying things that were not so. One morning I got up and wrote her name on a piece of paper before sunrise and went out in the yard and buried it, standing, looking to the east, and saying the Lord's Prayer. I did this for seven mornings. Right after that, this woman got real sick and sent for me and told me she was very sorry for what she had done." Sickness could also be inflicted, according to an African American resident of Adams County, by putting sulfur on a piece of the victim's clothing, then burying it.[233]

African Americans, in particular, seemed interested in harming a person's feet and causing hair loss. Among other techniques, filling the victim's shoe with hot ashes and burying it was believed to cause the victim to experience a burning sensation in his or her feet. Practitioners of hoodoo were also believed to be able to cause a person to continually walk to exhaustion and expiration. One informant told Hyatt, "If you do something to a person they don't like, they can drive a nail in your footprint and it will make you walk yourself to death; and if they want you to stop walking, they take the nail out of your footprint and throw it into running water and they will stop walking."[234] To cause baldness, one African American resident of Adams County recommended putting tar on an enemy's comb. Urine could also be used. "I know a woman that had beautiful hair and another woman was jealous of her hair but didn't let her know it," another informant explained. "She was always wanting to comb it, and she bewitched it. While she would comb it, she would always put pee on it. The other woman did not know it, and one day all her hair fell out of her head over her putting that pee on to bewitch her hair."[235]

Believers also turned to sympathetic magic to harm their enemies. Sympathetic magic involved the use of images or physical objects that in some way resembled the person to be affected, much like drawing an image of a witch and striking it caused injury to the alleged witch. An Irish American

resident of Adams County explained, "If you want to get even with someone, take and draw their picture on a board and put it on a white oak tree. If you put the nail through their eyes, their eyes will go out; if you put it through the side, they will have a pain in their side. You can make them hurt wherever you want them to. Just drive the nail where you want them to hurt."[236]

If a person wanted to cause someone to go insane, believers imagined, he or she could do so using strands of the victim's hair. Because hair is closely associated with the head, and the head with madness, the victim's hair was a logical target for inducing madness through magical means. Similarly, natural events like decay, running water and even the pressure of a growing tree acting against the victim's hair was believed to impart those effects onto the victim's brain, causing him or her to go insane. "A person can take your old clothes and run you insane," an African American resident of Adams County explained. "They take your clothes and hair and mix it with some kind of stuff and bury it in the ground, and it will cause you to go to an asylum for the rest of your life. I don't see how it's done, but people say they can do these things." Alternatively, "If you want to make someone lose their mind, throw some of their hair in running water and their mind will wander on just like the hair is wandering on in the water." A more elaborate technique involved cutting a small hole in a growing tree, placing a few strands of the intended victim's hair inside the hole and then resealing it using the cut out pieces. As the tree grew, it exerted pressure against the hair, and by magical transference, that pressure slowly caused the victim to lose his or her mind.[237]

DEATH

Harry Middleton Hyatt recorded a disturbing number of spells dedicated to ending the intended victim's life. Practitioners of folk magic, it seemed, imagined a variety of ways to kill their neighbors. Not content with instantaneous demise, many of these spells were specifically designed to cause the victim to suffer and "fade away." The acting of burying an image of the victim or the victim's clothing featured prominently, and again, physical decay and contact with materials like ashes (associated with burning) were important catalysts. Informants repeated some of the same spells used for inflicting harm and insanity but with slight variations. The same technique for using a tree and the victim's hair to inflict madness, for example, was also believed to bring death. According to one African American resident of

Adams County, "If you don't like someone, if you can get some of their hair and nail it on a tree; when that [tree] starts to grow, they will die." Another explained, "If you want someone to die, take and drill a hole in a tree, then take some hair off the back of their head and put in this hole, then plug it up; and they will start to fade and then die."[238]

The act of burying a victim's clothes appeared cross-culturally, the idea being that as the victim's clothes rotted in the ground, he or she would also physically waste away. An Irish American informant told Hyatt, "If you have got it in for someone, get one of their dresses, if a woman, and if a man, a pair of their pants they wear, and bury them; and when the pants or dress rot, they will die." Similarly, an African American explained, "If you can bury anyone's dirty clothes down by a stream of running water, when that cloth rots they will start to fade and die."[239]

Just as superstitious Illinoisans believed burying a victim's clothing would bring death, they also believed burying or submerging a photograph of the victim would have the same effect. Including something physical from the intended victim, such as hair, increased the potency. In one spell, the practitioner placed a lock of hair and a photo of his or her intended victim in a bottle and then filled the bottle with urine. In another, a photo was combined with burnt straw and buried. "If you want someone to die, dig a hole in the ground, then put some straw in that hole, then get the picture of the one you want to get rid of and lay on that straw, then light that straw without touching that picture, and let it burn," a German American resident of Adams County explained. "The ashes will fall in that hole, then cover them up with dirt, and they will soon get sick and die." Naturally, cemeteries were also associated with death in folk magic. According to an African American informant, burying a photo of someone in a cemetery caused him or her to die. Allegedly speaking from personal experience, the informant explained, "I know a girl that had a beau years ago and he got angry at her, and took her tintype and put it in a little box and took it out to the cemetery and buried the box; and the girl started to fade, and it was no time until that girl died."[240]

Reptiles and Amphibians

A great many examples of folk magic from *Folk-Lore from Adams County, Illinois* involved reptiles and amphibians. Superstitious Illinoisans, particularly

African American believers in hoodoo, employed lizards, snakes, salamanders and frogs in an attempt to annoy and torture their neighbors. They imagined that powder made from these animals could cause hundreds of smaller creatures to erupt inside a victim and torment him or her. The following story from Quincy, written from the perspective of a young hired hand, gives an interesting glimpse of an encounter with a believer in this magic:

> *Years ago I was working on Broadway between Sixth and Seventh. I was out sweeping the sidewalk when I saw something on the walk. I went over to see what it was, and it happen to be a little puppy dog (salamander). I started to killing it and a colored man that was walking up the street holler over at me and said, "Don't kill it. Give it to me." But I killed it just the same. I said to this man, "What did you want with that. It is poison." He said, "I could dry it up and make a powder out of it and put it in a little paper bag and carry it, and if anyone was across the street I could drop it on the sidewalk, and if the wind was in the right way to carry it across the street, it would go up their nostril and poison them and they would be full of puppy dogs." I was glad I didn't let him have it, but I was always afraid of that man. The woman I was working for said he could not hurt me, but I was scared of him just the same for years.*[241]

In most cases, the prescribed method was to kill a lizard or snake, cut off and dry its head and grind the dried head into powder. The powder was then sprinkled in various places, depending on the desired effect. "Take lizards and make them real mad," one African American informant explained. "Then kill them and cut off their heads. Dry them and make a powder of the heads. If you will sprinkle that on someone's head, they will have pains and misery all the time in their heads. If you sprinkle it on their body, they will just dribble away like consumption. If you put it in their coffee to drink, they will have live things in them."[242]

Sometimes a combination of animals was used. Harry Middleton Hyatt interviewed one person who recommended squeezing a snake, lizard and a mole to death and then drying their bodies. Another instructed him to dry the heads of a scorpion, lizard and snake. The dried animals were then to be powdered and placed in a bag. When an enemy approached, the practitioner threw the bag in front of him or her, magically causing the creatures to enter his or her body. An alternative method for disbursal was to put a pinch of the powdered creatures in a handkerchief and then subtly shake it out while speaking with the intended target. Another informant recommended putting

the powder in the intended victim's coffee. "If you don't like someone, take a rattlesnake and kill it," he or she said. "Then dry and make a powder of it. Then put that powder in their coffee or something they eat, and in four months they will be just full of little snakes."[243] Alternatively, one person Hyatt interviewed prescribed drinking lizard powder mixed with whiskey to break a hoodoo spell.[244]

In the following tales, told by a pair of African Americans to Harry Middleton Hyatt, spouses found themselves hoodooed by their loved ones. At a loss for a cure, they approached a hoodoo doctor, whose recommendation would have broken the spell but resulted in their loved ones' deaths. In the first story, a wife chose to suffer with her affliction rather than harm her husband:

> *I had a friend that her husband was very jealous of her. They did not get along at all. He was always telling her, when he got mad, he was going to hoodoo her. So one day he got real mad and left town. In a few days after he left, she got a little frog in her throat. It worried her, because her grandma died with a frog choking her to death over someone hoodooing her. This frog kept choking this woman, so she went to a hoodoo doctor. And he told her, her husband had put the spell on her, and if she would write him a letter and send it to this hoodoo doctor, he would send the letter to her husband and break the spell, but it would kill her husband. This woman is in love with her husband and didn't write the letter, for she did not want him to die. But she still has that frog in her throat, choking her at times.*[245]

In the second story, suffering overcame a husband's willpower and he took the hoodoo doctor's advice, reversing the spell onto his spouse:

> *My father had a man friend years ago and his wife (the friend's wife) was very jealous of him (her husband). She was always getting mad. So one day she thought she would make him suffer, so she gave him some lizard powder. It was no time at all until he was just full of little lizards. You could just see them crawling up his arm. The man could not stand it, so one day he went to see a hoodoo doctor and he told him, "Your wife has hoodoo you because she is jealous" and told him that when his wife went to sleep, he should hit her real hard in the back, and the shock would scare the little lizards out of him and into her, and she would suffer and die. The man did not want his wife to die, but he kept suffering so that one night he did hit his wife real hard in the back, and the shock did scare the lizards out*

of him into his wife. She just got full of them. You could see them crawling everywhere under her flesh. And at last she died.[246]

According to social historian Owen Davies, tapeworms, cancerous growths, nervous disorders and severe stomach acid were all likely explanations for feelings of infestation by tiny reptiles and amphibians. Hoodoo or root doctors cleverly hid lizards and other creatures in shirtsleeves or bandages and produced them at the critical time in a convincing display to their audience.[247] Accounts of victims vomiting creatures, however, are more difficult to explain. One African American resident of Adams County told Harry Middleton Hyatt, "My girlfriend's sister, someone hoodooed her; and snakes, frogs and lizards all came out of her mouth. They just run down on the floor. They got the doctor but he could not do her any good, because when you are hoodooed they can't help you. So this girl died."[248] Though often illusory, the presence of physical evidence readily reinforced these beliefs, despite skeptical attempts to disprove them. In western Illinois, as well as the American South, reptiles and amphibians continued to play an important role in the African American folk magic of hoodoo.

Caro.
death in

Witches in Illinois Folklore

No exploration of witchcraft in Illinois would be complete without discussing various witch legends in local folklore. A legend is a nonhistorical or unverifiable story handed down by tradition and popularly accepted as historical. This can include popular stories about certain individuals with purported magical powers. Many witch legends are centered on "witch graves," which have become objects of legend tripping. Legend tripping is the act of traveling to a site that is alleged to have been the scene of some tragic, horrific and possibly supernatural event or haunting. Often performed at night, visitors go to test the validity of the legend—as well as their courage. Witch graves can also be places of veneration. Visitors take pictures and leave coins and other tokens of their sympathy.

According to local legend, witches are buried in at least four Illinois cemeteries, including Baker Cemetery in Crawford County, St. Omer Cemetery in Coles County, Chesterville Cemetery in Douglas County and Whitaker/Methodist Church Cemetery in St. Clair County. As legends, the backstories behind these burials are pseudohistorical, meaning it is likely the subjects were never suspected of being witches or might never have existed. In some cases, legends may have developed around certain graves simply because they were unusual or appeared "strange" or "creepy."

An unusual family monument in St. Omer Cemetery, outside the small town of Ashmore in Coles County, for example, has spawned a legend that Caroline Barnes, one of four people buried under the large stone, was put to death in the 1800s for practicing witchcraft. It is said that no pictures can be

The grave alleged to belong to the "Chesterville Witch," a popular legend in east-central Illinois. *Author's collection.*

taken of her monument and it glows on moonless nights. Made of granite, the Barnes family monument is shaped like a large orb resting on top of a base of crisscrossed logs. Some visitors describe it as a crystal ball atop a pyre. Though unique, similar monuments can be found in several central Illinois cemeteries, including Union Cemetery in northeastern Coles County. Orbs in cemetery art represent faith, and logs or tree trunks are common imagery representing growth and enduring life. As if to ward off any similar misconceptions, the nearly identical monument in Union Cemetery features the inscription "He lived as he died: A Christian."

Most explanations for the witch legend revolve around Caroline Barnes's impossible date of death etched into the stone: February 31, 1882. The monument is also oriented north–south, while most headstones face east. Of course, these two things can be explained without appealing to the supernatural. Being such a large monument, it is likely that if a mistake had been made in the date it would have been difficult and expensive to correct. As for the unconventional orientation of the stone, cemetery trustees have had to hoist it upright several times after vandals knocked it down, and it

This 1876 map shows the location of St. Omer, a village in Coles County where Caroline and Marcus Barnes lived. *From* Atlas of the State of Illinois.

was reoriented in the process. Still, the witch story is popular among young people in the community. In 2003, Maria Kelley, then a Lake Land College student, told the *Coles County Leader*, "They tried to kill [Caroline] by hanging her but that didn't kill her so they buried her alive....When they went back to see if she was dead, they said she was gone. That's why people say she was a witch." They changed the date on her tombstone to prevent her from rising from the grave and taking revenge on the anniversary of her death.[249] Despite the rumors, there is no historical or documentary evidence supporting the notion that Caroline Barnes was accused of witchcraft, let alone put to death for it.

Historically, the fate of the Barnes family was less dramatic. According to local historian Carolyn Stephens, Marcus Barnes (Caroline's husband) died in a sawmill accident in December 1881. Caroline, only twenty-four years old, died two months later of "double pneumonia" on either February 26 or 28 (the Coles County death record reads February 28). The cemetery in which they are buried is all that remains of the once thriving community of St. Omer. St. Omer was officially founded in 1852, although it was previously called Cutler's Settlement. According to *The History of Coles County*, the village was a collection of around six houses, a store, post office and a blacksmith's

The gravestone of Caroline and Marcus Barnes, now referred to in popular lore as a "witch's grave." *Author's collection.*

shop, but the *Coles County Map & Tour Guide* says that forty to fifty families once lived there.[250] St. Omer disappeared in the 1880s, around the same time both Caroline and Marcus Barnes died. Families living in the village packed up and moved to nearby Ashmore when the railroad was built. In 1893, a schoolhouse and Presbyterian church still stood on the Barnes family land, but nothing remains of either of the buildings. The church burned down in the 1950s.

A more historical tale involves Elizabeth "Betsey" Reed and her grave in Baker Cemetery, outside the unincorporated community of Heathsville, Illinois, in Crawford County. She was the first woman to be executed and the only woman to be executed by hanging in the history of Illinois. Elizabeth Reed, forty, lived with her husband, Leonard Reed, five miles southeast of Palestine, Illinois, in Crawford County. In August 1844, Elizabeth began slowly poisoning her husband's food with small doses of arsenic. One morning, sixteen-year-old Eveline Deal, a hired servant, witnessed Elizabeth putting something in the husband's coffee. It was a larger dose than usual, and he became violently ill and died. The girl told some of their neighbors what she had seen, and Elizabeth Reed was promptly arrested and charged with her husband's murder.

According to *History of Crawford and Clark Counties, Illinois* (1883) by William Henry Perrin, a medical examination found traces of arsenic in his stomach. While awaiting trial, Reed was lodged in the jail at Palestine. She attempted to escape, however, by slowly burning a hole in the wooden wall. The flame quickly got out of hand, and she had to be rescued from the fire and was moved to the jail in Lawrence County.[251] On April 28, 1845, a jury convicted her of first-degree murder. Judge William Wilson proclaimed, "The judgment of the law and the court is that you, Elizabeth Reed, be taken from hence to the place of your confinement, and that the 23rd day of May next you be taken from thence to some convenient place within 1 mile of this courthouse, and there be hanged by the neck until you are dead; and that the Sheriff execute the sentence; and may the Lord have mercy on your soul."[252]

On May 23, 1845, Elizabeth Reed rode toward the gallows on her coffin, dressed in a long white gown. She claimed to have found peace with God and shouted praises as the minister read the eulogy. An audience of twenty thousand people turned out to watch the execution, and eyewitness reports say the crowd was deathly silent as Reed was ushered into eternity a few minutes before noon. Relatives quietly buried her body next to her husband near their home in tiny Baker Cemetery.

In 2007, a man named Rick Kelsheimer wrote a historical fiction novel based on Elizabeth Reed's trial and execution called *The Hanging of Betsey Reed: A Wabash River Tragedy on the Illinois Frontier*. In it, he explored the notion that many of Reed's neighbors believed she was a witch. She allegedly practiced some form of folk medicine, and Kelsheimer claimed local men found her "beautiful and mysterious."[253] William Henry Perrin, who did not shy away from discussing witchcraft at length in his *History of Effingham County, Illinois* (1883), made no mention of anyone suspecting Elizabeth Reed was a witch in his retelling of her arrest and trial. Nevertheless, Baker Cemetery has become a destination for curiosity seekers and those interested in the paranormal. The headline of a 2013 *Decatur Herald-Review* article referred to Reed as an "accused witch and killer" and discussed paranormal activity that allegedly takes place at the cemetery.[254] Articles such as this have helped reinforce the legend, and it is likely Elizabeth Reed's grave will continue to be a popular legend-tripping destination.

There are other witch-related legends in Illinois as well. Mary Worth, for example, is one of the most well-known witches in contemporary Illinois folklore. According to legend, Worth was a notorious practitioner of the black arts who lived on a farm west of Gurnee or Wadsworth, Illinois, in

Lake County in the mid-1800s. Prior to the Civil War, storytellers allege, she captured runaway slaves and tortured them in her barn. Outraged locals took the law into their own hands and burned her to death. Some say her bones were buried in St. Patrick's Cemetery, but others say they were buried on her farm. Years later, a house was built over the foundation of the former barn. The family who lived there found a stone on the property and used it as a step beneath their front door. Poltergeist activity quickly followed. In 1986, the house burned to the ground, and subsequent efforts to build at the location have failed. Folklorists like Jan Harold Brunvand believe this tale is a local manifestation of the "Bloody Mary" urban legend.[255]

Another popular witch tale comes from western Winnebago County. She is known as Beulah, the Meridan Witch, after the road on which her dilapidated home was located. Local storyteller William Gorman described Beulah as an "old, reclusive woman." As a young man, he recalled venturing out beyond the bright lights of Rockford, Illinois, with a group of friends to track down her home and see if the legend was true. They said Beulah was born in a log cabin on Mill Creek near Ursa, Illinois, in Adams County, an area known for its strong superstitions. In Beulah's youth, shards from a broken speculum disfigured her face. Its reassembled pieces formed a looking glass that was key to her powers. They said she was a Gypsy fortuneteller or fallen nun who had exiled herself to the woods along Meridian Road, where she lived with two German shepherds: Vinegar and Gristle. Some locals blamed fatal accidents along the road on her dark powers. According to one story, a boy became lost in the area and later appeared along the road, his hair turned white. Color drained from the hair is an old element of folklore to signify something shocking or traumatic has occurred. In another tale, Beulah cursed the surrounding farms, causing the trees to wither, cows to give sour milk and chickens to lay eggs with baby snakes inside. She was once spotted standing naked in the moonlight, covered in blood and wearing a necklace of Adam's apples gathered from missing children.[256]

The wild details of these tails hark back to the traditional image of the witch as a negative force of nature: harming crops and livestock, causing accidents and killing children, with her familiars (the German shepherds) at her side. She even lived in a fanciful former one-room schoolhouse, complete with white clapboards covered in dried cornstalks, a smoking iron chimney, an old coal shed and a sagging clothesline.

According to Gorman, his father later confirmed that Beulah was a real person. She taught at the one-room schoolhouse where she later lived, and an accidental fire claimed the lives of two of her students. That event, he

said, started the rumors that she was a witch. She spent her later years isolated and alone, harassed by teenagers looking to find confirmation of the tales. They reportedly threw empty bottles, straw brooms and even garlic into her yard.[257] This brings to mind Grace Partridge Smith's lamentation that the belief in witchcraft still existed "in out-of-the-way sections where one occasionally hears of a persecuted old soul whom everyone believes a witch."[258] Beulah eventually died, and the one-room schoolhouse where she lived was demolished. Still, stories remained, and her legend acquired more supernatural elements. As a legend, few details about this person's life can be confirmed, even in the reportedly "true" version of events. It is, however, one of the most recently developed witch tales in Illinois.

Since the early nineteenth century, legends about witches and witchcraft have appeared on the Illinois prairie. Like southern Illinois's Mary Toombs and Eva Locker, Mary Worth and Witch Beulah may never have existed—at least not as popularly imagined—but their names were real enough to strike fear in superstitious hearts. In rural areas and graveyards, off seldom-traveled roads at the margins of the familiar, there is still a place for the traditional image of the witch, even if it is in the murky realm of folklore and urban legend. The witches themselves are dead and buried beneath the fertile prairie soil, but they live deep in our collective subconscious, where they have cast a spell on our imaginations.

Glossary

abstergent: a cleansing agent.

bezoar: a hard mass, such as a stone or hairball, in the stomach and intestines of animals, especially ruminants, and man; formerly thought to be an antidote to poisons.

conjure: to affect or influence by or as if by invocation or spell; to call or bring into existence by or as if by magic.

contagious magic: magic that attempts to affect a person through something once connected with him or her, as a shirt once worn by the person or a footprint left in the sand; a branch of sympathetic magic based on the belief that things once in contact are in some way permanently so, however separated physically they may subsequently become.

feather wreath: a spherical cluster of feathers found in feather pillows believed to herald death or illness.

folklore: the traditional beliefs, legends, customs and so forth of a people; a body of widely held but false or unsubstantiated beliefs.

folk magic: an informal attempt to practice charms, spells and so forth to control events or people based on popular beliefs.

hex: (v.) to bewitch, practice witchcraft on; (n.) a spell or charm.

hoodoo: a person or thing that brings bad luck; African American folk magic.

Illinois Country: (French: *Pays des Illinois*) a region of New France in what is now the midwestern United States from roughly 1671 to 1763, sometimes referred to as Upper Louisiana.

imitative magic: magic that attempts to control the universe through the mimicking of a desired event, as by stabbing an image of an enemy in an effort to destroy him or her or by performing a ritual dance imitative of the growth of food in an effort to secure an abundant supply; a branch of sympathetic magic based on the belief that similar actions produce similar results.

legend: a nonhistorical or unverifiable story handed down by tradition from earlier times and popularly accepted as historical.

Little Egypt: a folkname for southern Illinois, sometimes described as encompassing area code 618. In the nineteenth century, the southern third of Illinois was colloquially known as Egypt.

magic: the art of producing a desired effect or result through incantation or various other techniques that presumably ensure human control of supernatural agencies or the forces of nature.

maleficium: a Latin term meaning "wrongdoing" or "mischief" and describing malevolent, dangerous or harmful magic, evildoing or malevolent sorcery. In general, the term applies to any magical act intended to cause harm or death to people or property. Maleficium can involve the act of poisoning or drugging someone.

neopaganism: a twentieth-century revival of interest in the worship of nature, fertility and so forth as represented by various deities.

Northwest Territory: a U.S. territory roughly encompassing the present-day states of Ohio, Indiana, Illinois, Michigan and Wisconsin from 1787 to 1803.

superstition: a belief or notion, not based on reason or knowledge, in or of the ominous significance of a particular thing, circumstance, occurrence, proceeding or the like.

sympathetic magic: magic based on the belief that one thing or event can affect another at a distance as a consequence of a connection between them.

trichobezoar: a compact mass of hair that forms in the stomach of cats, calves and other beasts as a result of licking and swallowing the fur.

voodoo: a polytheistic religion practiced chiefly by West Indians, deriving principally from African cult worship and containing elements borrowed from the Catholic religion; black magic; sorcery.

Wicca: a nature-oriented religion having rituals and practices derived from pre-Christian religious beliefs and typically incorporating modern benevolent witchcraft.

witch: a person who professes or is supposed to practice magic or sorcery.

witchcraft: the art or practices of a witch; sorcery; magic; magical influence.

witch doctor: also called shaman, medicine man or witch master; a man in certain societies who appears to possess magical powers, used especially to cure sickness but also to harm people.

Notes

Introduction

1. Hurd, *Revised Statutes of the State of Illinois*, 269.
2. *Laws Passed by the First General Assembly*, 3; *Public and General Statute Laws of the State of Illinois*, 440.
3. *Statutes of the Realm*, 1,028.
4. Meyer, "Foreign Immigrants in Illinois, 1850," 18; Clark, *Frontier America*, 301.
5. Hyatt, *Folk-Lore from Adams County, Illinois*, 471.
6. Neely, *Tales and Songs of Southern Illinois*, 106.
7. Hohman, *Long-Lost Friend*, 10.
8. Davidson and Stuvé, *Complete History of Illinois from 1673 to 1873*, 230.
9. Reynolds, *Pioneer History of Illinois*, 174.
10. Erwin, *History of Williamson County, Illinois*, 62.
11. Perrin, *History of Effingham County, Illinois*, 14.
12. *Chicago Tribune*, July 9, 1871.
13. *Chicago Inter Ocean*, May 29, 1904.
14. *New York Times*, July 30, 1911; *Inter Ocean*, October 29, 1911.
15. *Chicago Daily Tribune*, April 19, 1879.
16. *Decatur Herald*, October 13, 1885.
17. *Morning Review*, October 13, 1885.
18. *Daily Whig*, September 28, 1904.

19. Roosevelt, *Winning of the West*, 174.
20. Gunn, "Witchcraft in Illinois," 463.
21. Perrin, *History of Effingham County*, 14.
22. Smith, "Folklore from 'Egypt,'" 47.

CHAPTER *1*

23. Pope Innocent VIII, *"Summis Desiderantes Affectibus,"* in *Witchcraft in Europe, 400–1700: A Documentary History*, 177–79.
24. Briggs, *Witches & Neighbors*, 260.
25. See Thomas, *Religion and the Decline of Magic: Studies in Popular Beliefs in Sixteenth- and Seventeenth-Century England*.
26. Reay, *Popular Cultures in England, 1550–1750*, 111, 130; Macfarlane, *Witchcraft in Tudor and Stuart England*, 168–76.
27. Briggs, *Witches & Neighbors*, 408.
28. *Divels Delusions*, 1–3.
29. Ibid, 2–3.
30. *Witch of Wapping*, 1.
31. Ibid, 6–7.
32. *Declaration in Answer to Several Lying Pamphlets*, 4.
33. Ibid, 4–5.
34. Ibid, 6–7.
35. Ibid, 7–8.
36. *Great News from the West of England*, 1.
37. Ibid, 1–2.
38. Jacob and Jacob, "Anglican Origins of Modern Science," 264.
39. See Glanville, "Sadducismus Triumphatus," in *Witchcraft in Europe, 400–1700*, 370–90.
40. Cotton Mather, "A Discourse on Witches," in *Witchcraft in Europe, 400–1700*, 367–69.
41. Ibid.
42. Kittredge, *Witchcraft in Old and New England*, 368.
43. Kors and Peters, *Witchcraft in Europe, 400–1700*, 392.
44. Fischer, *Albion's Seed*, 340–41, 527.
45. Ibid., 608–9, 710.

CHAPTER 2

46. Davidson and Stuvé, *Complete History of Illinois*, 115, 231.

47. Gleeson, *Millionaire*, 167–78, 258.

48. See Williams, *Voodoos and Obeahs: Phases of West India Witchcraft*.

49. Davidson and Stuvé, *Complete History of Illinois*, 230.

50. Roosevelt, *Winning of the West*, 174.

51. Gunn, "Witchcraft in Illinois," 462.

52. Palmer, *Through the Codes Darkly*, 179.

53. Alvord, "Virginia Series, Volume I: Cahokia Records, 1778–1790," in *Collections of the Illinois State Historical Library*, 2:459.

54. Reynolds, *Pioneer History of Illinois*, 175.

55. Gunn, "Witchcraft in Illinois," 459.

56. Roosevelt, *Winning of the West*, 175.

57. Hyatt, *Folk-Lore from Adams County*, 461.

58. Chireau, *Black Magic*, 69–70.

59. Alvord, *Collections of the Illinois State Historical Library*, 13–15.

60. Ibid., 15–19.

61. Ibid., 19–21.

62. Mason, "John Todd, John Todd's Record-Book and John-Todd Papers," in *Early Illinois*, Fergus' Historical Series, No. 33, 172.

63. Alvord, "Virginia Series, Volume II: Kaskaskia Records, 1778–1790," in *Collections of the Illinois State Historical Library*, 5:97.

64. Mason, "John Todd, John Todd's Record-Book and John-Todd Papers," 173.

65. Gunn, "Witchcraft in Illinois," 461.

66. Gibson, *Witchcraft and Society in England and America, 1550–1750*, 5–8

67. Ibid., 459.

CHAPTER 3

68. Fischer, *Albion's Seed*, 51.

69. Perrin, *History of Effingham County*, 58.

70. Erwin, *History of Williamson County*, 60.

71. Neely, *Tales and Songs of Southern Illinois*, 104.

72. Erwin, *History of Williamson County*, 61.

73. John W. Allen, *Legends & Lore of Southern Illinois*, 57.

74. Erwin, *History of Williamson County*, 61.

75. Ibid., 60.
76. Franklin County Historical Society, *Franklin County, Illinois, 1818–1997*, 8, 114.
77. *New York Times*, June 30, 1871.
78. *Chicago Tribune*, July 9, 1871.
79. Ibid.
80. Franklin County, Illinois Federal Census, 1870.
81. Franklin County Historical Society, *Franklin County, Illinois, 1818–1997*, 14.
82. Perry County, Illinois Federal Census, 1860.
83. *Nashville Union and American*, July 9, 1871.
84. *New York Times*, July 30, 1911. The *New York Times* confused the names of the key players, referring to James Spiva as Abel, Elizabeth Friend as Mary and Abel Friend as Charles. Census, court and marriage records were used to correct the discrepancy.
85. Williams, *History of the United States, to 1877*, 42.
86. Clarke, *History of McDonough County*, 49.
87. Marriage record for William Spiva and Phebe Van Winkle; Marriage record for James H. Spiva and Rhenansy Friend.
88. Illinois State Archives, *Illinois Public Domain Land Tract Sales Database*.
89. Primitive Baptist Library, "Church and Family History Assistance for Primitive Baptist Churches in McDonough County, Illinois," http://www.carthage.lib.il.us/community/churches/ primbap/FamHist-McDon.html.
90. Hallwas, *McDonough County Heritage*, 131. Hallwas's account, which included the Spiva family's bad luck, is based on an article in the *Warsaw Record*. The *New York Times* did not mention that element.
91. *People v. Jas. H. Spivy*.
92. Clarke, *History of McDonough County*, 54.
93. Hallwas, *McDonough County Heritage*, 131. The *New York Times* described Samuel Wilson's intervention, while Hallwas merely stated that James (he called him Abie) was turned over to the sheriff and released.
94. Illinois State Archives, *Illinois Civil War Muster and Descriptive Rolls Database*.
95. Savagde, *Relation of the Most Remarkable Proceedings at the late Assizes at Northampton*.
96. *Ruama Spiva v. James Spiva*.
97. *Ruama Spiva v. James H. Spiva*. All legal records pertaining to their divorce are located in the same file.
98. *Macomb Eagle*, December 11, 1858.
99. *Decatur Herald*, October 13, 1885.
100. Richmond, *Centennial History of Decatur and Macon County*, 178.

Chapter 4

101. *Chicago Daily Tribune*, April 18, 1879.

102. Ibid., April 19, 1879.

103. Ibid., April 22, 1879.

104. *Daily Herald*, October 6, 1901.

105. *Newark Advocate*, November 22, 1901; *Daily News*, November 25, 1901.

106. *Morning Register*, December 24, 1901; *Telegraph-Herald*, December 21, 1901.

107. *Daily News*, December 21, 1901.

108. *Morning Register*, December 24, 1901.

109. *Logansport Journal*, August 20, 1903.

110. *Chicago Daily Tribune*, August 5, 1939.

111. *Indianapolis Star*, November 5, 1906; *Leavenworth (KS) Post*, November 16, 1906; *Punxsutawney (PA) Spirit*, November 30, 1906.

112. *Chicago Inter Ocean*, October 16, 1906.

113. *Chicago Daily Tribune*, February 24, 1919.

114. Ibid., August 23, 1903.

Chapter 5

115. Rose, *Razor for a Goat*, 56–61. See also Hutton, *Triumph of the Moon*.

116. "Real Witches Practice Samhain: Wicca on the Rise in U.S.," *ABC News*, October 31, 2009.

117. "Witch School Opens Doors in Midwestern Town," *ABC News*, June 30, 2006.

118. "Temple of The Phoenix, Council By-Laws."

119. *Northern Star*, March 30, 2009.

120. *Daily Eastern News*, January 25, 2002.

121. Ibid., January 23, 2003.

122. Donald Lewis, "Re: Questions about the Correllian Tradition in Illinois," e-mail message to author, May 15, 2015.

123. *Kokomo (IL) Tribune*, February 6, 1953; *Galveston (TX) Leader*, December 24, 1953.

124. *Pharos-Tribune*, June 19, 1988.

125. Lewis, e-mail.

126. Lewis, "History."

127. Ibid.

128. "Witch School Divides Illinois Town Residents," *USA Today*, November 11, 2007.
129. Lewis, e-mail.
130. *USA Today*, November 11, 2007; *Chicago Tribune*, October 28, 2007, October 31, 2009.
131. *Commercial News*, August 29, 2008.
132. *Chicago Tribune*, October 31, 2009.

CHAPTER 6

133. Erwin, *History of Williamson County*, 60.
134. Hyatt, *Folk-Lore from Adams County*, 455.
135. Erwin *History of Williamson County*, 60.
136. Allen, *Legends & Lore of Southern Illinois*, 56.
137. *Chicago Tribune*, July 9, 1871.
138. Neely, *Tales and Songs of Southern Illinois*, 101.
139. Hyatt, *Folk-Lore from Adams County*, 460–61.
140. Neely, *Tales and Songs of Southern Illinois*, 102–3.
141. Allen, *Legends & Lore of Southern Illinois*, 57.
142. Yeats, *Fairy and Folk Tales of Ireland*, 141.
143. Hyatt, *Folk-Lore from Adams County*, 458.
144. Ibid., 482.
145. Ibid., 458–59.
146. Ibid., 459.
147. Bradsby, *History of Bureau County, Illinois*, 77.
148. Neely, *Tales and Songs of Southern Illinois*, 103.
149. Hyatt, *Folk-Lore from Adams County*, 539.
150. Ibid., 542.
151. Ibid., 458.
152. Ibid., 532.
153. Davidson and Stuvé, *Complete History of Illinois*, 230.
154. Neely, *Tales and Songs of Southern Illinois*, 104.
155. Allen, *Legends & Lore of Southern Illinois*, 57.
156. Erwin, *History of Williamson County*, 62.
157. Hyatt, *Folk-Lore from Adams County*, 483.
158. Bradsby, *History of Bureau County*, 78.
159. Baker, *Hoosier Folk Legends*, 109–10.

160. Hyatt, *Folk-Lore from Adams County*, 471.

161. *Chicago Daily Tribune*, August 23, 1903.

162. Frazer, *Golden Bough*, 1:9.

163. Daly, "'Slows': The Torment of Milk Sickness on the Midwest Frontier," 30.

164. Hyatt, *Folk-Lore from Adams County*, 461–62.

165. Ibid., 463.

166. Ibid., 470.

167. Ibid., 464.

168. Ibid., 460.

169. *New York Times*, June 30, 1871; *Chicago Tribune*, July 9, 1871.

170. Hyatt, *Folk-Lore from Adams County*, 460.

171. Ibid., 526.

172. Ibid., 530–31.

173. Ibid., 534–35.

174. Dadd, *Dadd on the Nature and Treatment of the Diseases of Cattle*, 375.

175. *Medical Dictionary for the Health Professions and Nursing*, s.v. "bezoar."

176. Hyatt, *Folk-Lore from Adams County*, 467.

177. Perrin, *History of Effingham County*, 13–14.

178. Hyatt, *Folk-Lore from Adams County*, 489.

179. Neely, *Tales and Songs of Southern Illinois*, 105–6.

180. Hyatt, *Folk-Lore from Adams County*, 490.

181. Ibid., 493.

CHAPTER 7

182. Hyatt, *Folk-Lore from Adams County*, 460.

183. Ibid., 480–81.

184. Ibid., 458.

185. Ibid., 482.

186. Ibid., 484.

187. Ibid., 523.

188. Neely, *Tales and Songs of Southern Illinois*, 107.

189. Hyatt, *Folk-Lore from Adams County*, 530, 515.

190. Ibid., 529–30.

191. Ibid., 485.

192. Baker, *Hoosier Folk Legends*, 108.

193. Hyatt, *Folk-Lore from Adams County*, 481, 484.

194. Yeats, *Fairy and Folk Tales of Ireland*, 137–38.

195. Ibid., 481.

196. Ibid., 515–16.

197. Baker, *Hoosier Folk Legends*, 113–14.

198. Hyatt, *Folk-Lore from Adams County*, 467, 519.

199. Ibid., 540.

200. Neely, *Tales and Songs of Southern Illinois*, 107.

201. Hyatt, *Folk-Lore from Adams County*, 540–41.

202. Perrin, *History of Effingham County*, 14.

203. Hyatt, *Folk-Lore from Adams County*, 461, 522.

204. Ibid., 523.

205. Ibid., 536–37.

206. Ibid.

207. Ibid., 468, 543.

208. Ibid., 521.

209. *Full and True Account*, 3–4.

210. Bradsby, *History of Bureau County, Illinois*, 77–78.

211. Hyatt, *Folk-Lore from Adams County*, 461.

212. Smith, "Folklore from 'Egypt.'"

213. Hyatt, *Folk-Lore from Adams County*, 526–27, 545.

214. Ibid., 528.

215. Ibid., 458.

216. *Chicago Daily Tribune*, November 22, 1915.

217. Marbella and Flanagan, *Melrose Park*, 22; *Chicago Tribune*, April 8, 1923.

218. *Chicago Examiner*, November 24, 1915.

219. *Greenwood (SC) Daily Journal*, November 26, 1915.

220. *Chicago Daily Tribune*, December 12, 1915.

221. Ibid., April 2, 1916.

222. *Daily Whig*, September 28, 1904; September 29, 1904.

223. Ibid., September 28, 1904.

224. Davies, *America Bewitched*, 131.

CHAPTER 8

225. Hyatt, *Folk-Lore from Adams County*, 472, 463.
226. Allen, *Legends & Lore of Southern Illinois*, 71.
227. Ibid., 62.
228. Hyatt, *Folk-Lore from Adams County*, 478
229. Ibid., 499–500.
230. Ibid., 514–15.
231. Ibid., 503–4.
232. Ibid., 475, 478.
233. Ibid., 463, 471.
234. Ibid., 462, 474.
235. Ibid., 465.
236. Ibid., 473.
237. Ibid., 463, 466.
238. Ibid., 466.
239. Ibid., 463.
240. Ibid., 466, 473, 506.
241. Ibid., 468–69.
242. Ibid., 469.
243. Ibid., 467, 470.
244. Ibid., 527–28.
245. Ibid., 502.
246. Ibid., 505.
247. Davies, *America Bewitched*, 80.
248. Hyatt, *Folk-Lore from Adams County*, 528.

CHAPTER 9

249. *Coles County (IL) Leader*, October 31, 2003.
250. Perrin, *History of Coles County*, 406.
251. Ibid., *History of Crawford and Clark Counties*, 186.
252. *Chicago Daily Tribune*, October 18, 1885.
253. Kelsheimer, *Hanging of Betsey Reed*.
254. *Herald-Review*, September 28, 2013.
255. Brunvand, *Mexican Pet*, 80.

256. Gorman, *Ghost Whispers*, 78–81.
257. Ibid., 85–86.
258. Smith, "Folklore from 'Egypt,'" 47.

Bibliography

Articles

Daly, Walter J. "The 'Slows': The Torment of Milk Sickness on the Midwest Frontier." *Indiana Magazine of History* 102 (March 2006): 29–40.

Gunn, John H. "Witchcraft in Illinois." *Magazine of American History* 14 (July–December 1885): 458–63.

Jacob, James R., and Margaret C. Jacob. "The Anglican Origins of Modern Science: The Metaphysical Foundations of the Whig Constitution." *Isis* 71, no.2 (June 1980): 251–67.

Meyer, Douglas K. "Foreign Immigrants in Illinois, 1850." *Illinois History Teacher* 5 (1998): 15–21.

Smith, Grace Partridge. "Folklore from 'Egypt.'" *Hoosier Folklore* 5 (June 1946): 45–70.

Books

Allen, John W. *Legends & Lore of Southern Illinois.* Carbondale: Southern Illinois University Press, 1963.

Baker, Ronald L. *Hoosier Folk Legends.* Bloomington: Indiana University Press, 1982.

Briggs, Robin. *Witches & Neighbors: The Social and Cultural Context of European Witchcraft.* New York: Penguin Books, 1998.

Brunvand, Jan Harold. *The Mexican Pet: More "New" Urban Legends and Some Old Favorites.* New York: W.W. Norton & Company, 1986.

Chireau, Yvonne Patricia. *Black Magic: Religion and the African American Conjuring Tradition.* Berkeley: University of California Press, 2006.

Clark Thomas D. *Frontier America: The Story of the Westward Movement.* New York: Charles Scribner's Sons, 1969.

Dadd, G.H. *Dadd on the Nature and Treatment of the Diseases of Cattle.* Boston: John P. Jewett and Company, 1859.

Davidson, Alexander, and Bernard Stuvé. *A Complete History of Illinois from 1673 to 1873.* Springfield, IL: D.L. Phillips, 1877.

Davies, Owen. *America Bewitched: The Story of Witchcraft after Salem.* Oxford: Oxford University Press, 2013.

Fischer, David Hackett. *Albion's Seed: Four British Folkways in America.* New York: Oxford University Press, 1989.

Frazer, J.G. *The Golden Bough: A Study in Comparative Religion.* Vol. 1. New York: MacMillan and Company, 1894.

Gibson, Marion, ed. *Witchcraft and Society in England and America, 1550–1750.* Ithaca, NY: Cornell University Press, 2003.

Gleeson, Janet. *Millionaire: The Philanderer, Gambler, and Duelist Who Invented Modern Finance.* New York: Simon & Schuster, 1999.

Gorman, William. *Ghost Whispers: Tales from Haunted Midway.* Rockford, IL: Helm Publishing, 2005.

Hohman, John George. *The Long-Lost Friend.* Harrisburg, PA: self-published, 1850.

Hutton, Ronald. *The Triumph of the Moon: A History of Modern Pagan Witchcraft.* Oxford: Oxford University Press, 2001.

Hyatt, Harry Middleton. *Folk-Lore from Adams County, Illinois.* New York: Memoirs of the Alma Egan Hyatt Foundation, 1935.

Kelsheimer, Rick. *The Hanging of Betsey Reed: A Wabash River Tragedy on the Illinois Frontier.* West Conshohocken, PA: Infinity Publishing, 2007.

Kittredge, George Lyman. *Witchcraft in Old and New England.* New York: Russell & Russell, 1956.

Kors, Alan Charles, and Edward Peters, eds. *Witchcraft in Europe, 400–1700: A Documentary History.* Philadelphia: University of Pennsylvania Press, 2001.

Macfarlane, Alan. *Witchcraft in Tudor and Stuart England: A Regional and Comparative Study.* Prospect Heights, IL: Waveland Press, 1991.

Marbella, Fidencio, and Margaret Flanagan. *Melrose Park.* Charleston, SC: The History Press, 2009.

Neely, Charles. *Tales and Songs of Southern Illinois*. Carbondale: Southern Illinois University Press, 1998.

Palmer, Vernon Valentine. *Through the Codes Darkly: Slave Law and Civil Law in Louisiana*. Clark, NJ: Lawbook Exchange Ltd., 2012.

Reay, Barry. *Popular Cultures in England, 1550–1750*. New York: Addison Wesley Longman Limited, 1998.

Reynolds, John. *The Pioneer History of Illinois*. Chicago: Fergus Printing Company, 1887.

Roosevelt, Theodore. *The Winning of the West*. Vol. 2, *From the Alleghenies to the Mississippi*. New York: G.P. Putnam's Sons, 1889.

Rose, Elliot. *A Razor for a Goat: A Discussion of Certain Problems in the History of Witchcraft and Diabolism*. Toronto: Toronto University Press, 1962.

Thomas, Keith. *Religion and the Decline of Magic: Studies in Popular Beliefs in Sixteenth- and Seventeenth-Century England*. London: Penguin Group, 2012.

Williams, Joseph J. *Voodoos and Obeahs: Phases of West India Witchcraft*. New York: AMS Press, 1970.

Williams, T. Harry. *A History of the United States, to 1877*. New York: Alfred Knopf, 1966.

Yeats, W.B., ed. *Fairy and Folk Tales of Ireland*. New York: Macmillan Publishing Company, 1983.

BROADSIDES

A Declaration in Answer to Several Lying Pamphlets Concerning the Witch of Wapping. London [1652].

The Divels Delusions, or A Faithful Relation of John Palmer and Elizabeth Knott Two Notorious Witches Lately Condemned at the Sessions of Oyer and Terminer in St. Albans. London: Richard Williams [July 19, 1649].

A Full and True Account of the Proceedings at the Sessions of Oyer and Terminer, Holden for the City of London, County of Middlesex, and Goal-Delivery of Newgate which Began at the Sessions-House in the Old Bayly, on Thursday, June 1st. and Ended on Fryday, June 2d. 1682. London: I. Denskill, [1682].

Great News from the West of England. London: T.M. in Jewen-Street [October 26, 1689].

A Relation of the Most Remarkable Proceedings at the Late Assizes at Northampton. Northampton [1674].

The Witch of Wapping. London: T.N. Spring [July 19, 1652].

COUNTY HISTORIES

Bradsby, H.C., ed. *History of Bureau County, Illinois.* Chicago: World Publishing Company, 1885.

Clarke, S.J. *History of McDonough County, Illinois.* Springfield, IL: D.W. Lusk, 1878.

Erwin, Milo. *History of Williamson County, Illinois.* Marion: n.p., 1876.

Franklin County Historical Society. *Franklin County, Illinois, 1818–1997.* Paducah, IL: Turner Publishing, 1996.

Hallwas, John E. *McDonough County Heritage.* Macomb: Illinois Heritage Press, 1984.

Perrin, William Henry, ed. *History of Coles County, Illinois.* Chicago: W. Le Baron, 1879.

———. *History of Crawford and Clark Counties, Illinois.* Chicago: O.L. Baskin & Company, Historical Publishers, 1883.

———. *History of Effingham County, Illinois.* Chicago: O.L. Baskin & Co., Historical Publishers, 1883.

Richmond, Mabel E. *Centennial History of Decatur and Macon County.* Decatur, IL: Decatur Review, 1930.

NEWSPAPERS AND NEWS MEDIA

ABC News (New York) June 30, 2006; October 31, 2009.

The Advocate (Newark, NJ). November 22, 1901.

Chicago Daily Tribune. July 9, 1871; October 18, 1885; April 18, 19, 22, 1879; August 23, 1903; November 22, 1915; December 12, 1915; April 2, 1916; February 24, 1919; August 5, 1939.

Chicago Examiner. November 24, 1915.

Chicago Inter Ocean. May 29, 1904; October 16, 1906; October 29, 1911.

Chicago Tribune. October 28, 2007; October 31, 2009.

Coles County Leader (Tuscola, IL). October 31, 2003.

Commercial-News (Danville, IL). August 29, 2008.

Daily Eastern News (Charleston, IL). January 25, 2002; January 23, 2003.

Daily Herald (Chicago, IL). October 6, 1901.

Daily News (Des Moines, IA). November 22, 1901; December 21, 1901.

Daily Whig (Quincy, IL) September 28–29, 1904.

Decatur (IL) Herald. October 13, 1885.

Galveston (TX) Leader. December 24, 1953.

Greenwood (SC) Daily Journal. November 26, 1915.

Herald-Review (Decatur, IL). September 28, 2013.

Indianapolis Star. November 5, 1906.

Kokomo (IN) Tribune. February 6, 1953.

Leavenworth (KS) Post. November 16, 1906.

Logansport (IN) Journal. August 20, 1903.

Macomb (IL) Eagle. December 11, 1858.

Morning Register (Fort Worth, TX). December 2, 1901.

Morning Review (Decatur, IL). October 13, 1885.

Nashville (TN) Union and American. July 9, 1871.

New York Times. June, 30, 1871; July 9, 1871; July 30, 1911.

Northern Star (DeKalb, IL). March 30, 2009.

Pharos-Tribune (Logansport, IN). June 19, 1988.

Punxsutawney (PA) Spirit. November 30, 1906.

Telegraph-Herald (Dubuque, IA). December 21 1901.

USA Today. November 11, 2007.

PUBLIC DOCUMENTS AND PRIMARY SOURCES

Alvord, Clarence Walworth, ed. "Virginia Series, Volume I: Cahokia Records, 1778–1790." In *Collections of the Illinois State Historical Library*. Vol. 2. Springfield: Illinois State Historical Library, 1907.

———. "Virginia Series, Volume II: Kaskaskia Records, 1778–1790." In *Collections of the Illinois State Historical Library*. Vol. 5. Springfield: Illinois State Historical Library, 1909.

Franklin County, Illinois Federal Census, 1870. Transcribed by James Stephenson. http://files. usgwarchives.org/il/franklin/census/1870/.

Hurd, Harvey B., ed. *Revised Statutes of the State of Illinois*. Springfield: Illinois Journal Company, 1874.

Illinois State Archives. *Illinois Civil War Muster and Descriptive Rolls Database*. http://www.cyberdrive illinois.com/departments/archives/datcivil.html.

———. *Illinois Public Domain Land Tract Sales Database*. http://www.ilsos.gov/GenealogyMWeb/landsrch.html.

Laws Passed by the First General Assembly of the State of Illinois at Their Second Session, Held at Kaskaskia. Kaskaskia, IL: Blackwell & Berry, 1819.

Marriage record for James H. Spiva and Rhenansy Friend. *Schuyler County Marriage Book* 1:12. Illinois Regional Archive Depository, Macomb, Illinois.

Marriage record for William Spiva and Phebe Van Winkle. *Schuyler County Marriage Book* 1:6. Illinois Regional Archive Depository, Macomb, Illinois.

Mason, Edward G., ed. "John Todd, John Todd's Record-Book and John-Todd Papers." In *Early Illinois*, Fergus' Historical Series, No. 33. Chicago: Fergus Printing Company, 1890.

People v. Jas. H. Spivy. McDonough County Circuit Court Case. Box 223, File 53 (1850).

Perry County, Illinois Federal Census, 1860. Transcribed by Stella Runyon. http://ftp.us-census.org/pub/usgenweb/census/il/perry/1860/.

The Public and General Statute Laws of the State of Illinois. Chicago: Stephen F. Gale, 1839.

Ruama Spiva v. James Spiva. McDonough County Circuit Court Case. Box 225, File 9 (1855).

Ruama Spiva v. James H. Spiva. McDonough County Circuit Court Case. Box 91, File 9 (1860).

Statutes of the Realm. Vol. 4, part 2. London: 1819.

Websites

Lewis, Donald. "History." *The Correllian Tradition.* May 16, 2013. http://www.correllian.com/index.htm.

The Primitive Baptist Library. "Church and Family History Assistance for Primitive Baptist Churches in McDonough County, Illinois." http://www.carthage.lib.il.us/community/churches/primbap/FamHist-McDon.html.

"Temple of The Phoenix, Council By-Laws." *Temple of the Phoenix.* June 8, 2008. https://web.archive.org/web/20080703180941/http://www.templeofthephoenix.org/by-laws.html.

Index

About the Author

Michael Kleen has a master of arts degree in history from Eastern Illinois University and a master of sciences in education from Western Illinois University. He is the author of *Ghostlore of Illinois Colleges & Universities*, *Haunting Illinois: A Tourist's Guide to the Weird & Wild Places of the Prairie State*, *Paranormal Illinois* and *Tales of Coles County* and editor of the anthology *Secret Rockford*.

His nonfiction articles have appeared in publications such as *Historic Illinois* and the *Journal of the Illinois State Historical Society*, and his short stories have appeared in anthologies, including *Hunting Ghosts: Thrilling Tales of the Paranormal* and *Mythos: Myths & Tales of H.P. Lovecraft and Robert E. Howard*.

Michael has spoken about local history and folklore at conventions, libraries, cafés, museums, schools and colleges and on radio and television and has presented research papers at the 2007, 2010 and 2011 Conference on Illinois History in Springfield. To keep up to date on his latest travels, stories and research projects, please visit www.michaelkleen.com.